A VOLUME IN THE SERIES

Public History in Historical Perspective

Edited by Marla R. Miller

THE STAGES OF MEMORY

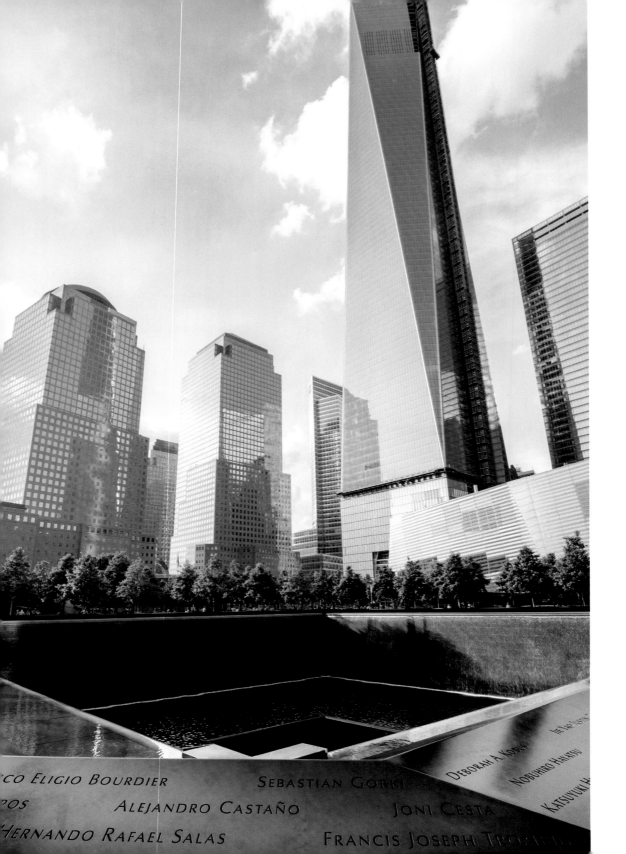

The Stages of Memory

Reflections on Memorial Art, Loss,
and the Spaces Between

JAMES E. YOUNG

University of Massachusetts Press
Amherst & Boston

ISBN 978-1-62534-257-7

Designed by Jack Harrison
Set in Adobe Garamond Pro with Weiss display.
Printed and bound by Friesens.

Frontispiece: Ben Harding / Shutterstock.com
Jacket design by Jack Harrison
Jacket art: Inner void of Michael Arad and Peter Walker's "Reflecting Absence." Photograph by Lisa Ades.

Library of Congress Cataloging-in-Publication Data
Names: Young, James Edward, author.
Title: The stages of memory : reflections on memorial art, loss, and the spaces between /
 James E. Young.
Description: Amherst : University of Massachusetts Press, 2016. |
 Series: Public history in historical perspective | Includes bibliographical
 references and index.
Identifiers: LCCN 2016026894 | ISBN 9781625342577 (jacketed cloth : alk. paper)
Subjects: LCSH: Memorialization—Social aspects. | Memorials—Social aspects.
 | Loss (Psychology) in art.
Classification: LCC GT3390 .Y68 2016 | DDC 394/.4--dc23
LC record available at https://lccn.loc.gov/2016026894

British Library Cataloguing-in-Publication Data
A catalog record for this book is available from the British Library.

*All photographs within the text are by James E. Young
unless otherwise credited.*

To the memory of cherished mentor and friend
Geoffrey H. Hartman, 1929–2016

My destiny no longer has me conquering the highest towers in the world, but rather the void they protect. This cannot be measured.

—Philippe Petit, *To Reach the Clouds: My High Wire Walk between the Twin Towers*

"Eleven"

We join spokes together in a wheel,
but it is the center hole that makes the wagon move.
We shape clay into a pot,
but it is the emptiness inside that holds whatever
 we want.
We hammer wood for a house,
but it is the inner space that makes it livable.
We work with being,
but non-being is what we use.

—from the *Tao Te Ching,* as compiled by the sixth-century BCE Chinese poet-philosopher Lao Tsu (trans. S. Mitchell, 1995)

CONTENTS

ACKNOWLEDGMENTS

Everything in these pages stems from the ongoing, lifelong conversation about memory, art, and loss I have had with my family, with the artists and architects whose works move and inspire me, and with the friends and colleagues who share my preoccupation with memorials and museums. The artists and architects whose works I discuss here are thus both subjects of my writing and partners in it. Here I would like to begin by thanking the memory artists whose friendships, collaborations, and creations have meant so much to me over these last twenty years or so, and who have inspired large parts of this book: Maya Lin, Daniel Libeskind, Michael Arad, Peter Eisenman, Esther Shalev-Gerz, Vitaly Komar and Alexander Melamid, Art Spiegelman, Shimon Attie, Tobi Kahn, Mirosław Bałka, Horst Hoheisel, Jochen Gerz, Anna Schuleit-Haber, Julian Bonder, Krzysztof Wodiczko, Renata Stih and Frieder Schnock.

I am especially grateful for the invitations to write the following catalog essays, on which a handful of these chapters are based, specifically: "Spaces for Deep Memory: Esther Shalev-Gerz and the First Countermonuments," in *The Memory Works of Esther Shalev-Gerz: A Retrospective,* ed. Nicole Schweizer (Lausanne: Musée des Beaux-Arts, 2012); "The Memory Spaces Within," in *Embodied Light: 9/11 in 2011, an Installation by Tobi Kahn* (New York: Educational Alliance and UJA Federation of New York, 2011); "Mirosłav Bałka's Graves in the Air," in *Mirosłav Bałka: Topography,* ed. Suzanne Cotter (Oxford: Oxford Modern Art, 2009); "Daniel Libeskind's New Jewish Architecture," in *Daniel Libeskind and the Contemporary Jewish Museum: New Jewish Architecture from Berlin to San Francisco,* ed. Connie Wolf (New York: Rizzoli, 2008); and "The Monument in Ruins," in *Monumental Propaganda,* ed. Dore Ashton (New York: Independent Curators International, 1995).

Other chapters in this collection are adapted from essays I have written at the invitation of journals, exhibition curators and catalog editors, and conference

conveners, including "The Memorial's Arc: Between Berlin's *Denkmal* and New York City's 9/11 Memorial," in *Power—Memory—People: Memorials of Today,* ed. Anna Louise Manly (Copenhagen: KØS Museum of Art in Public Spaces, 2014), catalog for the exhibition curated by Lene Bøgh Rønberg at the KØS Museum of Art in Public Spaces, Denmark; "Memory and the Monument after 9/11," in *The Future of Memory,* ed. Richard Crownshaw, Jane Kilby, and Antony Rowland (New York: Berghahn Books, 2010); "Nazi Aesthetics in Historical Context," in *After Representation? The Holocaust, Literature, and Culture,* ed. Clifton Spargo and Robert Ehrenreich (New Brunswick, NJ: Rutgers University Press, 2010), based on my review essay, "The Terrible Beauty of Nazi Aesthetics," *Forward.com,* April 25, 2003; "Regarding the Pain of Women: Gender and the Arts of Holocaust Memory," *PMLA* (October 2009), based on a paper I gave at the conference "In the War Zone: How Does Gender Matter?" convened by Drew Gilpin Faust at the Radcliffe Institute in 2005; "The Stages of Memory at Ground Zero," in *Religion, Violence, Memory, and Place,* ed. Oren Baruch Stier and J. Shawn Landres (Bloomington: Indiana University Press, 2006); "The Memorial Process: A Juror's Report from Ground Zero," in *Contentious City: The Politics of Recovery in New York City,* ed. John Mollenkopf (New York: Russell Sage Foundation, 2005); and "Foreword: Looking into the Mirrors of Evil," in *Mirroring Evil: Nazi Imagery/Recent Art,* ed. Norman Kleeblatt (New York and New Brunswick, NJ: Jewish Museum and Rutgers University Press, 2001), catalog for the exhibition at the Jewish Museum.

For my concluding chapter on Utøya and Norway's July 22 memorial process, I must thank my dear friend and Norway's preeminent memorial historian, Tor Einar Fagerland of Trondheim, whose invitation to consult on this process and whose leadership in the Memorial Research Project in Norway have been foundational to my own reflections on the events and memory of July 22, 2011. For what they have taught me about July 22 memory, I must also thank Mari Aaby West and Jørgen Frydnes of the Norwegian Labor Youth League. And for their profoundly insightful work on all kinds of memory, but specifically that at Ground Zero in New York, I must thank Alice Greenwald, director of the National September 11 Memorial Museum, Clifford Chanin, vice president of education and public programming at the 9/11 Museum, David Blight (historian par excellence of Civil War memory and a fellow member of the 9/11 Museum's "Kitchen Cabinet" advisory group), and Edward Linenthal, whose writings on the U.S. Holocaust Memorial Museum and the Oklahoma City bombing memorial continue to guide an entire generation of "memorialists."

Of course, it is impossible for me even to contemplate the 9/11 Memorial process at Ground Zero without recalling the profoundly humbling and moving

experiences I shared with the other members of our "memorial jury." It was an absolute honor and privilege to have been sequestered for some nine months during our selection process with this group of brilliant and generous artists, architects, historians, civic leaders, art world professionals, and courageous family member. I thank all of them here, with all of my heart, for opening up their hearts and minds to me and to one another, to the families of victims, to New York City, and to every single one of the 5,201 design submissions we viewed for this competition. For all they have taught me about how to enable life with memory, I thank Enrique Norten, Michael Van Valkenburgh, Maya Lin, Martin Puryear, Susan Freedman, Nancy Rosen, Lowery Stokes Sims, Vartan Gregorian, Patricia Harris, Michael McKeon, Julie Menin, and Paula Grant Berry. And for creating and administering this memorial process, for supporting and then holding open the space and time we needed, and for keeping faith in us, I will be forever indebted to former mayor Michael Bloomberg, former governor George Pataki, LMDC directors John Whitehead and Kevin Rampe, and most especially to the director of the memorial competition, Anita Contini, and to assistant director John Hatfield—both of whom shared every minute of our deliberations and then kept us going when we thought we couldn't go any further.

Here I must also acknowledge the ongoing and invaluable critical work on memorial culture by Andreas Huyssen, Aleida Assman, Marita Sturken, Patrick Amsellem, Shelley Hornstein, Kirk Savage, Michael Rothberg, Yasemin Yildiz, Gavriel Rosenfeld, Harriet Senie, Harald Welzer, Ernst van Alphen, and Oren Stier, among many others who have long informed my own thinking and writing on "memorial art." Without the emotional support and friendships of Christopher Benfey, Susan Shapiro, and Colby Smith, I would not have had the spaces for intellectual free association I needed for my own "working through" process.

I also want to thank from the bottom of my heart Clark Dougan, former senior editor, Mary Dougherty, director, Jack Harrison, production manager, and Carol Betsch, managing editor, at the University of Massachusetts Press for becoming the partners and critical readers I so desperately needed to pull together all of these "stages of memory" into a single volume. Coming home to write this book for my own university press has been a revelatory experience, for which I must also thank former UMass Press director Bruce Wilcox, whose wonderful idea this was in the first place. It's also true that this book would not have been possible without the academic and administrative support I received at all levels within the university, especially in the founding and running of the Institute for Holocaust, Genocide, and Memory Studies, from Lara Curtis, associate director

of the Institute, Julie Hayes, dean of Humanities and Fine Arts, Vice Chancellor for Research and Engagement Michael Malone, Deputy Chancellor Robert Feldman, and University Chancellor Kumble Subbaswamy.

Finally, it is to my wife, Lisa Ades, and my two sons, Asher Young and Ethan Young, that I owe my deepest, most profound thanks. Without their love and companionship, joy in life, and our ongoing conversation about both the stages of memory and the stages of life, none of this would have been worth writing.

THE STAGES OF MEMORY

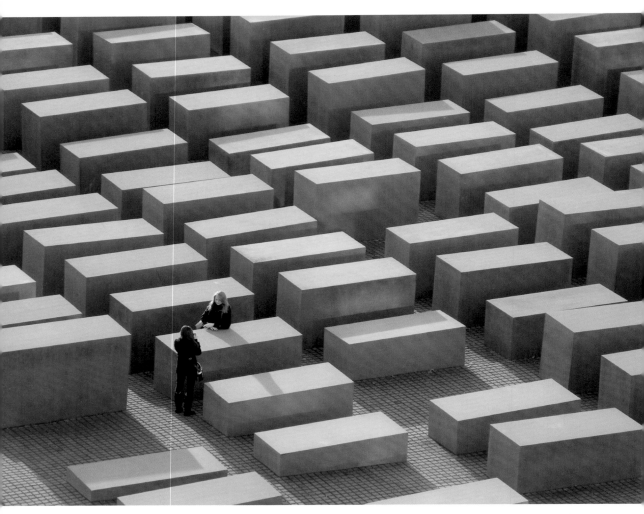

Part of the "Field of Stelae," Berlin's *Denkmal* (Memorial to the Murdered Jews of Europe), designed by Peter Eisenman, dedicated in 2005.

Introduction

The Memorial's Vernacular Arc between Berlin's Denkmal *and New York City's 9/11 Memorial*

In April 2003, the Lower Manhattan Development Corporation called a press conference at the just-repaired Winter Garden of the World Financial Center in Lower Manhattan, located across the street from the gaping pit of Ground Zero. Here the LMDC announced an open international design competition for a World Trade Center Site Memorial, and I was one of thirteen members of the design jury introduced that day. Together with jurors Maya Lin (designer of the Vietnam Veterans Memorial in Washington, D.C.) and Paula Grant Berry (whose husband David died in the South Tower on 9/11), among others, we implored potential entrants to this blind competition to "break the conventional rules of the monument," to explore every possible memorial medium in their expressions of grief, mourning, and remembrance for what would become the National September 11 Memorial.[1]

Within two months, we received some 13,800 registrations from around the world, and by the August 2003 deadline, we had received 5,201 official submissions from 63 nations, and from 49 American states (only Alaska was missing from the list). In January 2004, after six months of exhausting, occasionally tortured debate and discussion, we announced our winning selection at Federal Hall on Wall Street, where George Washington had taken his oath as America's first president.

The winning design, "Reflecting Absence," by Michael Arad and Peter Walker, proposed two deeply recessed voids in the footprints of the former World Trade Center towers, each 200 square feet, with thin veils of water cascading into reflecting pools some 35 feet below, each with a further deep void in its middle.

The pools were to be surrounded by an abacus grid of trees (even rows replicating the city grid when viewed west to east, seemingly natural, random groves when viewed north to south), which would deepen the volumes of the voids as they grew, even as they softened the hard, square edges of the pools. This memorial would indeed "reflect absence," even as it commemorated the lives lost with living, regenerating flora.

Until that day in January 2004, the 9/11 Memorial jurors were not allowed to speak to the press. Now for the first time since our appointment nine months earlier, we could take questions. The first question I took from a reporter caught me off-balance. "Knowing that you have written much about Holocaust negative-form monuments in Germany and that you were also on the jury that chose Peter Eisenman's design for the Berlin *Denkmal* (for Europe's Murdered Jews), it seems that you've basically chosen just another Holocaust memorial. Is this true?" Surprised and somewhat offended, I replied that obviously this design had nothing to do with Holocaust memorials.

Here the same reporter pressed me further: "But is it possible that Jewish architects are somehow predisposed toward articulating the memory of catastrophe in their work? Would this explain how Daniel Libeskind [original site designer of the new World Trade Center complex], Santiago Calatrava [designer of the new World Trade Center Transportation Hub abutting Ground Zero in Lower Manhattan], and now Michael Arad [designer of the memorial at Ground Zero] have become the architects of record in post-9/11 downtown Manhattan?" I had to concede that while I saw no direct references to Jewish catastrophe in these designs for the reconstruction of Lower Manhattan, it could also be true that the forms of postwar architecture have been inflected by an entire generation's knowledge of the Holocaust. Michael Arad and Peter Walker's "Reflecting Absence" is not a Holocaust memorial, I said, but its formal preoccupation with loss, absence, and regeneration may well be informed by Holocaust memorial vernaculars. This was also a preoccupation they shared with poets and philosophers, artists and composers: How to articulate a void without filling it in? How to formalize irreparable loss without seeming to repair it?

As I continued to mull my answer, I began to imagine an arc of memorial forms over the last eighty years or so and how, in fact, post–World War I and II memorials had evolved along a discernible path, all with visual and conceptual echoes of their predecessors. Here I recalled that counter-memorial artists and architects such as Horst Hoheisel, Jochen Gerz, Esther Shalev-Gerz, and Daniel Libeskind (among many others) all told me that Maya Lin's design for the Vietnam Veterans Memorial (1982) broke the mold that made their own

A visitor in the underground recessed space of the Memorial to the Martyrs of the Deportation, Île de la Cité, Paris. A statement by the Ministry of Defense at the site explains: "This monument was inaugurated on April 12th, 1962, by General De Gaulle, President of the French Republic, as a place of contemplation and remembrance of the suffering caused by the deportation [of 76,000 Jews, including 11,000 children]. It was created by the architect Georges-Henri Pingusson, and depicts certain features that define the concentration camp environment: narrow passages, tight staircases, spiked gates, restricted views with no sight of the horizon, and frequent references to the triangle, the distinctive mark of the deportees."

counter-memorial work possible. And here I remembered that Maya Lin had also openly acknowledged her own debt to both Sir Edwin Lutyens's "Memorial to the Missing of the Somme" (1924) in Thiepval, France, and later to George-Henri Pingusson's "Memorial to the Martyrs of the Deportation" (1962) on the Île de la Cité in Paris.[2] Both are precursors to the "negative form" realized so brilliantly by Maya Lin, both preoccupied with and articulations of uncompensated loss and absence, represented by carved-out pieces of landscape, as well as by the visitor's descent downward (and inward) into memory.[3]

Carved into the ground, a black wound in the landscape and an explicit counterpoint to Washington's prevailing white, neoclassical obelisks and statuary, Maya Lin's design articulated loss without redemption, and formalized a national ambivalence surrounding the memory of American soldiers sent to fight and die

Maya Lin's original submission to the competition for the Vietnam Veterans Memorial, pastel drawing accompanied by a hand-lettered text, 1981. *Photo: Maya Lin Studio.*

in a war the country now abhorred. In Maya Lin's words, she "imagined taking a knife and cutting into the earth, opening it up, an initial violence and pain that in time would heal."[4] That is, she opened a space in the landscape that would open a space within us for memory. "I never looked at the memorial as a wall, an object," Maya Lin has said, "but as an edge to the earth, an opened side."[5] Instead of a positive V-form (like a jutting elbow, or a spear-tip, or a flying-wedge military formation), she opened up the V's obverse space, a negative space to be filled by those who come to remember within its embrace. Moreover, as Maya Lin described it in her original proposal, "The memorial is composed not as an unchanging monument, but as a moving composition, to be understood as we move into and out of it."[6] That is, as a "monument" is fixed and static, her memorial would be defined by our movement through its space, memory by means of perambulation and walking through.

After the dedication of Maya Lin's Vietnam Veterans Memorial in 1982, it was as if German artists had also found their own uniquely contrarian memorial vernacular for the expression of their own national shame, for their revulsion against traditionally authoritarian, complacent, and self-certain national shrines. Preoccupied with absence and irredeemable loss, and with an irreparably broken world, German artists and architects would now arrive at their own, counter-memorial architectural vernacular that could express the breach in their faith in civilization without mending it, that might articulate the void of Europe's lost Jews without filling it in.

With Maya Lin's design for the Vietnam Veterans Memorial in mind, these German artists set out on their own quest to express their nation's paralyzing Holocaust memorial conundrum: How to commemorate the mass murder of Jews perpetrated in the national name without redeeming this destruction in any way? How to formally articulate this terrible loss without filling it with consoling

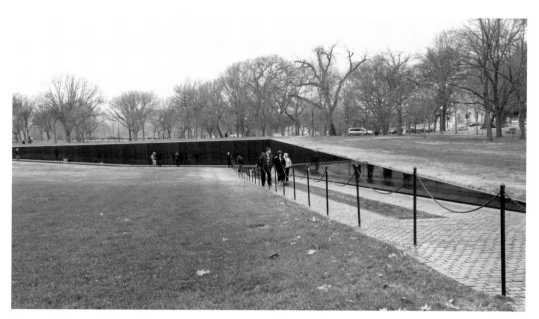

Vietnam Veterans Memorial, one axis pointing toward the Washington Monument, the other toward the Lincoln Memorial.

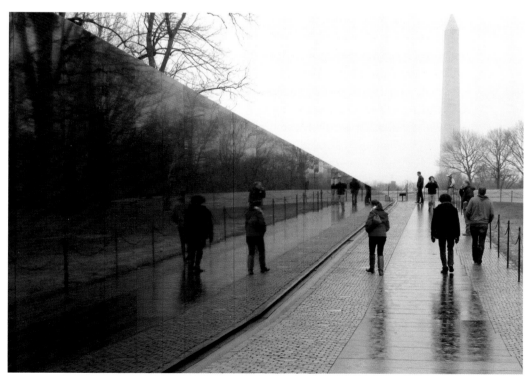

meaning? The resulting counter-monuments and negative-form designs of the 1980s and 1990s in Germany commemorating the Holocaust may have taken their initial cue from the Vietnam Veterans Memorial, but they also extended Maya Lin's implicit critique of the conventional monument's static fixedness, bombast, self-certainty, and authoritarian didacticism.[7]

Of all the dilemmas facing post-Holocaust memorial artists and designers, perhaps none is more difficult, or more paralyzing, than the potential for redemption in any representation of the Holocaust. Some, like Adorno, have warned against the ways poetry and art after Auschwitz risk redeeming events with aesthetic beauty or mimetic pleasure.[8] Others like Saul Friedländer, have asked whether the very act of history writing potentially redeems the Holocaust with the kinds of meaning and significance reflexively generated in all narrative.[9] Unlike the utopian, revolutionary forms with which modernists hoped to redeem art and literature after World War I, the post-Holocaust memory artist, in particular, would say, "Not only is art not the answer, but after the Holocaust, there can be no more final solutions."

Some of this skepticism has been a direct response to the enormity of the Holocaust—which seemed to exhaust not only the forms of modernist experimentation and innovation, but also the traditional meanings still reified in such innovations. Mostly, however, this skepticism has stemmed from post-Holocaust artists' contempt for the religious, political, or aesthetic linking of redemption and destruction that seemed to justify such terror in the first place. In Germany, in particular, once the land of what Saul Friedländer has called "redemptory anti-Semitism," the possibility that public art might now compensate mass murder with beauty (or with ugliness), or that memorials might somehow redeem this past with the instrumentalization of its memory, continues to haunt a postwar generation of memory artists.[10] For this generation, the shattered vessel of European Jewry cannot be put back together again; the rupture in human civilization represented by the Shoah cannot be mended. The traditional religious dialectic of "from destruction to redemption" would come to be regarded not as an answer to the history of the twentieth century, but as an extension of the redemptory cast of mind that made such destruction possible in the first place.

Here I recall being asked in several cases to help revive memorial processes in Boston, Berlin, and Buenos Aires that had gotten bogged down in what their organizers perceived as a morass of dispute, bickering, competing agendas, and politics. With the impertinence that only an academic bystander can afford, I always replied, Yes, it's true. You thought you were bringing a community together around common memory, and you found instead that the process is fraught with argument, division, and competing agendas. In Boston in 1988, I

gently suggested that the New England Holocaust Memorial Committee stop hiding the issues that divided them and instead make them the centerpiece of a public forum on their proposed memorial. Let debate drive the memorial process forward, I advised. Let the memorial's "memory-work" begin with the committee's own heated discussions, public symposia and community education, even in public challenges to the very idea of such a memorial in Boston.[11]

In Berlin, when asked by the Bundestag in 1997 to explain why I thought Germany's 1995 international design competition for a national "memorial for the murdered Jews of Europe" had failed, I answered that even if they had failed to produce a monument, the debate itself had produced a profound search for such memory and that it had actually begun to constitute the memorial they so desired. Instead of a fixed sculptural or architectural icon for Holocaust memory in Germany, the debate itself—perpetually unresolved amid ever-changing conditions—might now be enshrined. And then just to make sure they grasped my polemic, I offered the reassuring words, "Better a thousand years of Holocaust memorial competitions in Germany than a final solution to your Holocaust memorial question." A day later, I was invited by the speaker of the Berlin Senate, Peter Radunski, to join a five-member Findungskommission whose mandate would be to run yet another competition for a suitable design for the *Denkmal.* When I asked, "Why me? I don't think it can be done," Herr Sprecher Radunski answered with a Hegelian glint in his eye, "Because you don't think it can be done, we think you can do it." Thus hoisted on my own polemical petard, I agreed to serve—but only on two conditions: first, that we could make the process itself publicly transparent, so that it might be regarded as part of the memorial design for which we searched; and second, that we invite artists and architects not to solve Germany's paralyzing memorial conundrum but rather to articulate the problem formally in their designs.

With this précis in hand, we invited twenty-five artists and architects, of whom nineteen submitted designs. From these nineteen, we culled a shortlist of two, proposals by Gesine Weinmiller and Peter Eisenman, and recommended them to then-chancellor Helmut Kohl, who favored Eisenman's design for an undulating field of stelae. A lively public debate ensued, with the two finalists making public presentations to packed audiences, who eventually formed a consensus around Peter Eisenman's "Field of Stelae." With this public mandate in hand, our Findungskommission made an explicit, three-part recommendation to the Bundestag: (1) select Peter Eisenman's revised design for "Field of Stelae"; (2) build underneath it a "place of information" (or historical documentation); and (3) establish a permanent "memorial foundation" to support the memorial's building and maintenance.[12] Where the "monumental" had traditionally used

its size to humiliate or cow viewers into submission, we believed this memorial—in its humanly proportioned forms—would put people on an even footing with memory. Visitors and the role they play as they move knee-, or chest-, or shoulder-deep into this unevenly sloping grid of stones would not be diminished by the monumental but would be made integral parts of the memorial itself. Visitors, we hoped, would not be defeated by their memorial obligation here, nor dwarfed by the memory-forms themselves, but rather enjoined by them to come face to face with memory, able to remember together and alone.

Able to see over and around these stelae, visitors would have to find their way through the field, even as they would never actually get lost in or overcome by the memorial act. In effect, they would individually make and choose their own spaces for memory, even as they did so collectively. The implied sense of motion in the gently undulating field also formalizes a kind of memory that is neither frozen in time nor static in space. In their multiple and variegated sizes, the stelae would be both individuated and collected: the very idea of "collective memory" would be broken down here and replaced with the collected memories of individuals murdered, the terrible meanings of their deaths now multiplied and not merely unified. The land sways and moves beneath these pillars so that each one is some 3 degrees off vertical: we would not be reassured by such memory, but now disoriented by it.

Meanwhile, new national elections were called, a new government coalition was formed between the SPD and the Green Party, and the *Denkmal* itself had become a political flashpoint. Eventually, Joshka Fischer (head of the Green Party and eventual foreign minister for Chancellor Gerhard Schroeder's new government) agreed to join the coalition on condition that the *Denkmal* be built after all. Beginning at nine in the morning and running until after two in the afternoon on June 25, 1999, a full session of the German Bundestag met in public view to debate and finally vote on Berlin's "Memorial for the Murdered Jews of Europe." Both opponents and proponents were given time to make their cases, each presentation followed by noisy but civil debate. Finally, by a vote of 314 to 209, with 14 abstentions, the Bundestag approved the memorial in four separate parts: (1) the Federal Republic of Germany would erect in Berlin a memorial for the murdered Jews of Europe on the site of the former Ministerial Gardens in the middle of the city; (2) the design of Peter Eisenman's field of stelae (Eisenman-II) would be realized; (3) an information center would be added to the memorial site; and (4) a public foundation composed of representatives from the Bundestag, the city of Berlin, and the citizens' initiative for the establishment of the memorial, as well as the directors of other memorial museums, members of the Central Committee for the Jews of Germany, and other victim groups would

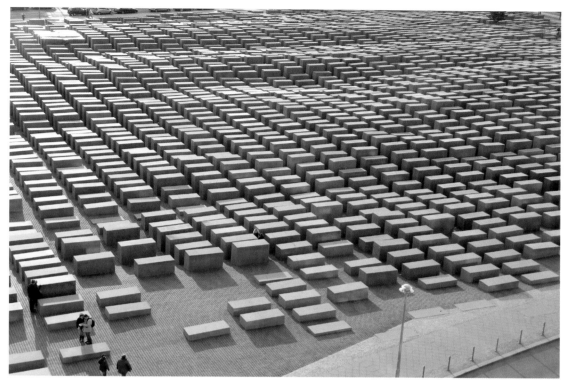

Broad view of the Berlin *Denkmal.*

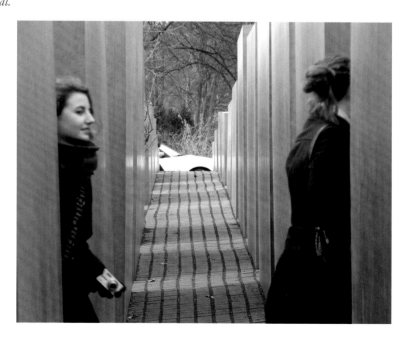

Between the stelae.

be established by the Bundestag to oversee the building of the memorial and its information center in the year 2000. Five years later, in May 2005, Germany's national Memorial to the Murdered Jews of Europe was dedicated.

Was this the end of Germany's Holocaust memory-work, as I had initially feared? No, debate and controversy continued unabated. Memorials to other victims of the Nazi Reich were proposed and built nearby, with the *Denkmal* becoming one node in a memorial matrix that would now include memorials to the Sinti and Roma, homosexuals, and handicapped and disabled murdered by Hitler's regime. Moreover, once the parliament decided to give Holocaust memory a central place in Berlin, an even more difficult job awaited the organizers: defining exactly what it was to be remembered in Eisenman's field. What would Germany's national Holocaust narrative be? The question of the memorial's historical content began at precisely the moment the question of memorial design ended. Memory, which had followed history, would now be followed by still further historical debate.

Today, on entering into the waving field of stelae, one is accompanied by light and sky, but the city's other sights and sounds are gradually occluded, blocked out. From deep in the midst of the pillars, the thrum of traffic is muffled and all but disappears. Looking up and down the pitching rows of stelae, one catches glimpses of other mourners, and beyond them one can even see to the edges of the memorial itself. At the same time, however, one feels very much alone, almost desolate, even in the company of hundreds of other visitors nearby. Depending on where one stands, along the edges or deep inside the field, the experience of the memorial varies—from the reassurance one feels on the sidewalk by remembering in the company of others, invigorated by the life of the city hurtling by, to the feelings of existential aloneness from deep inside this dark forest, oppressed and depleted by the memory of mass murder, not reconciled to it.

Where does memory end and history begin here? As so brilliantly conceived by the architect and Dagmar von Wilcken, the exhibition designer for the *Ort der Information,* this site's commemorative and historical dimensions interpenetrate to suggest an interdependent whole, in which neither history nor memory can stand without the other. As one descends the stairs from the midst of the field to the place of information, it becomes clear just how crucial a complement the underground Information Center is to the field of pillars above. It neither duplicates the field's commemorative function, nor is it arbitrarily tacked onto the memorial site as a historical afterthought. Rather, in tandem with the field of stelae above it, the Information Center reminds us of the memorial's dual mandate as both commemorative and informational, a site of both memory and of history, each as shaped by the other. While remaining distinct in their respective

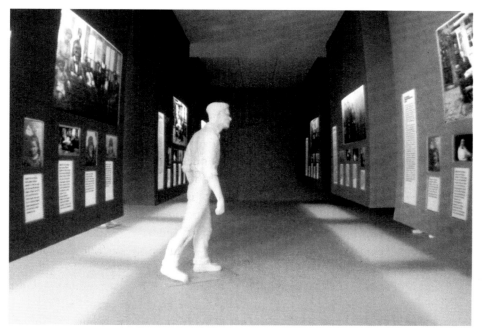

The *Denkmal*'s underground information and documentation center, the historical narrative that anchors the abstract memorial design. *Photo: Foundation Memorial for the Murdered Jews of Europe.*

functions, however, these two sides of the memorial are also formally linked and interpenetrating.

By seeming to allow the aboveground stelae to sink and thereby impose themselves physically into the underground space of information, the underground Information Center audaciously illustrates both that commemoration is "rooted" in historical information and that the historical presentation is necessarily "shaped" formally by the commemorative space above it. Here we have a "place of memory" literally undergirded by a "place of history," which is in turn inversely shaped by commemoration, and we are asked to navigate the spaces in between memory and history for our knowledge of events. Such a design makes palpable the yin and yang of history and memory, their mutual interdependence and their distinct virtues.

Like the mass murder of European Jewry it commemorates, Eisenman's memorial design provides no single vantage point from which to view it. From above, its five-acre expanse stretches like an Escherian grid in all directions and even echoes the rolling, horizontal plane of crypts covering Jerusalem's Mount of Olives. From its edges, the memorial is a somewhat forbidding forest of

stelae, most of them between one and three meters in height, high enough to close us in, but not so high as to block out sunlight or the surrounding skyline, which includes the Brandenburger Tor and Reichstag building to the north, the renovated and bustling Potsdamer Platz to the south, and the Tiergarten across Ebertstrasse to the west. The color and texture of the stelae change with the cast of the sky, from steely gray on dark, cloudy days; to sharp-edged black and white squares on sunny days; to a softly rolling field of wheat-colored stelae, glowing almost pink in the sunset.

Only when one moves back out toward the edges, toward the streets, buildings, sidewalks, and life, does hope itself come back into view. Neither memory nor one's experience of the memorial is static here, each depending on one's own movement into, through, and out of this site. One does not need to be uplifted by such an experience in order to remember and even be deeply affected by it. The result is that the memory of what Germany once did to Europe's Jews is now forever inflected by the memory of having mourned Europe's murdered Jews here, of having mourned the Holocaust together with others and alone, by oneself.

In post-9/11 New York, our memorial questions were very different: how to commemorate and articulate the loss of nearly three thousand lives at the hands of terrorists and, at the same time, how to create a memorial site for ongoing life and regeneration? By necessity, the National 9/11 Memorial and Museum would have to do both. This is why we chose a design that had the capacity for both remembrance and reconstruction, space both for memory of past destruction and for present life and its regeneration. It had to be an integrative design, a complex that would mesh memory with life, embed memory in life, and balance our need for memory with the present needs of the living. It could not be allowed to disable life or take its place, but rather inspire life, regenerate it, and provide for it. It would have to be a design that animates and reinvigorates this site, but does not paralyze it, with memory.

In Michael Arad and Peter Walker's design "Reflecting Absence," we found both the stark expressions of irreparable loss in the voids and the consoling, regenerative forms of life in the surrounding trees and pools of water. The cascading waterfalls simultaneously recall the source of life and the fall of the towers, even as they flow into a further unreplenishable abyss at their centers to suggest loss and absence. The fuller and taller the trees grow, the deeper the volumes of the voids become. The taller the surrounding skyscrapers of the World Trade Center grow, the deeper the open commemorative space at their center becomes. In the National September 11 Memorial at Ground Zero in New York City, the memorial expressions of loss and regeneration are now built into each other, each

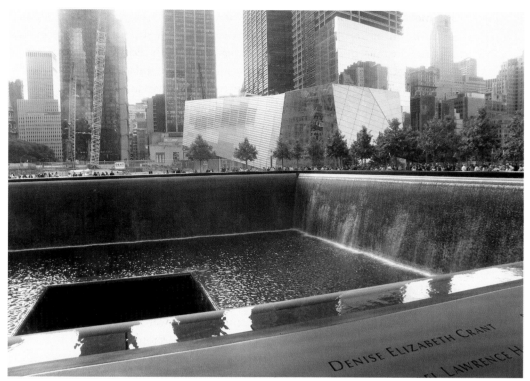

One of the two gargantuan voids of "Reflecting Absence."

helping to define the other. The memorial plaza and names of the victims have been brought to grade, stitched back into the grid and fiber of the city streets of Lower Manhattan. And finally, like the *Denkmal* in Berlin, the 9/11 Memorial at ground level is anchored by the underground 9/11 Memorial Museum built beneath it, which tells the hard history of that day, as well as the life stories of those who were lost in the terrorist attacks on September 11, 2001.

Underlying all of these national memorial projects, the question remains: What do monuments and memory have to do with each other? "Every period has the impulse to create symbols in the form of monuments," the theorist Sigmund Giedion has written, "which according to the Latin meaning are 'things that remind,' things to be transmitted to later generations. This demand for monumentality cannot, in the long run, be suppressed. It will find an outlet at all costs."[13] This may still be true, I believe, which leads me to ask just what these outlets and their costs are today. Indeed, the forms this demand for the monumental now takes, and to what self-abnegating ends, throw the presumptive link between monuments and memory into fascinating relief.

Here I would like to explore the ways both the monument and our approach to it have evolved over the last eighty years or so, the ways the monument itself has been reformulated in its function as memorial, forced to confront its own limitations as a contemporary aesthetic response to recent past events such as the September 11 attacks and more distant past events such as the Holocaust. In this somewhat contrary approach to the monument, I try to show what monuments do by what they cannot do. Here I examine how the need for a unified vision of the past as found in the traditional monument necessarily collides with the modern conviction that neither the past nor its meanings are ever just one thing.

The real problem with monumentality, Lewis Mumford once suggested, may not be intrinsic to the monument itself so much as it is to our new age, "which has not merely abandoned a great many historic symbols, but has likewise made an effort to deflate the symbol itself by denying the values which it represents."[14] In an age that denies universal values, he found, there can also be no universal symbols, the kind that monuments once represented. Or as put even more succinctly by Sert, Leger, and Giedion in their revelatory 1943 essay "Nine Points on Monumentality": "Monuments are, therefore, only possible in periods in which a unifying consciousness and unifying culture exist."[15]

Where the ancients used monumentality to express the absolute faith they had in the common ideals and values that bound them together, however, the moderns (from the early nineteenth century onward) have replicated only the rhetoric of monumentality, as Giedion put it, "to compensate for their own lack of expressive force." "In this way," he explains, "the great monumental heritages of mankind became poisonous to everybody who touched them" For those in the modern age who insist on such forms, the result can only be a "pseudomonumentality," what Giedion called the use of "routine shapes from bygone periods. . . . [But] because they had lost their inner significance they had become devaluated; mere clichés without emotional justification."[16] To some extent, we might even see such pseudomonumentality as a sign of modern longing for common values and ideals.

Ironically, in fact, these same good reasons for the modern skepticism of the monument may also begin to explain the monument's surprising revival in late modern or so-called postmodern societies. Because these societies often perceive themselves as no longer bound together by universally shared myths or ideals, monuments extolling such universal values are derided as anachronistic at best, reductive mythifications of history at worst. How to explain, then, the monument and museums boom of the late twentieth and early twenty-first centuries? The more fragmented and heterogeneous societies become, it seems, the stronger their need to unify wholly disparate experiences and memories with the common

meaning seemingly created in common spaces. But rather than presuming that a common set of ideals underpins its form, the contemporary monument attempts to assign a singular architectonic form to unify disparate and competing memories. In the absence of shared beliefs or common interests, memorial art in public spaces asks an otherwise fragmented populace to frame diverse pasts and experiences in common spaces. By creating common spaces for memory, monuments propagate the illusion of common memory. Public monuments, national days of commemoration, and shared calendars thus all work to create common loci around which seemingly common national identity is forged.

Part of our contemporary culture's hunger for the monumental, I believe, is its nostalgia for the universal values and ethos by which it once knew itself as a unified culture. But this reminds us of that quality of monuments that strikes the modern sensibility as so archaic, even somewhat quaint: the imposition of a single cultural icon or symbol onto a host of disparate and competing experiences, as a way to impose common meaning and value on disparate memories—all for the good of a commonwealth. When it was done high-handedly by government regimes, and gigantic monuments were commissioned to represent gigantic self-idealizations, there was often little protest. The masses had, in fact, grown accustomed to being subjugated by governmental monumentality, dwarfed and defeated by a regime's overweening sense of itself and its importance, made to feel insignificant by an entire nation's reason for being. But in an increasingly democratic age, in which the stories of nations are being told in the multiple voices of its everyday historians—that is, its individual citizens—monolithic meaning and national narratives are as difficult to pin down as they may be nostalgically longed for. The result has been a shift away from the notion of a national "collective memory" to what I would call a nation's "collected memory." Here we recognize that we never really shared each other's actual memory of past or even recent events, but that in sharing common spaces in which we collect our disparate and competing memories, we find common (perhaps even a national) understanding of widely disparate experiences and our very reasons for recalling them.

This relatively newfound sense of public ownership of national memory, that this memory may actually be ours somehow and not on vicarious loan to us for the sake of common identity, has been embraced by a new generation of memorial makers who also harbor a deep distrust for traditionally static forms of the monument, which in their eyes have been wholly discredited by their consort with the last century's most egregiously dictatorial regimes. Seventy years after the defeat of the Nazi regime, contemporary artists in Germany still have difficulty separating the monument there from its fascist past. In their eyes, the didactic logic of monuments—their demagogical rigidity and certainty of history—continues

to recall too closely traits associated with fascism itself. How else would totalitarian regimes commemorate themselves except through totalitarian art like the monument? Conversely, how better to celebrate the fall of totalitarian regimes than by celebrating the fall of their monuments? Monuments against fascism, or against the totalitarian regime of the former Soviet Union, therefore, would have to be monuments against themselves: against the traditionally didactic function of monuments, against their tendency to displace the past they would have us contemplate—and finally, against the authoritarian propensity in monumental spaces that reduces viewers to passive spectators.

Rather than continuing to insist that the monument do what modern societies, by dint of their vastly heterogeneous populations and competing memorial agendas, will not permit them to do, I have long believed that the best way to save the monument, if it is worth saving at all, is to enlarge its life and texture to include its genesis in historical time, the activity that brings a monument into being, the debates surrounding its origins, its production, its reception, its life in the mind. That is to say, rather than seeing polemics as a by-product of the monument, I would make the polemics surrounding a monument's existence one of its central, animating features. For I believe that in our age of heteroglossia (Bakhtin's term), the monument succeeds only insofar as it allows itself full expression of the debates, arguments, and tensions generated in the noisy give and take among competing constituencies driving its very creation. In this view, memory as represented in the monument might also be regarded as a never-to-be-completed process, animated (not disabled) by the forces of history bringing it into being.

In his concluding chapter of *Oblivion* (titled "A Duty to Forget)," the ethnographer and social theorist Marc Augé echoes Nietzsche's case against the kinds of fixed memory that disable life. But here he extends this critique by reminding us that because memory and oblivion "stand together, both . . . necessary for the full use of time," only together can they enable life.[17] Even survivors of the Nazi concentration camps, who do not need to be reminded of their duty to remember, may have the additional duty to survive memory itself. And to do this may mean to begin forgetting, according to Augé, "in order to find faith in the everyday again and mastery over their time."[18] In this view, the value of life in its quotidian unfolding and the meaning we find in such life are animated by a constant, fragile calculus of remembering and forgetting, a constant tug and pull between memory and oblivion, each an inverted trace of the other. "We must forget in order to remain present, forget in order not to die, forget in order to remain faithful," Augé concludes. Faithful to what? we ask. Faithful to life in its present, quotidian moment, I say.

In the pages that follow, I recount a handful of memorials, memory-themed exhibitions, and museum debates that took place between 1991 and 2014, which when regarded together, might trace what I call "the arc of memorial vernacular" connecting the dots between Maya Lin's design for the Vietnam Veterans Memorial, Berlin's Memorial to the Murdered Jews of Europe, and the National September 11 Memorial. The "stages of memory" here refer both to the public staging of these memorial projects and to the incremental sequence (or stages) of these memorial processes as they unfold. In every case, the emphasis here is on the process and work of memory over what we might call its end result. With this in mind, I would even suggest that as great and brilliant as Michael Arad and Peter Walker's realized design for the National 9/11 Memorial at Ground Zero may be, its true foundation is the process that brought it into being, which includes the hundreds of thousands of hours spent by the other 5,200 teams in their offices and studios, at their families' kitchen tables. The "stages of memory" at Ground Zero necessarily include both the built memorial and the unbuilt proposals, which deserve and will surely have their own public showing one day.

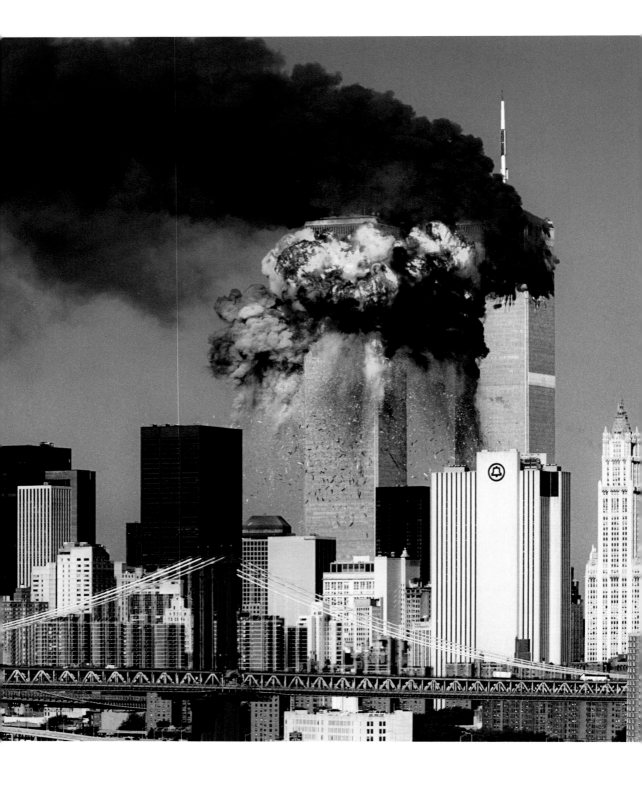

1

The Stages of Memory
at Ground Zero

The National 9/11 Memorial Process

On September 11, 2011, ten years to the day after two planes were flown by terrorists into the World Trade Center's twin towers in Lower Manhattan, a bell tolled at the site of the attacks, and President Barack Obama dedicated the opening of the National September 11 Memorial. On that morning, with skies as "severe-clear" as they were on that day in 2001, invited attendees included the family members of the 2,982 victims of the attacks in New York City, at the Pentagon, and on the terrorist-commandeered United Airlines Flight 93 that crashed near Shanksville, Pennsylvania, as well as of victims of the February 26, 1993, World Trade Center bombing. Together with the President and Mrs. Obama, Secretary of State (and former New York senator) Hillary Clinton, Mayor Michael Bloomberg, and dozens of other national, city, and state officials and politicians, the family members entered the memorial plaza for the first time. They filed in somberly and quietly, their voices muffled by the soft roar of waterfalls along the edges of the towers' footprints, 200 feet square and 35 feet deep, each pool with a further large void at its center.

Many of these family members and politicians had also attended the annual commemorative ceremonies at Ground Zero which had taken place every September 11 since the attacks, when bells tolled to mark the moment of the planes' impacts and the moments when each of the towers collapsed. Every year, family members would read their lost loved ones' names one by one, and then

9:02 a.m., September 11, 2001. United Flight 175 crashes into the South Tower.
Photo: Robert Clark / Aurora.

carry long-stemmed roses down a long ramp to be cast upon two small, square reflecting pools set up at bedrock 70 feet below street grade. The ten-year interval between the 9/11 attacks and the dedication of "Reflecting Absence," the memorial designed by Michael Arad and Peter Walker, seemed perfectly respectful, even a little belated (the Vietnam Veterans Memorial was dedicated just eight years after the end of the war). But for the victims' families, local neighbors, city officials, memorial and museum designers, and others involved in the rebuilding of Lower Manhattan, there seemed to be almost no interval at all between the attacks and the city's memory of them, a memory they experienced in its long durée as a continuous (if exhausting) skein of simultaneous rebuilding and remembering. The dedication of the National September 11 Memorial was just the latest, but not the last, of many stages of memory at Ground Zero.

For the families of victims and residents of New York City, there was no immediate need to ask how these attacks would be memorialized, for as a process, "the 9/11 Memorial" was already there—in the candlelight vigils by hundreds of city dwellers in Union Square, Washington Square, and on the promenade in Brooklyn Heights the same evening of the attacks; in the votive candles placed in lobbies of apartment buildings throughout the city that mothers, fathers,

Memorial vigil in New York City, September 12, 2001. *Photo: Andrea Mohin / The New York Times / Redux.*

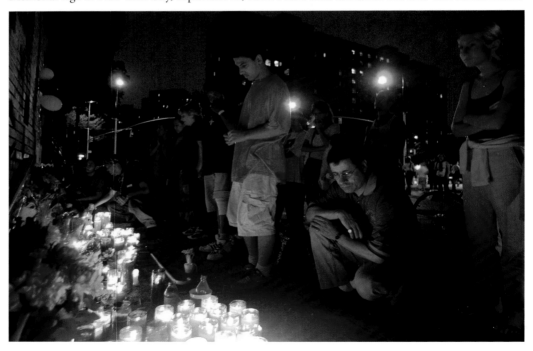

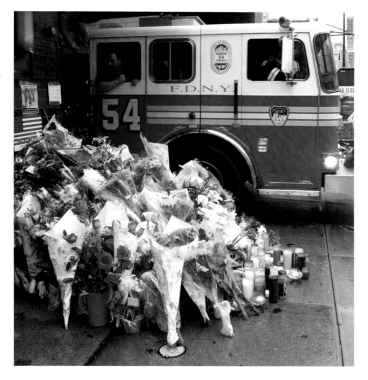

The firehouse on Eighth Avenue and 47th Street, home to Engine Company 54, Ladder Company 4, and Battalion 9. Together they lost fifteen firefighters.
Photo: Suzanne DeChillo/ The New York Times/Redux.

and children didn't come home to that evening; in the mountainous piles of flowers and wreaths laid in front of fire stations in every borough of the city; in the thousands of flyers of "missing" loved ones posted throughout the city for several days by families and friends of those who never came home. These photos and descriptions of loved ones were the spontaneous commemorations of loss and grief. Replete with images and descriptions of fathers and mothers, sons and daughters, these flyers read almost as epitaphs on paper instead of stone, as perishable and transitory as the hope that inspired them. These families' missing loved ones were, in turn, remembered and mourned by all who came across these ephemeral, "found memorials." Even without a conscious, systematic effort, a key memorial motif—absence—was thus spontaneously established by those who had begun mourning lost loved ones within hours of the falling towers.

On the two-month anniversary of the attacks, the *New York Times Magazine* ran a piece called "[Reimagine]; What to Build," which asked "two architects, an urban planner, a structural engineer and a landscape designer [to] consider the future of ground zero."[1] All of the proposed designs included spaces for a memorial, and some of the designers suggested that the space itself was the memorial. In his proposal, "A Memorial in the Sky," the landscape architect Ken Smith called

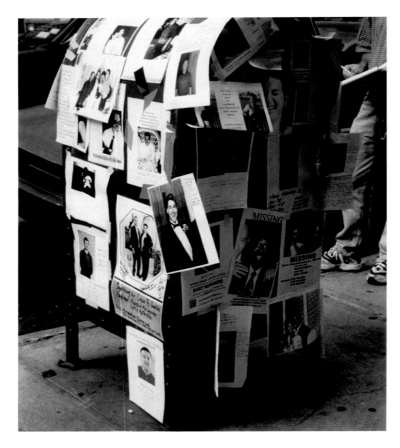

Some of the thousands of flyers posted throughout the city in the days following the attacks. *Photos: Gilles Peress/Magnum.*

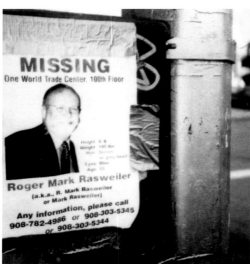

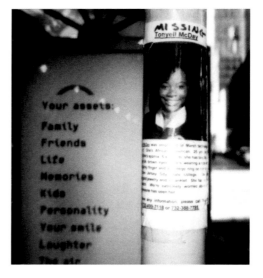

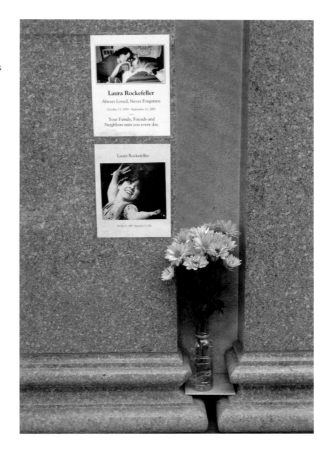

Annual memorial flyer and flowers recalling a lost loved one, posted near her building's doorway on the Upper West Side.

for both a new skyscraper and a memorial on its roof, in the sky (composed of the faces on the flyers still posted around the city), where visitors would have to make their pilgrimage to join those who "disappeared into the sky." In Smith's words, "this is one way to think about it, to experience the emptiness, see all those faces and feel the loss" (96). Within two months of the 9/11 attacks, "rebuilding" had now joined "absence" as its twin memorial motif, a pairing continued throughout the memorial and redevelopment process, and which found expression in the Lower Manhattan Development Corporation's triadic motto: "Remember, Rebuild, Renew." Remembering, rebuilding, and renewing—each regarded as an extension of the other—would now constitute the very raison d'être of the Lower Manhattan Development Corporation, a joint state–city corporation formed by the governor and mayor to oversee the rebuilding and revitalization of Lower Manhattan.

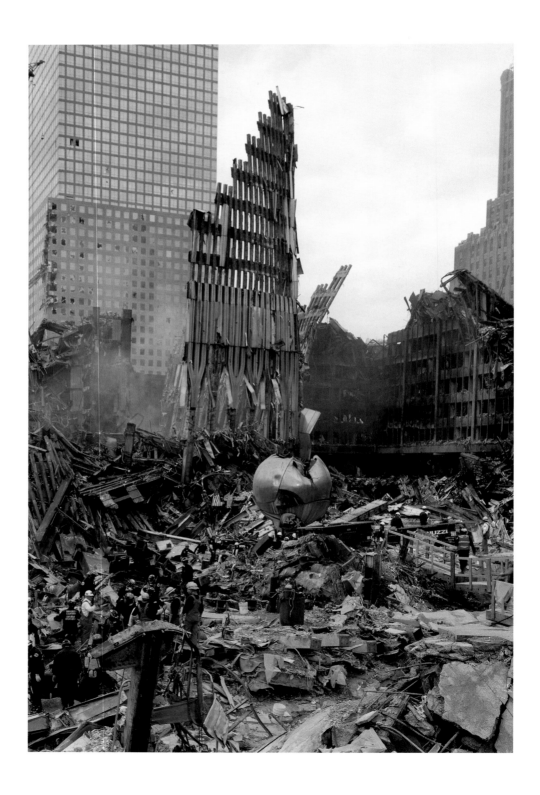

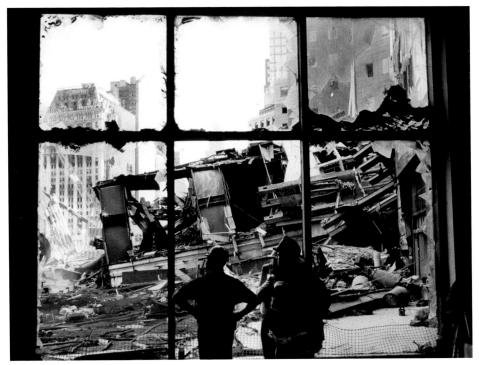

Firefighters survey the pile of debris through the blown-out windows of a World Financial Center building. *Photo: Eli Reed/Magnum.*

(*Opposite*) World Trade Center tower triton facade, standing precariously amid the rubble at Ground Zero in the weeks after the attacks. In the foreground, Fritz Koenig's *Sphere,* the large metallic sculpture that once stood in the Austin J. Tobin Plaza between the two towers. *Photo: Copyright Joel Meyerowitz. Courtesy Howard Greenberg Gallery..*

For the next six months, further stages of memory included the ever-changing landscape of destruction at Ground Zero. Where the seven-story mountain of tangled and jutting ruins stood literally as remnant of the ferocity of the attack and mass death, the gigantic hole in the ground came to stand as literally for the immeasurable void left in the city's lives and hearts, an open wound in the cityscape. The feverish pace of attempted rescue turned into a recovery operation, then into a salvage and cleanup process, bespeaking the need of all to remember this terrible breach by repairing it.

On March 11, 2002, the six-month anniversary of the attacks, the site installation of two stunning "towers of light" composed of eighty-eight seven-thousand-watt high-intensity xenon lights positioned to echo the original twin towers

beamed four miles high into the sky above Lower Manhattan. Seeming to reach infinitely into the heavens and visible from a sixty-mile radius, Tribute in Light (as it was renamed in deference to the human victims of the attacks) struck the millions of people who saw it as the perfect balance between the monumentality of the towers and their ultimate ephemerality, now consoling memorial beacons to the victims of 9/11.

Originally conceived and designed in 1999 by artists Julian LaVerdiere and Paul Myoda as a single-column "light-sculpture" (titled Bioluminescent Beacon) for installation atop the 360-foot radio tower on World Trade Center Tower One as a celebratory installation for the Twin Towers' thirtieth birthday in 2002, it was reconceived by the artists shortly after the attacks as two "phantom towers" of light for the cover of the September 23, 2001, issue of the *New York Times Magazine*.[2] At just about the same time (and unbeknownst to the artists), two architects from Proun Space Studio, John Bennet and Gustavo Bonevardi, were developing a light installation they titled PRISM (Project to Restore Immediately the Skyline of Manhattan), which also called for twin rectilinear clusters of light to be beamed skyward from barges in the Hudson River near Battery Park City. Shortly after discovering each other, the artists and architects teamed up together with the lighting designers Paul Marantz and Jules Fisher. Jointly sponsored by Creative Time and the Municipal Art Society of New York, they developed what became Tribute in Light, shown to such great acclaim on the six-month anniversary that it would be installed again on every anniversary of the 9/11 attacks thereafter—an annual kindling of lights to remember the massive loss of lives and buildings on that day in 2001.

By the six-month anniversary of the attacks, at least a dozen public symposia, conferences, and print media forums had also been held throughout the city at academic, cultural, and community venues. Like many others who had previously written about memorials and consulted on them, I was invited almost weekly to weigh in on how to frame and think about what was then being called the World Trade Center Memorial. I replied as honestly as I could that I wasn't sure where the unfolding history of the 9/11 attacks and their aftermath ended, and where their memory began. Beyond the immediate loss of nearly three thousand lives and the devastation of Lower Manhattan, I wasn't even sure what the "meaning" of the attacks was, and without some kind of agreed-upon meaning, I wasn't sure we could begin memorializing the events of that day. Only the loved ones and friends of victims had an absolute grasp on what their losses meant, what the attacks meant to them, and to the families and colleagues of firefighters and other first responders whose deaths were understood as both civic and personal tragedies.[3]

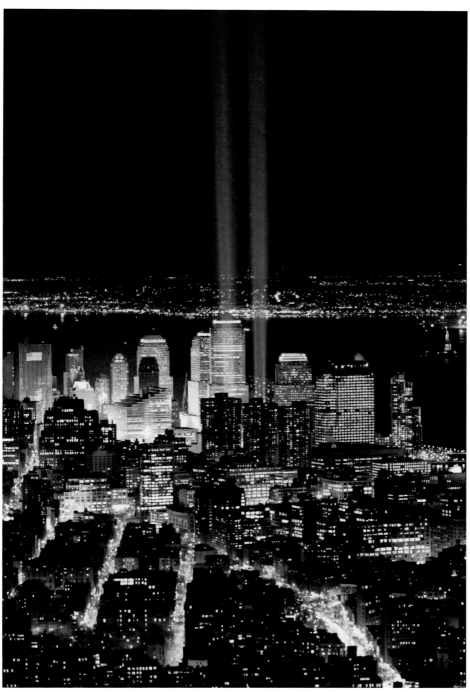

Tribute in Light. *Photo: Vincent Laforet / The New York Times / Redux.*

At each of these meetings, I ended up reprising some variation on all of these themes. As stages of mourning turned into stages of memory, I said, "the memorial" always needed to be regarded as a process, a continuum of stages. Before settling on a final plan for the new World Trade Center and a memorial to the 9/11 attacks, as urgent a task as that may have been, I believed from the outset that it might help first to articulate the stages of the memorial process itself—as a guide to where we've been, where we are, and where we would like to go. In so doing, we would begin to define a conceptual foundation for this site, which would take into account all that was lost and all that must now be regenerated. Here we needed to ask: What is to be remembered here, and how? For whom are we remembering? And to what social, political, religious, and communal ends?

Would this be a site commemorating the old World Trade Center and the thousands murdered here, or one that merely replaced what was lost in the attack? By necessity, it would be both. This is why we needed to design into this site the capacity for both remembrance and reconstruction, space for both memory of past destruction and for present life and its regeneration. This would have to be a complex, integrative design that meshes memory with life, embeds memory in life, and balances our need for memory with the present needs of the living. Our commemorations must not be allowed to disable life or take its place; rather, they must inspire life, regenerate it, and provide for it. We must animate and reinvigorate this site, not paralyze it, with memory. In this way, we might remember the victims by how they lived and not merely by how they died.

This is also why I argued strenuously that this devastated site should not be turned into a memorial only to the lives lost here. Such a memorial would preserve the sanctity of this space, as former mayor Rudolph Giuliani suggested at the time, but it also inadvertently would sanctify the culture of death and its veneration that inspired the killers themselves. For whether we like it or not, memorials to death and destruction can also monumentalize and privilege such death and destruction. Our memorial to the destruction of the towers and the lives lost also could even become the terrorists' victory monument. Our soaring shrine to the victims and our sorrow could become the murderers' triumphal fist, thrust into the air.

And what of the ruins? All cultures preserve bits of relics and ruins as reminders of the past; nearly all cultures remember terrible destructions with the remnants of such destruction. But Americans never have made ruins their home or allowed ruins to define—and thereby shape—their future. The power of ruins is undeniable, and while it may be fitting to preserve a shard or piece of the towers' facade as a gesture to the moment of destruction, it would be a mistake to stop with such a gesture, and allow it alone to stand for all those rich and varied lives

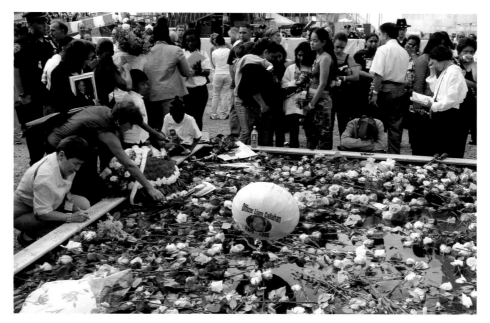

First Anniversary Commemoration at bedrock, Ground Zero.

that were lost. For by itself, such a remnant (no matter how aesthetically pleasing) would recall—and thereby reduce—all this rich life to the terrible moment of destruction, just as the terrorists themselves would have us remember their victims.

For some New Yorkers, it was similarly tempting to leave the void itself behind as a permanent symbol of the breach in their lives, the emptiness they felt in their hearts. I know for many the physical void left behind was nearly unbearable, a constant reminder of life changed, of mass death nearby, a personal assault on their "home." And sometimes, nothing seems to evoke such loss better than the gaping void itself. In fact, given my earlier work on "negative-form monuments" and the cultural preoccupation with absence and loss, I sympathized with the need to remember loss by preserving loss. But I also felt that by itself, this too would be an unmitigated capitulation to the bombers: it would be to remember the site exactly as the killers forced it upon us. It is they, not we, who created this void in our city and in our lives: preserving the gaping void seemed to me tantamount to extending the deed itself for perpetuity. Instead, I counseled, let us regard this present void as a necessary, yet transient stage in the memorial process. Let it lie fallow for now, akin to the biblical injunction, so that it may ultimately regenerate and become a source for life itself.[4]

Indeed, in rejecting the absolutist tenets of the terrorists, I hoped from the beginning that this site would become an ever-evolving memorial, one that not only would accommodate every new generation's reasons for coming to it but would be animated by every new generation. In the year after the attacks, I hoped that this would be a place where all the stages of memory—recalling the terrible attack in all of its immediacy, recalling the void left in the aftermath, recalling the attempt to commemorate life with life—themselves are remembered as parts of a living continuum and necessarily evolving memory.

In this spirit, I suggested to family councils and executives of the LMDC that they build into this site a worldview that allows for competing, even conflicting agendas—and make this, too, part of their process. Rather than fretting about the appearance of disunity (all memorial processes are exercises in disunity, even as they strive to unify memory), we should make our questions and the public debate itself part of our memory-work. Memory is, after all, a process and will be everlasting only when it remains a process and not a finished result.

On re-reading an op-ed piece I was invited to write for *New York Newsday* on the first anniversary of the 9/11 attacks, I found that, as it turns out, I was not above making relatively concrete memorial recommendations at this very early stage. And as I also discovered on this re-reading, my language and tone were still a little overheated by a grief and anger that I was not managing as successfully as I remembered. For the sake of full disclosure on my own conceptual and formal predispositions toward the memorial, I quote at some length from the piece, published on Sunday, September 8, 2002 (with apologies for its pugnacity, as true to the moment as it may have been).

> The Lower Manhattan Development Corp. has made it clear that downtown will be rebuilt according to an integrated design of new office buildings, living spaces, and memorials. In keeping with other rejuvenating memorial models, I would propose that we locate whatever else is built here in a setting that includes memorial groves of white-blossoming trees, each one planted and dedicated in the name of one of the victims of the World Trade Center attacks. Similar groves could be planted on the other 9/11 attack sites, with one tree for each of the victims who died at the Pentagon and in that field in Pennsylvania, as well. In this way, the victims can be recalled separately for the lives they lived and collectively for their mass murder, as individual trees and as a canopied forest.
>
> As for the actual commemorative site in Lower Manhattan, we must not forget that memory at ground zero is not zero-sum: It is an accumulation of many groups' different experiences and needs. The firefighters and their families, the police officers and their families, the office workers, traders and bankers, city officials, developers, architects, artists, immediate neighbors, outlying neighbors, tourists—all may want something a little different in this site. And the hundreds of victims from 84 other nations will be remembered in their own traditions.

Just as we live together but separately every day of our lives in this city, the site must allow us the ability to remember together and also separately. We will not share the same memory so much as a common place to remember.

We might even consider making our questions and public discussions about the site a permanent part of the memory-work that will occur here. But in our conceptual foundation, we must be clear: Let life remember life. Name your children after the victims, love life itself more fervently because of how they lived, not because they died so horribly. Defeat the culture of death with emblems of life, with trees teeming with birds, with gardens and flowers, where life is contemplated and death is rejected. Let the new complex breathe with open space, and allow the surrounding water—our greatest natural emblem of life—to permeate and animate this site. Instead of consecrating the space as a graveyard only, one forced upon us by the killers, let's dedicate this complex to everything the terrorists abhor: our modernity, our tolerance, our diversity. If they hate our buildings, let's rebuild them here; if they hate our prosperity, let's prosper here; it they hate our culture, let's celebrate it here; if they hate our lives, let's live them here.[5]

So while it was true that the historical meanings of the 9/11 attacks were not yet clear, and might not be for years, it was also true that the terrible loss itself would have to be marked and commemorated as part of rebuilding Lower Manhattan. The only "meanings" of the attacks at this point were the direct loss of lives felt by families of the victims, the incomprehensible destruction of sixteen acres of Lower Manhattan, and the profound sense of violation and vulnerability felt by all who witnessed the attacks. Almost from the outset, the twin motifs of loss and renewal emerged as foundational to what was being called "the WTC Memorial."

Finally, by dint of its location at the tip of Lower Manhattan, the World Trade Center Site Memorial would necessarily become part of a national memorial matrix and landscape much larger than itself. It would be within sight lines of the Statue of Liberty, Ellis Island, the War Memorials in Battery Park, and the Museum of Jewish Heritage—A Living Memorial to the Holocaust. But whereas these neighboring national shrines previously had been dwarfed and literally overshadowed by the towering twin icons of American commerce, they would now find themselves highlighted, perhaps even rejuvenated, by the new World Trade Center and Memorial. As a result, these national markers would themselves begin to assume a much greater prominence in the minds of New Yorkers, visitors, and memorial pilgrims—all trying to find their place in America's ever-changing landscape of memory.

Between September 2001 and September 2002, I wrote, spoke, and published these thoughts in a series of op-ed pieces and talks to New York City government and redevelopment agencies, all of us struggling to arrive at a conceptual point of departure for the memorial and its place in redeveloping the devastated sixteen-acre site of what had been the World Trade Center. In this way, I hoped

to emphasize the process of memorialization over its end result, thereby making room for a necessarily evolving place of memory to reflect the evolution of memory itself at this site. In the pages that follow, I reflect on what I call the "stages of memory at Ground Zero," bringing back into view the ways that the public memory of these events was necessarily a negotiated process that included both the built and the unbuilt, the memory of loss and of regeneration.[6]

THE PLANNING STAGE

"The stages of memory" continued that summer of 2002 through the highly public arbitration of a new site design, and later through the public process of the memorial competition itself. Some of the families of victims were adamant that the entire sixteen-acre site be regarded literally as a burial ground, sacred, and therefore off-limits to any and all redevelopment. This site, they insisted, must remain empty, to be visited only by the families coming to mourn their loved ones lost in the attacks there. Other family representatives argued as insistently that their loved ones be commemorated by rebuilding the WTC even bigger than it was, right in the same place, that to do otherwise would be capitulate to the killers, that as traders and bankers, they would want to be remembered by the icons of commerce they helped build. The families of firefighters and police officers tended to favor setting aside the footprints of the towers for a memorial, a place that would recall the heroism of their deaths. Meanwhile, the Lower Manhattan Development Corporation was trying to balance the needs of the Port Authority, the developers, and the financial community against the needs of mourners. And the city was juggling its civic duties to commemorate the dead with its own need for renewal and economic recovery.

The first casualty of this resulting gridlock of competing agendas was the set of six designs commissioned by the LMDC from the architectural firm Beyer Blinder Belle in May 2002. In trying to please everyone—with 12 million square feet of office space housed in a generic-looking cluster of mid-high-rise buildings, laced with spaces for proposed memorials and gardens—the designers pleased no one. The *Times* architecture critic Herbert Muschamp was especially blistering in his critique of the designs: "Mediocrity, the choice of this firm reminds us, is not a default mode. It is a carefully constructed reality, erected at vast public expense. Ignorance is the brick from which this wretched edifice is built. Secrecy is the mortar holding it together."[7] After "Listening to the City" and its responses to the Beyer Blinder Belle designs in a mammoth public forum at the Jacob C. Javits Center on July 22, LMDC chairman John Whitehead offered a seventh alternative: none of the above, which was the only proposal universally applauded. The

LMDC immediately issued a new "request for qualifications" for an "Innovative Design Study," which resulted in nine new site plans from leading international architectural firms.

Amid the noisy tumult of discussion surrounding the display of nine new, suitably audacious designs at the Winter Garden of the World Financial Center in November 2002 and the announcement of the two site design finalists in February 2003, debate over an actual memorial to the 9/11 attacks almost fell by the wayside. Because the designs by the two finalists, Daniel Libeskind and the Think Team (with Rafael Viñoly and Frederic Schwartz), included such prominent memorial elements, some suggested that "the whole thing was a memorial," that a separate memorial competition long planned by the Lower Manhattan Development Corporation as part of its renewal of Ground Zero would be redundant.[8] But in fact, despite the suggestive commemorative dimensions to both designs, neither the architects nor the LMDC ever conceived of "the whole thing" as the only memorial to the 9/11 attacks. On February 27, 2003, after weeks of charged public debate and LMDC evaluations and studies, Governor George Pataki declared that of the two finalist teams, he would choose Daniel Libeskind's "Memory Foundations" as the new master plan for the site.

Indeed, two weeks before "Listening to the City," on July 2, 2002, only ten months after the attacks, the LMDC announced the appointment of Anita Contini as Vice President and Director for the Memorial, Cultural, and Civic Programs at the LMDC. She had been cofounder of the downtown public arts program Creative Time and also a former artistic director for the World Financial Center Arts and Events Program. At that moment, Contini was Merrill Lynch's first Vice President for Global Sponsorships and Events Marketing, in charge of the company's worldwide program for supporting arts and cultural institutions. She was perfect for the job, and the job as described in the LMDC's press release was a very large one: "Ms. Contini will work closely with families of September 11th victims and other stakeholders to develop, implement and then oversee the process for creating a memorial, including associated fundraising. Ms. Contini, who is a career-long advocate for art in the public realm, will also oversee LMDC's efforts to retain and attract cultural and civic institutions in Lower Manhattan."[9]

A few days later, my phone rang, and it was Anita Contini calling. "Yes," I said, "I know who you are. Congratulations! I just read about it in the *Times*. You've got your work cut out for you!" On a Sunday afternoon several weeks later, I drove from my western Massachusetts home to her family's weekend house in the Berkshires, where she greeted me in a beautiful screened-in sun room, stacked high with dozens of books on memorials and monuments, public

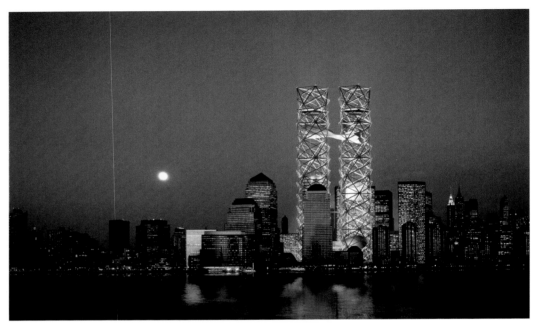

Site design competition submission by Think Team Rafael Viñoly and Frederick Schwartz. *Photo: LMDC.*

Daniel Libeskind's "Memory Foundations." The asymmetrical spire echoes the upraised torch held by Lady Liberty. *Photo: Studio Daniel Libeskind.*

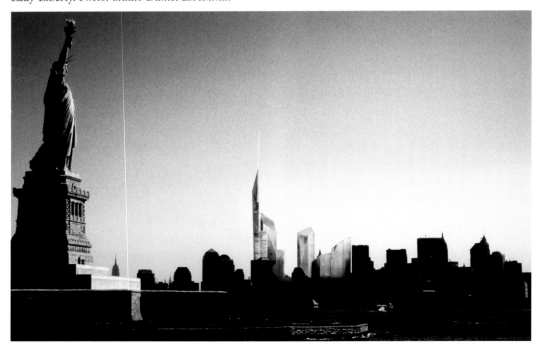

art and architecture, memory and urban spaces. "Doing your homework, I see." For the next three hours, we free associated every memorial issue that popped into mind—the minefields of aesthetics, politics, commercial redevelopment, and how the issues at Ground Zero were as complicated as they were in Berlin during Germany's "*Denkmal* process," even as they were altogether different. As a process, I suggested, the competition would necessarily raise, even if it could not answer, dozens of questions surrounding the commemoration of the 9/11 attacks and their victims. How will the memorial remember the loss of human life, the murderous intent of the killers, the destruction of Lower Manhattan? Will it remember these attacks as part of a larger attack on the United States, one that prompted what could be a "thirty-year war on terrorism"? Will it remember the lives of the victims or only mourn their deaths? Will it glorify the sacrifice of firefighters and police officers who came to rescue the victims? Or will it remember them too only as victims who were just doing their jobs? What is to be remembered here and how? To what political, civic, and aesthetic ends?

It was clear that Anita had already done an enormous amount of reading and consulting with others and was already a historian of other national memorial processes, including the Vietnam Veterans Memorial and Oklahoma City bombing memorial. On my way home that afternoon, I thought to myself, "She's perfect for this job."

As Anita Contini's appointment made clear, a separate design competition for a memorial was always part of the LMDC's original plan for the redevelopment of downtown. From the outset, the LMDC seemed to recognize that as tempting as it was to allow the new building complex to serve as a de facto memorial, the conflation of re-building and commemoration could also foreclose the crucial process of memorialization, a process they had also come to regard as essential to both memory and redevelopment. Rather than prescribing a particular aesthetic form or architectural approach to the memorial, the LMDC chose to open up the question of the memorial, to hammer out a mission and program statement outlining the various kinds of memory to be preserved, and then to initiate an open, blind, international competition for a design that would, they hoped, return responsibility for the memorial to the public for whom it is intended.

Between November 2002 and March 2003, as guided by Anita Contini, the Families Advisory Council of the LMDC (which included families of the victims, local residents and business people, and other groups affected by the attacks) appointed a committee of various Advisory Council members and hand-picked professionals and experts in public art to formulate a Memorial Mission Statement, which was to serve as a guiding mandate for the memorial and its process.[10] In fact, as its short preamble made clear, every word, theme, and issue

in the statement was debated in excruciating detail to ensure that all groups of victims were equally represented and that no hierarchies of victim-groups (e.g., first responders, office workers) would be established in the public's mind. In its final version, the Memorial Mission Statement read:

- Remember and honor the thousands of innocent men, women, and children murdered by terrorists in the horrific attacks of February 26, 1993 and September 11, 2001.
- Respect this place made sacred through tragic loss.
- Recognize the endurance of those who survived, the courage of those who risked their lives to save others, and the compassion of all who supported us in our darkest hours.
- May the lives remembered, the deeds recognized, and the spirit reawakened be eternal beacons, which reaffirm respect for life, strengthen our resolve to preserve freedom, and inspire an end to hatred, ignorance and intolerance.[11]

In addition to the Memorial Mission Statement, the LMDC's Memorial Program included two further sets of Guiding Principles and Program Elements. As proposed by the LMDC Memorial Program Drafting Committee,[12] these concrete guidelines "must be embodied within and conveyed through the memorial design" (18). Moreover, these "program elements provide memorial designers with a list of specific elements that should be physically included in the memorial, without prescribing how or inhibiting creativity" (18). In order to convey just how many issues the prospective memorial designers were being asked to address and what exactly they were being asked to remember in their submissions, I quote them in their entirety here. In its two parts, the memorial program read:

I. Guiding Principles
The memorial is to:
- Embody the goals and spirit of the mission statement;
- Convey the magnitude of personal and physical loss at this location;
- Acknowledge all those who aided in rescue, recovery and healing;
- Respect and enhance the sacred quality of the overall site and the space designated for the Memorial;
- Encourage reflection and contemplation;
- Evoke the historical significance and worldwide impact of September 11, 2001;
- Inspire and engage people to learn more about the events and impact of September 11, 2001 and February 26, 1993.

II. Program Elements

The Memorial should:

- Recognize each individual who was a victim of the attacks.
 1. Victims of the September 11, 2001 attacks in New York, Virginia and Pennsylvania;
 2. Victims of the February 26, 1993 terrorist bombing of the World Trade Center.

- Provide space for contemplation.
 1. An area for quiet visitation and contemplation;
 2. An area for families and loved ones of victims;
 3. Separate accessible space to serve as a final resting-place for the unidentified remains from the World Trade Center site.

- Create a unique and powerful setting that will:
 1. Be distinct from other memorial structures like a museum or visitor center;
 2. Make visible the footprints of the original World Trade Center towers;
 3. Include appropriate transitions or approaches to, or within, the Memorial.

- Convey historic authenticity.
 1. The Memorial or its surrounding areas may include:
 - Surviving original elements;
 - Preservation of existing conditions of the World Trade Center site.[13]

Meanwhile, during the spring of 2003, as the Memorial Mission Statement and Program Drafting committees polished their memorial précis, the LMDC quietly began putting together an international design competition. In consultation with the governor's and mayor's offices, and with the advice of scholars and other experts in design competitions, Anita Contini began assembling what the LMDC hoped would be an unassailable jury for the competition. Chosen from all walks of life, but with very particular credentials, they were (the LMDC hoped) both representative enough and respected enough in their professional worlds to bring an unimpeachable authority to whatever design they would finally choose.

THE JURY STAGE

On April 10th, 2003, the LMDC announced the members of the World Trade Center Site Memorial Jury, which included me. Though the precise details of how the LMDC arrived at this particular jury may never be made public, it was clear to all that its composition had been carefully calibrated to achieve a representative balance of design architects and artists (Enrique Norten, Michael Van Valkenburgh, Maya Lin, and Martin Puryear), arts community professionals

(Public Art Fund president Susan Freedman, art consultant Nancy Rosen, and Harlem Studio Museum director Lowery Stokes Sims), academic and cultural historians (Carnegie Corporation president Vartan Gregorian and me), political liaisons (Deputy Mayor Patricia Harris and former Deputy Governor Michael McKeon), a family member (Paula Grant Berry), and a local resident and business community leader (Julie Menin). In honor of his "accomplishments and devotion to New York City," David Rockefeller was also appointed to serve as an honorary, non-voting member.

Soon after our appointment as jurors, we received by overnight mail a provisional and highly confidential set of World Trade Center Site Memorial Competition Guidelines, which included a meticulously assembled competition outline, memorial mission and program statements, guidelines, background readings, a confidentiality statement, public perspectives, and a schedule of dates for submissions, review, and selection. In reading over the "competition boundaries," it became clear almost immediately to the design professionals on the jury that the combination of mandatory program elements, Libeskind's site design, and the actual state of the site itself (a pit some seventy feet deep, part of which would be filled in with necessary transportation, power, and water infrastructure) would pose a daunting challenge even to the most experienced artists and architects. We feared that once they realized just how "full" and overdetermined the 4.7-acre memorial site was by the site design and multiple layers of program elements, many potential designers might throw up their hands and walk away from the competition. With permission from the other jurors, several of us began working to expand what we considered the most constraining of the guidelines, especially as described in the "competition boundaries," in order to open up the site to the widest possible number of memorial designs.

The resulting final set of competition guidelines issued to competitors worldwide reflected our proposed changes, but we also realized that it would take a very close reading of them to appreciate how open we wanted these boundaries to be. Section 4.4 of the official WTC Site Memorial Guidelines, titled "Competition Boundaries," thus read:

> Competitors may locate or integrate the memorial anywhere within the memorial site limits and boundaries as shown. . . . The memorial site limit is indicated by a blue line on the site plan and sections and labeled as "site boundary."

> Competitors may, within the boundaries illustrated, create a memorial of any type, shape, height, or concept. Designs should consider the neighborhood context, including the connectivity of the surrounding residential and business communities. All designs should be sensitive to the spirit and vision of Studio Daniel Libeskind's master plan for the entire site.

Design Concepts that propose to exceed the illustrated memorial boundaries may be considered by the jury if, in collaboration with the LMDC, they are deemed feasible and consistent with site plan objectives.[14]

Though satisfied with this explicit invitation to "go beyond" the boundaries of the site plan, we feared that competitors still might not feel they had license to "violate" the site plan as it was illustrated in accompanying drawings and maps.

Thus, by the time the LMDC held its April 28, 2003, press conference at the newly reconstructed Winter Garden announcing the International Competition for a World Trade Center Site Memorial design, we jurors already had decided that part of our announcement, unbeknownst to the LMDC, would be an invitation to potential designers to break the rules and to challenge the site plan design, just as all the great buildings and monuments of our era had to break the rules of their day—including Libeskind's own Jewish Museum in Berlin and Maya Lin's Vietnam Veterans Memorial in Washington, D.C. We worried that even with a second or third close reading of the guidelines, without our explicit permission at the press conference, competitors might view Libeskind's design, "Memory Foundations," as the overall memorial, into which they would somehow have to fit their own memorial design, a kind of memorial within a memorial. Our remarks were widely reported (the *New York Times* headline declared, "Officials Invite 9/11 Memorial Designers to Break the Rules")[15] and well received by the LMDC itself, with its president Kevin Rampe congratulating us on asserting exactly the kind of independence that the LMDC had hoped from us.

Jurors are introduced at the official announcement of the WTC Site Memorial competition, April 2003. *Photo: LMDC.*

A few of the 5,201 memorial competition submissions as they arrived in the mail at the secret warehouse on West 36th Street. *Photo: LMDC.*

Competition rules and requirements invited anyone over the age of eighteen anywhere in the world to register for the competition, with a nonrefundable submission fee of $25. Designs were to be presented on single 30-by-40-inch rigid boards (preferably foam), vertically oriented, coded only with a registration number to ensure anonymity. The registration deadline was May 29, 2003. By that date, the LMDC had received some 13,800 registrations from 92 countries. By the second-stage deadline of June 30, 2003, the LMDC had received 5,201 eligible submission boards from 63 countries, and from all of the United States except Alaska. In a then-secret location on West 36th Street, the LMDC and its competition management consulting teams (Planning & Design Institute, Inc., and Landair Project Resources, Inc.) worked day and night for the month of July, determining eligibility, sorting submissions, recording bar codes and registration information, and organizing the first viewings of the design boards for the jury, to begin August 4.

Within weeks of the competition's announcement, fellow juror and Deputy Mayor Patricia Harris arranged a meeting for the jury with Mayor Michael Bloomberg, first in his "bullpen" at City Hall, and later for lunch at the LMDC offices on Liberty Street. In our first meeting, the mayor confessed that, in general, he wasn't a big fan of memorials and that when he died, he would be buried in a simple pine coffin. Instead of being remembered by a memorial, he said, he hoped to be remembered by the fortune he planned to leave for public schools,

universities, and research. But Mayor Bloomberg also reassured us that he absolutely understood why the memorial would be so important to family members and the rest of the city, even to the rest of the world. At the end of that meeting, as he led us back outside City Hall, he thanked us warmly for serving on the jury—and then instead of saying good-bye, he deadpanned, "Please, please don't fuck it up!" Despite his early qualms about a memorial, by the time the memorial was dedicated in 2011, nobody had done more than Mayor Bloomberg to support us, the process, and indeed the memorial itself, having established the 9/11 Memorial Foundation with his own funds.

On August 7 we met again with the mayor and then with Governor George Pataki, who stayed on for lunch. All of us were well aware of Governor Pataki's "executive decision" in choosing Daniel Libeskind's master site plan over the Think Team's plan, even though the LMDC had favored the latter. When one of us asked whether he might similarly overrule our own final selection, the governor laughed and said, "No, you're completely on your own this time!" "Even if, at the end of the process, we cannot make a final selection?" I asked. After a deep breath and a grimace as he contemplated a "failed competition," he replied, "Yes, even then." As strange as it may have seemed, we explained, the freedom to choose none of the submissions was crucial to our process. For it would ensure

Governor George Pataki listens to juror Maya Lin in a lunch meeting with jurors. *Photo: LMDC.*

that our final selection would be chosen for reasons of its merit, which we could justify and stand by—and not chosen as a result of our own fear of failing to find anything at all. After the governor left the LMDC offices, we also realized that it made perfect political sense for him to promise not to intervene in the memorial competition as he had in the master site planning competition. If we found a great design, he would be credited for running a successful process; but if our final choice was a clunker, the blame would be ours alone.

It was clear that a big part of our meetings over the next two months with the mayor and the governor was both to reassure them that the process was working and to be reassured by them that we had their full support. These meetings were always congenial, even pleasant insofar as we felt we had solid partners in our search for a memorial design. Much more difficult were the crucial meetings we had with the Families Advisory Council both in closed-door meetings at the LMDC offices and in public forums at the Tribeca Performing Arts Center and Pace University. It wasn't that the meetings were adversarial in any way, but that in these meetings, the jurors' job was only to listen to and to be informed by the losses these families had suffered. At first, some of the jurors worried that we would be lobbied by families for particular kinds of designs, toward remembering particular groups of victims over others—and indeed, we did hear these things. But in fact, after much discussion among ourselves, we realized that our role as listeners was only that—to listen and to be informed by the grief of mourning families. Not toward a particular end, but as an end in itself—which is why it was almost unbearably painful and emotionally exhausting.

One by one, family members began their remarks by thanking the LMDC for keeping them involved in the memorial process, and almost all began by thanking memorial juror Paula Grant Berry, in particular, for representing "all of the other families" and their needs to the rest of the jurors. Our first instinct was to protect Paula from just this kind of expectation, a burden and responsibility no single family member should have to carry. Later, behind closed doors, we discussed both the amazing support Paula had from other family members and the impossible expectations they seemed to have placed on her shoulders. Now it was Paula's turn to reassure us that she didn't carry this burden. Please don't worry, she said, I will do this only for myself as one of thirteen jurors, not as spokesperson for 2,800 families. But still, we did worry and always found ourselves especially attentive when she spoke, giving her words the weight we asked her not to carry.

So we listened, and we were informed. Some of the family members had very specific requests, such as "Please, no bus depots built on the site of my son's death!" Some insisted that there be no hierarchies among victims, that whether they were rescuers or office workers, airline pilots or attendants, all had to be

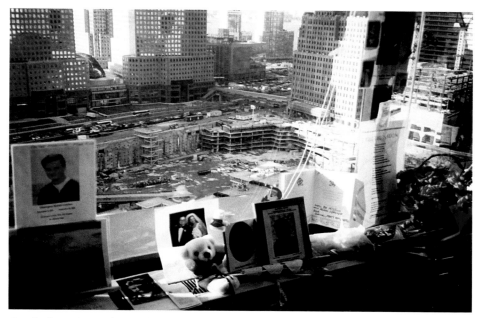

Overlooking Ground Zero during its reconstruction between 2002 and 2011, the Family Room at the LMDC offices on Liberty Street was open twenty-four hours a day to people who came to remember lost loved ones and leave mementos.

remembered individually, but as murdered together. Yet others, including a deputy fire chief, responded that hierarchies are part of life, that just as some of the memorial jurors have PhDs after their names, so should the firefighters be distinguished by their ladder company numbers, and be remembered together as part of the "family of firefighters" they were: "Don't separate them any more than you would separate family members in a cemetery!"

Jack Lynch, the father of fallen firefighter Michael Lynch, was the most pointed and moving in his remarks, which he addressed directly to the jurors. "[Michael] didn't die because of who he was. He died because of what he was. He got on a truck at 66th Street and Amsterdam Avenue just like many other firefighters and policemen all over the city—Brooklyn, Staten Island, the Bronx and Queens. And they came to rescue the people that were trapped in the World Trade Center. . . . The reason [they] died is because they were rescue workers, not because the tower was hit by barbaric terrorists and those that were trapped in there. They died because they took the choice to go in there to save the others. And they were very successful. We know that 25,000 of our fellow citizens were rescued that day, and basically it's due to the work of the rescue workers."[16] The question of

how to remember first responders as distinct from those they had come to rescue without creating a hierarchy of victims would re-emerge in the ensuing public forums as the single most difficult and contentious issue. As this first meeting closed, the LMDC's vice president for community relations reminded everyone that families from Somerset County in New Jersey and families of victims in the 9/11 Pentagon attack would be joining the Families Advisory Council for the next evening's "Public Forum for the World Trade Center Site Memorial" to be held at the Tribeca Performing Arts Center on May 28.

The Tribeca Performing Arts Center is a large bowl-shaped auditorium that seats about four hundred people, located on the corner of Chambers and West Streets, part of the Borough of Manhattan Community College campus. We sat at a long table on the stage, with LMDC president Kevin Rampe and moderator Jennifer Hurley flanking us. After introducing ourselves, we sat quietly and listened for the next three hours. In the course of that evening, the microphone was handed to fifty-eight men and women, most but not all family members of the victims.

At about 8:00 p.m., "Brendan" (who said his full name was not important) stood up and said, "I'm from Engine 40, Ladder 35 . . ." He followed by declaring that "just as art isn't something you do, you are artists, firefighting isn't something

Memorial competition jurors are introduced to family members at the Tribeca Center for the Arts, where jurors listened to family members' stories of loved ones and how they wanted to remember them. *Photo: LMDC.*

we do but firefighting is something that we are. We are firefighters. It's what we do throughout our day. And I just want you to keep that in mind."[17] But what did I have in my mind at that moment? In my notes, I quoted Brendan's last line, then followed with my own bracketed question: "What am I? A father first. I need them" (referring to my two sons, then aged five and seven). Then a mother of a lost firefighter spoke, and I jotted a paraphrase of her statement: "Names without affiliation do not educate or inform." Then I wrote another bracketed sentence, "It will be a changed family and relationship—but it will still exist." I was thinking of my own children, how they defined me as a father, and that listening to these parents describe the loss of their firefighter children made me miss my own children, made me wonder what I would be without them. "In any new loss, we remember every other loss we have ever known," my therapist told me. I looked over at a fellow juror who was also going through a separation and divorce, also with young children, and he nodded—even as he stared straight ahead into the auditorium filled with four hundred 9/11 family members.

The third and final forum was a joint meeting of the memorial competition jury and all advisory councils, which took place on June 5, 2003, at Pace University's multipurpose auditorium. The format was the same, and as we gathered there, the first design boards had begun to arrive at the secret location on 36th Street. In that meeting, we heard heartfelt pleas from some twenty-three advisory council members, including members of Community Board No. 1; Development Advisory Council; Residents Advisory Council; Families Advisory Council; Restaurant, Retailers, and Small Business Advisory Council; General Advisory Council; and Arts, Education, and Tourism Advisory Council. Once again, after introductions, our job was only to listen, with any questions from participants about the process itself to be directed to the LMDC. About a month later, on July 7, we received printed transcripts from each of these three meetings, accompanied by a large binder of 1,200 further comments received by the LMDC as part of its Public Perspectives Outreach Campaign. The campaign itself included a mailing to over 6,500 family members and elected officials, which posed two questions: (1) Are there things you feel are important for the jury to consider as they evaluate memorial design submissions? (2) Many years from now, what do you want the memorial to mean to future generations? The 1,200 responses to these questions received by the LMDC ranged from one or two short sentences to more than one thousand words. These thousands of pages of transcripts and comments would be our summer reading before meeting the first week of August to begin reviewing the 5,201 submissions.

The Judging Stage

Guarding the location of what was being called the "Jury Review Site" was so important to the LMDC that we jurors were not told where it was until the first day of our viewings, August 4, 2003. At 8:00 a.m. we met at the LMDC offices at 1 Liberty Plaza, where we were instructed to reconvene on the thirtieth floor of 120 Broadway, a couple of blocks away, an empty office building owned by Larry Silverstein, owner of the World Trade Center Towers. We were asked to walk over separately or in small groups, taking different routes, and to make sure we were not being followed by members of the press. Carrying cups of coffee, we straggled in a few at a time, ringing a buzzer outside a papered-over glass door with a small peephole flap cut open, through which we could be identified before being admitted. Here we were greeted by two staff members from the Planning and Design Institute, who would be responsible for managing our voting process and tabulation; and by two staffers from Landair Project Resources, who were responsible for the physical handling and sorting of submissions, as well as for transporting six hundred submissions a day from the secret storage facility to our "Jury Review Site."

By 8:30, we were joined by Anita Contini and John Hatfield, who was serving as Anita's assistant vice president and program manager. Breakfast was waiting for us on a large table in a windowless office, which would also be our deliberations room. A door from this office passed into another, enormous corner office, flooded with light from windows overlooking Ground Zero, a twenty-four-hour beehive of construction. This large, bright office easily accommodated three hundred design boards mounted on easels in several neat, long rows. For the next two weeks, we met here every morning for breakfast, followed by a short orientation and discussion, before reviewing the day's six hundred submissions. Jurors were divided into three groups, each asked to evaluate one hundred of the three hundred boards on display in a "close-up review" and then to do a "walk-by review" of the other two hundred, which would be receiving their own "close-up review" by the two other groups of jurors. This allowed every juror to review every submission, but since we were asked to take all the time we needed, the distinction between a "close-up" and a "walk-by" review began to melt away. By our ending time at six every evening, each of us had seen all six hundred boards, at the pace each of us needed to give them, which was mostly very "close-up."

As apprehensive as we had been in the face of somehow viewing 5,201 designs, the professionalism of the two competition management teams and the "well-oiled machine" of the review process they had engineered now put us at ease. But

A group of memorial competition submission boards. *Photo: LMDC.*

the review itself was still exhausting, at times mind- and soul-numbing. And as the sheer number of human hours of memory-work that went into every single board began to sink in, we found ourselves slowing down to give every design its due. Of course, this was easier to do in some cases than in others. The obviously kitschy submissions (such as Big Apples) or monstrously grotesque (such as planes crashing into big apples) didn't demand much more than a walk-by review.

More demanding were the conceptually compelling but logistically difficult to execute proposals, such as filling the entire five-acre "bathtub" within the slurry walls with water by connecting it to the harbor nearby, whose level would rise and fall with the tides, a kind of living, breathing reminder of life and loss. I for one found the accompanying narrative especially powerful: "The entirety of the area is flooded with waters of the Hudson, which will rise and fall with the tides. The great slurry wall designed to hold back the Hudson River is now supported by the weight of the water it was meant to hold back. The walls which withstood unimaginable trauma on September 11th are allowed, at last, to rest" (#790143). Another especially appealing design seemed to have been assembled at the kitchen table, a collage of drawings, poems, and sculpture by a family group of self-described "architects, students, landscapers, artists, and a poet, ages 2–77."

I tried to imagine their conversations, tears, and laughter as they jostled to fit everything onto their board. I wondered how many hours they had spent over how many days.

By Thursday the first week, we had viewed 1,800 design boards, but the only ones that jumped out at us were the memorably bad ones. So when Governor Pataki asked us over lunch that day whether we had seen anything interesting so far, we could honestly answer, "Yes!" With straight faces, we said that we were having a hard time choosing between the Big Shiny Apple Memorial and Giant Black 9/11 Telephone Memorial. The fact is, we needed all of these designs as a kind of baseline against which to measure the good, the bad, and the ugly. The governor swallowed hard. Then in no particular order, we free associated for him the most prevalent kinds of designs we had seen: burial mounds, formations of flags, memorial gardens, large crosses (some with airplanes flying between them), a three-thousand-word prose poem, large broken hearts, laser-light shows, several Phoenixes, a gigantic vase with five red roses, many stairways to Heaven, two five-hundred-foot tall trees sprouting American flags, and a giant whale ("I choose the form of a whale for this monument because I think the whale is the closest living form to represent the greatness and mysterious power of God").

At lunch on the third day, we asked each other which elements we found ourselves walking by and which ones slowed us down to consider more closely. Figures, flags, hearts, apples, blood, airplanes, and Phoenixes were a no. Reflecting pools, lights, trees, and earth forms were often yes. But in their detail, craft, and thoughtfulness, the design boards spoke to hundreds of hours of intense meditation and working through of grief and memory. It was clear by accompanying statements that no matter how beautiful or off-putting any given design may have been, their creators found therapeutic value in the process; and we, in turn, found something consoling in remembering in the company of these boards. Sometimes I actually found myself thinking how strange it was that every design made me feel a little bit better, whether or not it was a "yes." Often, as I came to the end of a row, I would go to the nearest window and look out at the city, then down at Ground Zero, bustling with construction of new foundations and infrastructure. I thought of Daniel Libeskind's title for his original site design, "Memory Foundations," and then realized that when taken together, all of these thousands of boards needed to be regarded as the memorial's invisible foundation, whatever the final design would be. Whatever design we finally chose would be built on the collective platform of thousands of unbuilt designs—and the millions of human hours spent imagining, sketching, and working through the memory of that day.

The voting rules were clear. After each round of "close-up reviewing," each juror would go down the list and vote yes, maybe, or no, with the possibility of five "passion votes" per week, which would automatically advance any given submission. All submissions with even one yes vote would advance, but if at the end of the day we ended up with more than 60, the total number of yes votes would be tabulated, with only the top 50 advancing. But everyone had one passion vote per day, which could be added to that total. Of the 600 submissions reviewed each day, some 50 or so would make this cut, with a handful of passion votes each round advancing a few others. By the middle of the second week, however, we realized we would still have some 500 submissions in the pool and would need another "metric" for winnowing the total down to a more manageable "final" 250. In this context, I proposed a set of seven organizing thematic and formal categories, asking whether it would be possible to name the "best" in each category as a way to thin the list still further. The categories I suggested reflected the thematic variety of submissions still in the running:

1. Orchards, Forests, and Gardens
2. Light Rods, Light Columns, Fields of Lights
3. Reflecting Pools, Flooded Areas, Water
4. Monoliths, Sculpture, Symbolic Towers
5. Mounds of Earth, Earthworks, Waving Topographies
6. Off-site Designs, Walking Tours, Tops of Buildings, Harbor
7. Rotundas, Canopies, Buildings

Here we organized a spontaneous seminar on the varieties of designs within these categories, with juror and landscape architect Michael Van Valkenburgh graciously volunteering a minilab on the differences between an Orchard, a Bosque, a Grove, a Forest, a Thicket, a Hedgerow, and an Allée. In fact, we had examples of all of these tree formations and needed Michael's expertise to begin judging how and why some worked better as "memorial" than others. Here we realized that among our final 250 or so, perhaps 50 contained significant plantings of trees. Some were full pine forests, others blossoming orchards, and others neatly patterned rows.

We then asked Maya Lin if she would walk us through the designs featuring water and earth forms. Maya had already given us copies of her book *Boundaries,* which explored the conceptual and formal origins of her designs for the Vietnam Veterans Memorial and the Civil Rights Memorial in Montgomery, Alabama. Here she could walk us through a couple of dozen boards, doing an aesthetic critique that explained why some "worked" as memorials and why some did not.

We found her reflections on her water design for the Civil Rights Memorial especially moving and instructive for our evaluations here.

Eight Finalists

After intense deliberations but without a clear sense of a dominant design, we arrived at a list of eight finalists in mid-October. By this time, it had also become clear to us that we were going to be an interventionist jury, that because we could not recommend any of the designs without significant modifications, we would make specific and in some instances extensive recommendations to all the teams. The LMDC approached each of these teams, still unidentified to the jury, and provided them with our detailed critiques, provided funds for them to develop their boards into three-dimensional models and to animate their designs with a short video walk-through. We then met with each of the teams over the course of two days the second week of November, exploring their models with them and hearing their own conceptual descriptions of their designs. In fact, until the morning we met them, we didn't know their names or where they had come from.

On November 19, 2003, we announced the list of eight finalists, whose designs, models and animations were revealed to the public in an exhibition at the newly reconstructed Winter Garden of the World Financial Center. They were (in alphabetical order): "Reflecting Absence," by Michael Arad; "Passages of Light: The Memorial Cloud," by Giesela Baurmann, Sawad Brooks, and Jonas Coersmeier; "Lower Waters," by Bradley Campbell and Matthias Neumann; "Garden of Lights," by Pierre David with Sean Corriel and Jessica Kmetovic; "Suspending Memory," by Joseph Karadin with Hsin-Yi Wu; "Votives in Suspension," by Norman Lee and Michael Lewis; "Inversion of Light," by Toshio Sasaki; and "Dual Memory," by Brian Strawn and Karla Sierralta. It was a source of both comfort and unease that most ended up being young, if professionally well regarded; but we were still left wondering where the big names had been.

After meeting with all eight finalist teams and making several further recommendations that we felt would enhance all their designs as well as bring them closer to the criteria required by the Memorial Mission Statements, we issued our own jury statement. This was intended both to provide a rationale for our choices and to make public for the first time the kinds of issues that we felt had driven the memorial process to this moment. This statement, intended as a public document and outlining the rationale for the competition, appears below in its entirety, as a historical reference point and anchor for our further, final deliberations:

World Trade Center Memorial Jury Statement
19 November 2003, World Financial Center, New York City

For the Announcement of the Eight Design Finalists

We, the 13 individuals selected to serve as the World Trade Center site memorial jurors, are ever mindful of the historical importance of the task we have come together to carry out. We understand the obligation we have to the victims, to their families, to society—indeed, to history—to serve the mission given to us: to remember and honor those who died, to recognize the endurance of those who survived, the courage of those who risked their lives to save the lives of others, and the compassion of all those who supported the victims' families in their darkest hours. The program statement of the families and other advisory councils has also asked us to be especially mindful of the memorial's mandate to recognize the victims, to keep the footprints unencumbered, and provide access to the bedrock at Ground Zero.

In selecting the competition finalists, our goal has been to find, within them, the elements that best embody both the letter and the spirit of the mission entrusted to us. In these finalists, we have sought designs that represent the heights of imagination while incorporating aesthetic grace and spiritual strength.

We jurors come from many different walks of life. We include among our number a victim's family member, artists and architects, engineers, public art administrators, a museum director, a resident of downtown New York, public officials, an educator and a historian. During the past five months, it has been our responsibility and our privilege to review every single one of the 5,201 submissions for the World Trade Center site memorial in order to select the design among them that will best capture so many individual tragedies, which collectively amount to both national and international tragedies, as well; a design that will recall an event that defies reason by the wantonness and sheer enormity of its destruction. Our aim was to identify a memorial design that would do justice to New York and its spirit, by becoming a symbol of its resiliency. Our aim has also been to find a design that will begin to repair both the wounded cityscape and our wounded souls, to provide a place for the contemplation of both loss and new life.

We have been profoundly moved by the fact that people from 62 countries and many continents have submitted memorial designs, people of different faiths, ethnic, racial, and cultural backgrounds and beliefs. Their participation in the memorial competition reaffirms our common humanity and is a testament to the solidarity and shared values of mothers, fathers, brothers, sisters, daughters, sons, friends and families from every corner of the world.

Choosing the eight finalists has been very difficult. Coming to a consensus has entailed hours of frank discussions, agreements and disagreements, always with the goal of arriving at common ground. From the very beginning, the jury strongly supported the LMDC process, in both its transparency and its equitable treatment of all the submissions. Proceedings were kept absolutely confidential, and submissions were kept absolutely anonymous. As jurors, we have enjoyed complete autonomy, and we continue to appreciate the responsibility entrusted to us as the ultimate judges of the competition.

It has also been crucial for us to be able to hear all interested parties' and constituencies' opinions and views. We met with representatives of the victims' families, who shared their grief and the magnitude of their loss with us. We met with the downtown community to hear their concerns about the site and its place in their neighborhood. We met with the competent authorities entrusted with the task of rebuilding Ground Zero, including the architects, the board of the Lower Manhattan Development Corporation (LMDC) and their chairman. In addition, we met with Mayor Bloomberg, Governor Pataki, and Mayor Giuliani. Each of them assured us that while they have their own individual views, they will respect and honor the jury's decision.

The eight memorial designs chosen as finalists have a number of characteristics in common. They strive neither to overwhelm the visitor nor their immediate surroundings. They aspire to soar—not by competing with the soaring skyline of New York but rather by creating spaces that strive to reconcile vertical and horizontal, green and concrete, contemplation and inspiration. They allow for the change of seasons, passage of years and evolution over time. They emphasize the process of memorialization over their own grandeur and present themselves as living landscapes of living memory that both connect us to our past and carry us forward into the decades ahead.

We have interviewed all eight teams of designers and have taken time to form our opinions and establish perspective in order not to rush to judgment. While the eight final designs we have chosen all address the guidelines of the memorial competition, we recognize that they are still in development, and that even the final version of the winning design will require additional refinements, including how the names of each of the victims should be recognized, how to respect the tower footprints and keep them unencumbered, how to provide access to bedrock, and what the relationship of the memorial will be to the site's interpretive museum. The jury feels that if the memorial alone cannot address all the issues put forth in the mission statement, then together with the planned interpretive museum, all parts of the mission statement can be realized over time.

We are particularly pleased that the LMDC has agreed to our request to exhibit all 5,201 submissions and to issue a certificate of appreciation to each of them for honoring our city by participating in this global contest, the largest of its kind and most inclusive in its democratic outreach. Furthermore, as promised, the eight final designs will be exhibited to the public while we continue our deliberations toward making our ultimate choice.

At this stage of the process, we also want to acknowledge that, ultimately, the memorial itself is a process, an attempt to bring reconciliation to that which can never be reconciled: love and loss, heroism and horror, past and present, public recognition and private introspection. The power and pain of this memorial's public discussions energize and animate this process, and thus help keep this memory alive. To give up, on the other hand, or to grow weary, is to begin to forget.

With these thoughts in mind, we thank everybody in New York City, the nation and the international community for your confidence in us. Your faith in the process and our part in it is instrumental in inspiring us to select the one final memorial

design that will embody the spirit of our restless, energetic, resilient city and stand as a beacon of hope on the bright path to the future.

This statement was included in the press release announcing the eight finalists and was also printed as an introduction to the exhibition of designs, when they were displayed for public contemplation in the Winter Garden.

For the next several weeks, tens of thousands of visitors came to see the design boards and models, among them dozens of reporters and cultural critics. While generally positive, it's also fair to say that the visiting public and much of the press were "underwhelmed" by the eight final designs, finding them "too cold," "too fashionable," "too generic," and "too small" compared to the significance of events they were to commemorate. Some were deeply disappointed that none of the designs included relics of the attacks: "The Coalition of 9/11 Families issued a Memorial Design Finalists Report Card, which gave each of the proposals an F. 'All these designs have failed because none really incorporate the historic remnants of the towers,' said a spokesman, Anthony Gardner, whose brother, Harvey Joseph Gardner III, died in the north tower." Other family members, such as Michael Macko, whose father William Macko was killed in the February 23, 1993, attack, were more appreciative. "Over all, these plans show an amazing breadth of talent and creativity," he said. Still other family members were just glad that the process was moving forward. After saying how grateful he was "for the care taken to think out each one of these [designs]," Michael Cary (whose wife Nellie died on Flight 11) concluded, "It means so much to me that something will actually be done there."[18]

Judgment was also swift and not always kind among the city's cultural critics. But at least one notoriously difficult-to-please critic, Herbert Muschamp (the architecture critic for the *New York Times*), took a longer, more generous view, in his aesthetic judgment. "Keep it simple," he wrote. "Eliminate inessentials. Cut the rhetoric. . . . Seen as a group, these finalists make the strongest possible case for simplicity as the most suitable aesthetic for ground zero. None of them deserve to be built in their present form," he continued, somewhat presciently. "A few of them, however, have the makings of a good beginning. If one of these, titled 'Reflecting Absence,' enjoys an advantage over the others, that is because it has the greatest potential to be the least." Muschamp went on to reflect on one of the most intractable aesthetic conundrums of any memorial to catastrophe: "There are no embarrassments [here], unless beauty is embarrassing, but perhaps, in this context, it is."[19] Finally, relieved that the designs seemed to have been chosen for "cultural, not capriciously political" reasons, Muschamp even paid glowing tribute to Anita Contini for creating what he called "an island of

credibility within the dubious political tempest that has been buffeting the site for more than two years."[20]

The editors at the *Times* took a similarly sympathetic approach and even tried to explain what they called the "generally tepid" public response: "To a great degree, that may simply be due to scale. The models and renderings of the plans simply do not convey how big the memorial really is or what it would be like to stand in its midst."[21] The jurors were thankful for the *Times*'s encouraging conclusion, that "the best news so far is the possibility of seeing one of these memorial designs come to life." But it's also true that we, too, had a very difficult time imagining the scale of this site, that even as we were inclined toward more minimal design, the scale of the footprints alone would dictate at least a partial replication of the World Trade Center's absolute monumentality—whether we wanted it or not.

Even as we issued this statement on the eight finalists, we were perfectly aware that we would also be shaping memorial policies that had not been worked out yet. Specifically, we wanted to emphasize that as a process, the memorial necessarily would evolve in discussions between the jury and the designers, and whatever required elements that seemed to be missing in the end would be incorporated somehow. We also realized that we now faced a diplomatic challenge: throughout our deliberations, we were excruciatingly aware of the changes Daniel Libeskind's own master plan was undergoing as it ran into the realities of New York City planning and politics. Though designed initially as a placeholder for the cultural buildings, one feature of Libeskind's design, in particular, seemed to be incompatible with any memorial we chose: this was the cultural building cantilevered over the top of the north footprint. The jury was unanimous in its judgment that it would have to be removed if the footprints themselves were to remain accessible and unencumbered, as the Memorial Mission Statement had required.

It also seemed crucial to us that this memorial be enlarged in the minds of the public to include not only the design we chose but also the thousands of unbuilt designs proposed for this and other sites around the city. With the exhibit of all 5,201 designs, in fact, we wanted to suggest that these, too, would have to be regarded as part of the memorial being built, that the millions of human hours spent on them must also be recognized as part of the massive work of memory already accomplished by this open and democratic competition.

In seeking a design that was both a great memorial and a great work of art, therefore, we took pains to choose among the eight final designs forms and environments that would not diminish the essential role visitors would play in the memorial, designs that would not overwhelm or dominate visitors with inhuman

scale or spectacle. We sought a strong, yet hospitable design, one that would allow for human reflection and inner contemplation.

Between our November announcement of the finalists and our next meetings in December 2003 and January 2004, we had requested further detailed elaborations and relatively extensive changes from three designs only: "Garden of Lights," by Pierre David with Sean Corriel and Jessica Kmetovic; "Passages of Light: The Memorial Cloud," by Giesela Baurmann, Sawad Brooks, and Jonas Coersmeier; and "Reflecting Absence," by Michael Arad, who had now invited the renowned landscape architect Peter Walker to join his team. In fact, we had requested of all the finalists in November that they add various experts to their teams to shore up deficiencies in lighting, stonework, and landscape. All three teams had responded cooperatively to our requests, with the most significant addition being Peter Walker to Arad's design team.

As we voted to advance "Reflecting Absence" from the very beginning, we all had qualms about what we regarded as its replication of the original World Trade Center plaza's terribly open and inhospitable plazas. When we asked Arad to address the "lack of life" on the memorial plaza between the pools, the architect had responded by introducing some eighteen extremely tall and spindly pine trees, leaving the plaza almost as exposed as before. This model was the one included in the finalists' exhibition. In our next meeting with the young architect, Michael Van Valkenburgh asked him to seek out a great landscape architect to help him with plantings on the plaza. Arad came back with the one of the best. With the addition of Peter Walker's "abacus grid" of trees covering the plaza between the pools, planted in east–west rows to suggest the city's grid of streets and in irregular intervals when viewed from north or south to suggest the randomness of a natural grove, we felt that the design's greatest weakness had been turned into its greatest strength. Arad's design would bring the memorial to street grade, and Walker's "abacus grid" of trees would seamlessly stitch it into the city's grid.

Speculation on a "final two or three" was rife in the press. After dozens of articles and commentary by family members, architectural historians, art critics, and editorial boards, a loose consensus had gathered around "Passages of Light" and "Garden of Lights" as the most likely frontrunners of the "final eight." But this conjecture was based entirely on the models on view at the Winter Garden, which were already under vast revision, unbeknownst to all but the jurors and the LMDC. Without knowing just how fluid these designs had become, some pundits and even a few politicians, including former mayor Giuliani, began to call for an overthrowing of the competition and a new start. "Ladies and gentlemen

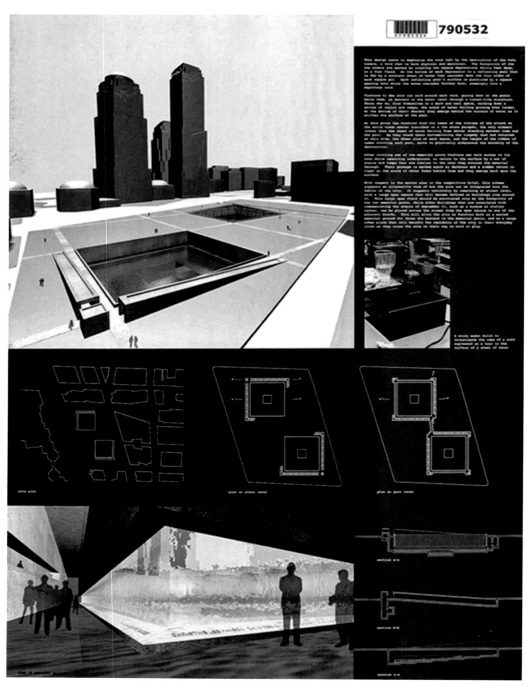

Arad's original 2003 submission, "Reflecting Absence." *Photo: LMDC.*

of the jury," Michael Kimmelman intoned in a front page *New York Times* commentary, "now that everyone agrees that the ground zero memorial finalists are a disappointment, there's only one thing to do. Throw them all out."[22] In Kimmelman's view, the process itself—a transparent and democratic competition—was fatally flawed by its very openness and inclusiveness. "Democratic competitions are only as good as the people who choose to take part in them," he wrote. "But good art, like science, is not democratic. An open competition can produce a Maya Lin Vietnam memorial once in a generation, maybe, but mostly it results in the generic monuments that are now the universal standard." By this point, the jury was more amused than annoyed by what we had come to regard as "kibitzers of culture."

Better to make this competition closed and elite, looking to established "excellence" for a great memorial? Of course, critics are free to question the efficacy of an open, blind competition for finding a great work of public memorial art. Like democracy itself, such competitions are notoriously inefficient, and as one of the jurors reminded the rest of us, about as reliable as democracy in picking the best candidate for president. Yet it was such a competition that resulted in Maya Lin's sublime Vietnam Veterans Memorial. An invited competition of elite artists and architects may well have yielded a great monument as well, but it wouldn't have been Maya Lin's design.

To those who maintained that an open and blind process discouraged the best artists and architects from entering this competition by neutralizing their fame and notoriety on a level playing field, we asked, "Where is the civic-mindedness of our generation's greatest artists and architects? Why don't we ask them why they declined the open invitation to take the time so many others took to contemplate how to memorialize the devastating attacks of 9/11?" We wanted to ask them whether it was because they had nothing to say or whether the investment in such memory-work without a guaranteed payoff in a commission was just not worth their while. And what of the jurors, all of them at the top of their fields, who gave hundreds and hundreds of hours to the process without compensation? Was the time of elite artists and architects any more valuable than that of Maya Lin, Michael Van Valkenburg, Enrique Norten, Martin Puryear, Vartan Gregorian, Lowery Sims, or Susan Freedman?

Would a process that invited only fifty of the world's greatest artists and architects and excluded the thousands of people and teams who collectively spent millions of human hours on their designs really be preferable to an open, democratic, and blind competition? What is more important here? A great piece of art for our time, a new ornament for the city of New York, or a process in which

everyone could participate to find a memorial for these specific events? As difficult a process as it would be, the jurors were glad that the LMDC courageously chose the hardest path.

By January 2004, the additions to their personnel and incorporations of the jury's critiques each of the three finalist teams had made over the last several months had elevated their designs well above the others. We also were aware that all three designs we now contemplated were much further evolved than what the public was still viewing at the Winter Garden. After meeting with each of the final three teams in two-hour-long presentations at Gracie Mansion at the beginning of December, the jury gave itself a week to decide on the winner.

FINAL DELIBERATIONS STAGE

During our contemplation of "Garden of Lights," which would have planted over the tower footprints with meadows of wildflowers and made the rest of the site an orchard of fruit-bearing trees, I recalled encountering a singular apparition in several Polish villages I had visited over the years. A large forest of vines and brush occupied the villages' centers, like a wild, unkempt common, with neat houses and storefronts built around them. When I asked once what the area was, villagers answered that the square had been where the Jews lived and where their homes and markets had once stood. During the Nazi time, some of the homes were burned along with the wooden synagogue, the other homes plundered. After the war the local villagers regarded the center as a kind of memorial, profaned and now untouchable. Vines grew up around the ruins and nature took over, and the result is a big patch of wilderness marking what had once been the Jewish quarter.

Here we also mused that if we had asked the architect Tadao Ando to submit something, we likely would have gotten either a grassy burial mound or a green network, or some combination of the two. For we knew that two years after the Great Hanshin earthquake of January 17, 1995, in Kobe, Japan, Ando proposed to commemorate the 6,000 victims of this catastrophe (plus another 300,000 left homeless) with just such a mass planting of trees. In an article that appeared in the *Royal Institute of British Architects Journal* in 1997, Ando proposed a "green network": that is, planting 250,000 trees, including some 50,000 white blossoming trees such as cucumbers or magnolias. "The white flowers," he wrote, "will serve as both a prayer for those who perished in the disaster and a reminder of what has happened to those who survived it. Trees and plants are living things, and caring for them is not easy. By cooperating to protect and nurture the living things as they grow, I believe that little by little the community will rejuvenate

itself. . . . We must leave the children of the next generation irreplaceable assets. Like twirling a baton, we must foster life itself . . . This is what I hope for."[23] In fact, the architect's dream has been realized. The emperor himself journeyed to Kobe to plant the three hundredth tree, and planting continues to this day.

During this deliberation, I also described how, in Israel, a forest of six million trees is being planted in the Judean hills between Jerusalem and Tel Aviv, in the words of B'nai B'rith, "as a living memorial to the six million Jews who perished in the Holocaust."[24] Begun in 1954, this planting clearly takes on several layers of practical and symbolic meaning in Israel: it remembers both the martyrs of Nazi genocide and a return to life itself as cultivated in the founding of the state. Rather than remembering the victims in the emblems of destruction left behind by the Nazis, thereby succumbing to the Nazi cult of death, these trees recall both the lives lost and the affirmation of life itself as the surest memorial antidote to murder. It was also with this traditional veneration of life in mind, as symbolized in Jewish tradition by the Etz Chaim (tree of life), that Yad Vashem has planted a tree to remember and to name every single Gentile who rescued a Jew during World War II.

One of these is a commemoration of a natural catastrophe, the other of a mass murder. But in both cases, the dead are remembered by living forms, with the regeneration of life itself, so that the victims' lives—and not just the terrible moment of their deaths—are at the center of our memory now. At the same time,

Jurors continue deliberations at Gracie Mansion. *Photo: LMDC.*

we make ourselves responsible for nurturing and sustaining such memory. We remind ourselves that without the deliberate attempt to remember, memory itself is lost, that like life, memory needs to be cultivated and attended to.

I reflected still further on what I was calling the "pastoral elegiac" tradition that has long comforted mourners and loved ones by locating life's passing in nature's cycle of life and death. The computer-generated images of "The Garden of Lights" showed beautifully how the memorial setting at Ground Zero would change with the seasons: snowy and dormant in the winter, coming into blossoms and life in the spring, fully verdant in the summer, and then fading in the autumn echoed the cycle of life itself, even as it also demanded our care and nurturing. "Think of the trees planted on Park Avenue to commemorate America's soldiers fallen in World War I," I said. "Think of the Forest of Six Million. Think of Ando's Green Network. Think of the Garden of Lights." In our early discussions of "Garden of Lights," I was a strong advocate. "The Garden embodies change, rebirth, dormancy, and renewal," I said. "It demands tending and cultivation, just as all memory must."

In the end, we felt that such a planting would suggest primarily a redemptive, consoling memorialization of an attack that must remain an irredeemably open wound for us all. Though none of us wanted destruction alone as a motif, neither did we want to memorialize these deaths only in a redemptory vein, beauty or logic. The victims and their families, and by extension, their communities, are entitled absolutely to remember the victims as they lived, in the consoling emblems of life and renewal. But how to articulate the terrible loss, without filling it in with consoling rebirth?

The "Garden of Lights"—really an orchard and two gigantic squares of wildflowers—seemed the most audacious of the three finalists and the surest to remind people that something unimaginable happened here. Its predominant motif was the counterpointing of a densely built urban space with nearly five acres of trees and flowers. Unlike redevelopment in most cities, which bury such events beneath layers of new civilization, this design had chosen to let nature mark this site with its own cycles of rebirth. This would be a living and dying form to mark living and dying human beings. It would be a place to nurture, to remind us that without our tending memory, it, too, dies. But with every iteration, its designers made it more complex. Its elegiac memorial logic was being buried beneath a welter of baroque flourishes—such as glass walls surrounding the millefleurs gardens in the footprints, accessible only to victims' families; and underground altar levels. Every time we asked for an element to be simplified, another two seemed to grow more complicated. In its overly complex subterranean layers and the designers' inability to simplify the scheme of lights planted

"Garden of Lights" by Pierre David with Sean Corriel and Jessica Kmetovic. *Photo: LMDC.*

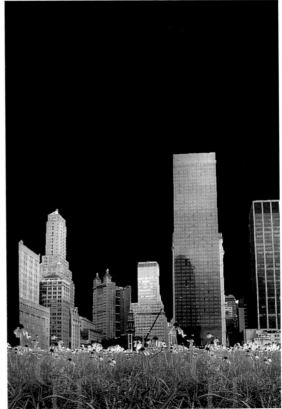

The wildflower gardens proposed in "Garden of Lights," to be accessible only to family members. *Photo: LMDC.*

in the orchard, combined with their unwillingness to open the site year-round to the neighborhood so that it would remain completely integrated and accessible, we finally found it untenable.

In contrast, "Passages of Light: The Memorial Cloud" presented itself as a beautiful, even spectacular piece of architecture. But in its architectural audacity, "Passages of Light" also raised a fundamental question for us. We were acutely aware of the implicit aesthetic requirements of the memorial, its dual role as commemorative site and architectural centerpiece of Lower Manhattan's redevelopment. Here we had to balance the needs of memory against the needs of art and architecture, to find an equilibrium between art for the sake of memory and art for its own sake. In fact, some on the jury feared that the more spectacular the work of art or architecture, the more eye-absorbing and viscerally evocative it was, the less intrinsic its memorial logic seemed to be. Unlike many great and beautiful works of contemporary public architecture (such as Frank Gehry's Guggenheim Museum Bilbao), this memorial could not be about itself or its form. In fact, in Santiago Calatrava's beautiful and soaring design for the new transit center, there is just such self-possessed beauty, and in the new cultural centers that were being planned there may be as well. But the memorial would have to take us back to events, into ourselves, to the memory of those lost, and the memory of the now missing towers. It could not overwhelm or dominate visitors with inhuman scale or spectacle.

As design, "Passages of Light" was by far the most spectacular of our three finalists, which in the end may have compromised its function as a memorial. For as spectacle, it absorbed all our visual and visceral attention into its amazing surfaces. Man-made materials like glass or translucent plastic seem impervious to memory, unyielding and not as pliant as memory needs to be. They are hard, brittle, repellent, not resilient, show no trace of visitors, are not interactive. Our discussion on the penultimate day of deliberations was completely absorbed in this design's materiality, its surfaces, its buildability, but there was almost no mention of its capacity for memory. Aside from its titular reference to the smoking cloud of debris immediately after the attacks, we could not find its memorial logic. The debate around the cloud among jurors was easily the most animated and in the end, wrenching for all. It was the clear favorite of nearly half the jury, with the other half favoring Michael Arad and Peter Walker's "Reflecting Absence." In the end, arguments came down not to which of the two designs was more beautiful and moving but to which of the two made the better memorial.

Of all the jurors, Maya Lin was most eloquent and persuasive in her argument for "Reflecting Absence," asking us to hear the sound of falling water, even being

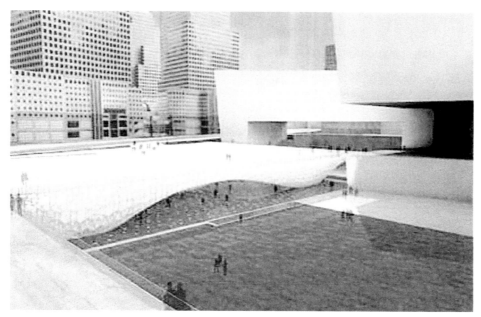

"Passages of Light: The Memorial Cloud" by Giesela Baurmann, Sawad Brooks, and Jonas Coersmeier. *Photo: LMDC.*

"Passages of Light: The Memorial Cloud" would have cast a soft glowing light skyward at night. *Photo: LMDC.*

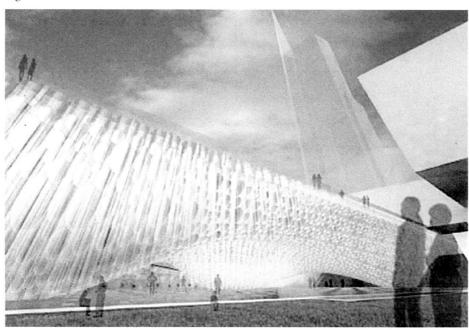

drawn by the sounds to the two identical voids as we walked through groves of trees. "The power of those footprints is the memorial," she wrote in a printed reflection she handed out to the rest of us. "All that is left of those towering structures is a simple absence—and water flowing down into the footprints. You would be drawn to these voids—and to the scale which again harkens back to the towers themselves." As she talked of falling water, I thought of the gravity that sucked these buildings down into themselves continuing to suck these waters into "the void." I thought of the falling towers themselves—and then worried that the falling water was too literal an echo of the falling buildings. With Maya's push in our December 2003 meetings, "Reflecting Absence" was not only returned to our final three designs, it was now to my mind the leader. It remembered life with life, loss with loss. We submitted one last set of questions to the three finalist teams, who would respond by January 1 and then return for one more day of meetings at Gracie Mansion on January 5, after we had spent the weekend poring over their answers.

We convened at ten thirty that morning for half hour meetings with each of the teams, each followed by a short break and discussion among jurors. By one we had finished our last meeting and now sat together for lunch. We were scheduled to go home at nine thirty, and if we still had no decision, to reconvene from six to nine on Tuesday evening. That was to be our drop-dead deadline.

Here we read and re-read the words of Michael Arad and Peter Walker prepared for their design statement:

"Reflecting Absence" proposes a space that resonates with the feelings of loss and absence that were generated by the destruction of the World Trade Center and the taking of the lives of thousands of people. It is located in a field of trees that is interrupted by two large voids containing recessed pools. The pools and ramps that surround them mark the general location of the footprints of the twin towers. A cascade of water that describes the perimeter of each square feeds the pools with a continuous stream. They are large voids, open and visible reminders of absence.

The surface of the memorial plaza is punctuated by the linear rhythms of rows of Sycamore trees, forming informal clusters, clearings and groves. This surface consists of a composition of stone pavers, plantings and low ground cover. Through its annual cycle of rebirth, the living park extends and deepens the experience of the memorial.

Bordering each pool is a pair of ramps that lead down to the memorial spaces. Descending into the memorial, visitors are removed from the sights and sounds of the city and immersed in a cool darkness. As they proceed, the sound of water falling grows louder, and more daylight filters in from below. At the bottom of their descent, they find themselves behind a thin curtain of water, staring out an enormous pool. Surrounding this pool is a continuous ribbon of names. The great size of this

space and the multitude of names that form this endless ribbon underscore the vast scope of the destruction. Standing there at the water's edge, looking at a pool of water that is flowing away into an abyss, a visitor to the site can sense that what is beyond this curtain of water and ribbon of names is inaccessible.

The statement went on to describe how the upper and lower levels are linked, how the slurry wall will be revealed as part of the design, and where the unidentified remains of victims will be contained at bedrock. It concluded: "The memorial plaza is designed to be a mediating space; it belongs both to the city and to the memorial. Located at street level to allow for its integration into the fabric of the city, the plaza encourages the use of this space by New Yorkers on a daily basis. The memorial grounds will not be isolated from the rest of the city; they will be a living part of it."

Back and forth we went on that snowy night at Gracie Mansion. We were reminded how struck we had been in Michael Arad's first presentation of his design in November, when he showed us drawings he had made of two voids in the harbor just off of Battery Park City. He had even shown us slide photographs of a water-table mock-up of these voids in the river, which he had fabricated on his rooftop within only weeks of the attacks themselves. This was his memorial epiphany, moved to the World Trade Center site itself. The memorial logic of the voids, now coupled with the memorial logic of trees and regenerating flora, both bound by the sounds of falling water (symbolic and literal source of life), was undeniable. We voted once, then twice, then a third time in openly declared ballots. "Garden of Lights" had now been eliminated. We stopped to have dinner, which included many bottles of wine from Gracie Mansion and Mayor Bloomberg's astounding wine cellar, all New York State vintages.

Thus fortified and with few inhibitions left, our impassioned dinner-table discussions tumbled back into another vote after dinner, now tilting for "Reflecting Absence." Momentum had shifted, and we resolved to stay beyond our nine-thirty ending time, not stopping until getting to the plurality we had set for ourselves. We were now free associating every possible element of these designs' "memorial logic," pitting the fluidity of falling water against the frozen lake of glass, the ever-growing volumes of the voids against fixed glass tubes, the life-affirming emblems of regenerating flora against a spectacular but static "memorial cloud" of toxic gasses. There was more wine and another vote, and then there were tears and another vote. At nearly midnight, two jurors for "The Cloud" quietly and resignedly came over to our "Reflecting Absence" side, leading us to a unanimous vote for the Arad-Walker design. Anita Contini and John Hatfield congratulated us, an exhausted, spent, and weepy group.

Michael Arad's early sketch of two voids in the Hudson River, November 2001. *Photo: Courtesy Handel Architects, LLP.*

Arad's early model of "water voids," installed and photographed on the rooftop of his apartment building, November 2001. *Photo: Courtesy Handel Architects, LLP.*

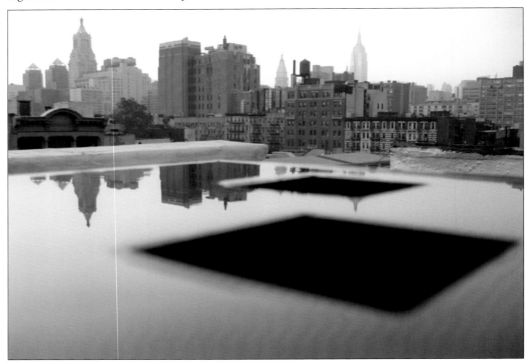

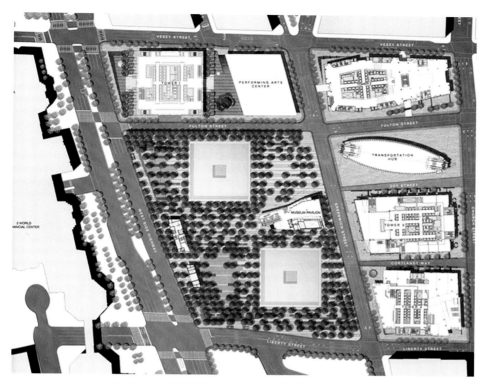

Computer-generated rendering of "Reflecting Absence" adding the abacus grid of trees.
Photo: LMDC.

The next morning a handful of us met at the LMDC offices to craft a "Jurors' Statement for the Winning Design." We knew that even at that moment Michael Arad and Peter Walker were at work on the final, revised version. We began to outline the foundational qualities of their design, the ones that finally won us over: its minimalist conception, the memorial logic of the voids, the essential incorporation of Peter Walker's abacus grid of trees, its succinct capturing of the twin motifs of loss and renewal already articulated so powerfully in Daniel Libeskind's "Memory Foundations." It also brought the memorial site to grade, thus weaving it completely back into the urban fabric. Rather than paraphrasing the statement, which was meant to be an explicit rationale for the jury's choice, I include it here as Vartan Gregorian read it on that morning of January 14, 2004, on a stage at Federal Hall, flanked by the winning designers, Mayor Bloomberg, and Governor Pataki, to an audience of hundreds of family members, the press, and us jurors:

WTC Memorial Jury Statement for Winning Design
14 January 2004

Let us begin by acknowledging that memory belongs primarily to the individual: the unique and personal remembrance of someone deeply loved, of shared lives, of unspeakable grief and longing. At the same time, we must acknowledge the extent to which the evolving process of memory also belongs to families and neighborhoods, communities and cities, even entire nations. How to collect the disparate memories of individuals and communities together in one space, with all their various textures and meanings, and give them material, spatial form has always been the daunting challenge of any memorial site. How to commemorate at Ground Zero the countless, accumulated memories of the attacks of February 26th, 1993 and September 11th, 2001, tragedies shared by countless individuals and communities here and abroad, has posed an inspiring, yet humbling challenge to thousands of designers from around the world—and to us, the 13 jurors charged with finding a single memorial design only two years after the attacks.

Our memorial mandate, in all of its own complex richness, has been clear from the outset: to remember and honor those who died, to recognize the endurance of those who survived, the courage of the rescuers who risked their lives to save the lives of others, and the unendurable number who died in the process—as well as the compassion of all those who supported the victims' families in their darkest hours. The families and other advisory councils have also asked us to be especially mindful of the memorial's need to recognize the victims and those who tried to save them, to keep the footprints unencumbered, and provide access to the bedrock at Ground Zero. In addition to meeting the program's needs, we also had to face the stark reality of reintegrating into the urban fabric a site that had been violently torn from it. How to do all this in a single, magnificent memorial design was a very tall order, indeed.

As is quite clear to everyone, we have taken the time we needed to make our final choice from among the 5,201 submissions from 63 different countries. It is with great pleasure, therefore, that we announce that of all the designs submitted, we have found that "Reflecting Absence" by Michael Arad, in concert with landscape architect Peter Walker, comes closest to achieving the daunting—but absolutely necessary—demands of this memorial. In its powerful, yet simple articulation of the footprints of the Twin Towers, "Reflecting Absence" has made the voids left by the destruction the primary symbols of our loss. By allowing absence to speak for itself, the designers have made the power of these empty footprints the memorial. At its core, this memorial is thus anchored deeply in the actual events it commemorates—connecting us to the towers, to their destruction, and to all the lives lost on that day.

In our descent to the level below the street, down into the outlines left by the lost towers, we find that absence is made palpable in the sight and sound of thin sheets of water falling into reflecting pools, each with a further void at its center. We view the sky, now sharply outlined by the perimeter of the voids, through this veil of falling water. At bedrock of the north tower's footprints, loved ones will be able to mourn privately, in a chamber with a vault containing unidentified remains of victims that will rest at the base of the void, directly beneath an opening to the sky above.

While the footprints remain empty, however, the surrounding plaza's design has evolved to include beautiful groves of trees, traditional affirmations of life and re-birth. These trees, like memory itself, demand the care and nurturing of those who visit and tend them. They remember life with living forms, and serve as living representations of the destruction and renewal of life in their own annual cycles. The result is a memorial that expresses both the incalculable loss of life and its consoling regeneration. Not only does this memorial creatively address its mandate to preserve the footprints, recognize individual victims, and provide access to bedrock, it also seamlessly reconnects this site to the fabric of its urban community.

Because the jury has regarded this memorial as a process that began with the first candlelight vigils, the appearance of posters of missing loved ones, and the laying of flowers around the city, and continued through the rescue and clean-up operations, and continues still through the memorial competition, we do not view our selection of a winner as the end of the memorial. Rather, we see our selection as one more stage of memory. "Reflecting Absence" has evolved through months of conversation between the jury and its creators. This is why the jury is confident that whatever further issues this memorial may need to address over time (such as artifacts and the narrative history of that day) will be made part of the underground interpretive museum planned for this site. In this vein, we recommend that the Art Commission of the City of New York advise the Memorial Foundation on how to protect the integrity of the design. We also recommend that provisions be made to accommodate the annual showing of "Tribute in Light."

On behalf of all the jurors, we give our heartfelt congratulations to Michael Arad and Peter Walker on their beautiful and compelling winning design. We also wish to thank, from the bottom of our hearts, the leadership of the LMDC, the Governor, the Mayor, and the public for having granted us complete authority and autonomy to make this very difficult, but crucially important decision. Let this be a place where all of us come together to remember from generation to generation.

(Signed in alphabetical order by the individual members of the jury.)

THE BUILDING STAGE

After that day, of course, the site design process and highly public squabbles among agencies, developers, architects, and family member groups continued unabated. The design of Daniel Libeskind's Freedom Tower (now named World Trade Center One) evolved radically with the appointment of David Childs as lead architect for the building itself (leaving Libeskind as the lead architect of the overall site plan in name only). The memorial design by Michael Arad and Peter Walker was also forced to evolve dramatically as it ran into the hard bedrock of fiscal and structural boundaries of reconstruction at Ground Zero. On June 21, 2006, the mayor's and governor's office announced that it had accepted a revised plan, developed by construction executive Frank J. Sciame, which would

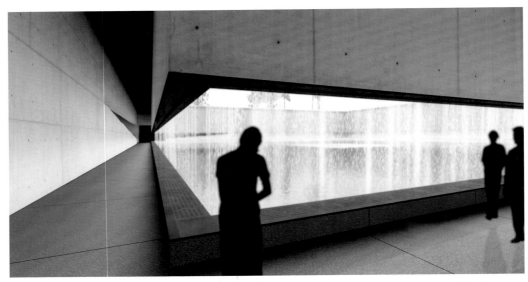

The original design included below-grade galleries that would have allowed visitors to view the sky through veils of falling water. *Photo: LMDC.*

The names of victims etched into the parapets marked by family members at the dedication.

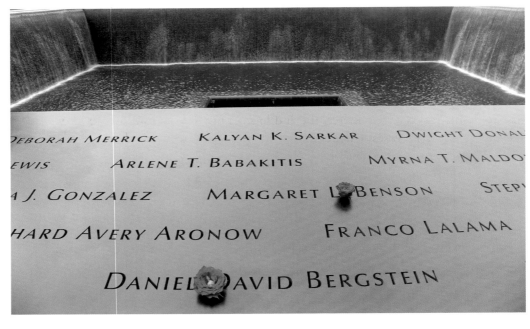

preserve the essential aboveground elements of "Reflecting Absence," but which would also eliminate the original design's underground galleries. As painful as it was to accept these changes, Michael Arad also recognized what he called "the imperative to move forward and begin construction on the memorial as soon as possible."[25]

In its fundamental experience at grade, the memorial would retain all of the conceptual and formal elements for which the jury originally chose it. But it would now have to make way for the National 9/11 Memorial Museum, to be located beneath and between the pools at bedrock level. Now anchored in the history of the day, the memorial could even be said to be stronger. It was also certainly improved by bringing the names above ground and engraved in the parapets around the edges of the pools, as became necessary when the underground galleries were eliminated. Once actual construction of the memorial commenced, in fact, Arad continued to improve his design in several other ways, including the brilliant arrangement of victims' names in what he called "meaningful adjacencies"—whereby every family was asked where and with whom they would like their lost loved one's name to appear on the parapets at the edges of the waterfalls. Every family's request was honored in the final arrangement.

Where it first appeared that the memorial would have to be fit into Libeskind's master site plan, it turned out that the Freedom Tower and associated cultural buildings and museums would be built around the memorial itself. Together, they constitute a site of living memory at Ground Zero. Despite reports in the city's papers that the site's constant evolution was somehow a betrayal and not a working through of memory, the two principal teams of designers—Daniel Libeskind and David Childs for the Freedom Tower, Michael Arad and Peter Walker for the Memorial—continued to view their projects as part of a larger matrix of memory and commerce, life and loss. In this vein, public memory of the 9/11 attacks and losses remains an animated process, by which the stages of memory follow each other, from generation to generation.

OPENINGS AND RECEPTION

For the first two years after its dedication in 2011, the National 9/11 Memorial was bordered on all sides by construction staging sites, forcing entry through a small number of gates around its perimeter. Visitors were forced to make an online appointment and wondered if the memorial would ever become a truly accessible part of the cityscape as promised. But now the staging is gone, and

Daniel Libeskind's rendering of the new World Trade Center master plan with "Reflecting Absence" at its center, April 2004. *Photo: LMDC.*

the memorial can indeed be entered from all sides, at all hours of the day. The waterfalls run from 6:00 a.m. to 10:00 p.m. and are lighted from dusk to their 10:00 p.m. closing time.

On its opening and dedication on the tenth anniversary of the attacks, the critical reception of the memorial was generally as warm as its reception among the victims' families. Martin Filler, the architecture critic for the *New York Review of Books* called it "the most powerful example of commemorative design since Maya Lin's Vietnam War Memorial . . . a sobering, disturbing, heartbreaking, and overwhelming masterpiece."[26] Indeed, the rest of Filler's review was positively effusive. He complained only of the bottleneck entries to the memorial plaza, a result of construction staging, which were removed by 2013 to allow for entry from all sides, as originally intended.

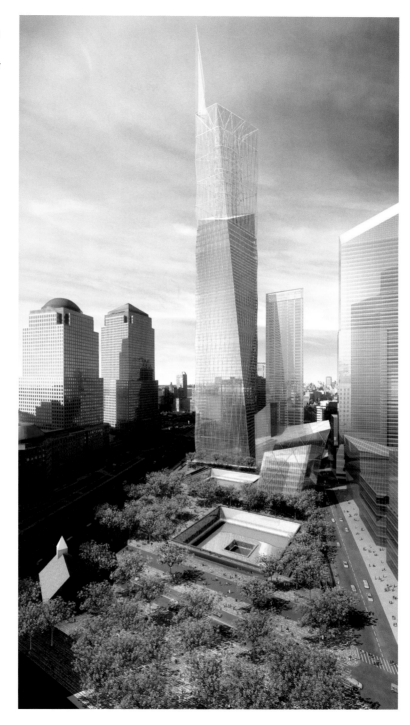

Michael Arad and Peter Walker's rendering of the World Trade Center Site Memorial, with a still evolving version of "The Freedom Tower," 2005. *Photo: LMDC.*

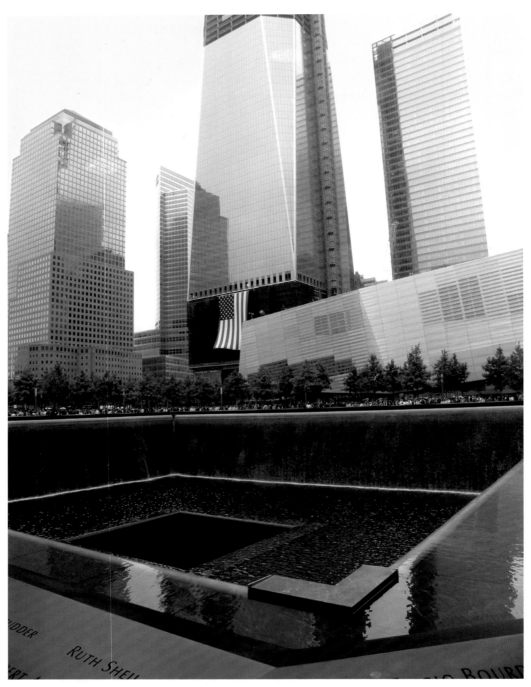

An American flag flew at the base of 1 World Trade Center, still under construction, on the dedication of the memorial in 2011.

Others have found the scale of the waterfalls to be wildly disproportionate to its setting, dwarfing the visitors and turning them into antlike specks. But it's clear that together with the mandate to articulate the towers' footprints, a corollary mandate to memorialize the towers' sheer monumentality was established as well. They are overwhelmingly gargantuan, even monumental, just as the towers were. At the same time, however, it may also be the inhumanly proportioned scale of the waterfalls that creates unexpectedly intimate spaces among small groups and families as they cluster together in the plaza and at the edges of the voids. The soft roar of the waterfalls mutes almost all of the other ambient city sounds, muffling the voices of all but those standing within a few feet of each other.

In its first five years, over twenty-three million people have visited the memorial from all fifty states and dozens of other countries. But as one immediately realizes on entering the plaza in 2016, the vast majority of visitors to the National September 11 Memorial are either out-of-town visitors or foreign tourists. In fact,

An airline pilot remembers, opening and dedication of the National September 11 Memorial. *Photo: Lisa Ades.*

James E. Young and Susan Freedman discuss the design process with Secretary of State Hillary Clinton at the dedication. *Photo: Lisa Ades.*

Visitors at the 9/11 Memorial.

relatively few New Yorkers themselves (aside from family members) seem to have any desire to see the memorial firsthand, including nearby residents who were forced out of their homes for weeks after the attacks. One day in May 2015, I asked two friends of mine who have lived on Beaver Street, a couple of blocks from the World Trade Center, for the last thirty years, if they wanted to meet me at the memorial before going to dinner that evening. "Why don't you come here to our loft," they answered. "We'll have some wine and cheese, then go to dinner from here."

One of them is an art dealer who was a block away from the World Trade Center when the first tower collapsed and survived the massive debris cloud by diving into a doorway and covering his head as it swept over him. A few years later, he was diagnosed with lung cancer and lost one lung to surgery. Seventy years old and a nonsmoker, he was told by his oncologist that the cancer was likely a result of the toxic particles he had inhaled that day and had coated their apartment for several weeks after the attacks. When I arrived for our pre-dinner glass of wine, I asked my friends what they thought of the memorial. They replied that they hadn't been to it yet, four years after it had opened and two blocks away, but said that it looked quite beautiful in the photographs they had seen. There was nothing hostile in their response, just a sense of still being unprepared to revisit the pain of that day. It was clear that they didn't need a memorial to remember what happened and that, if anything, they would prefer to live downtown without being forced to recall the trauma that they cannot forget. There's even a sense that insofar as the memorial turns homegrown New Yorkers into tourists, it estranges them from their own beloved city. They know that the memorial is not for them, for those who can never forget; rather, in their eyes, it is for those who weren't there on that day, who need to come there to remember, whose experience of the day will always and blessedly be a vicarious one. Studying the incredulous look on my face, my friend added with a wry smile, "Now if we had a place to visit where we could forget the 9/11 attacks, we'd be glad to go there."

Interior of the Danish Jewish Museum, Copenhagen, 2004. *Photo: Studio Daniel Libeskind.*

2

Daniel Libeskind's
Houses of Jewish Memory

What Is Jewish Architecture?

Before reflecting on the notion of a specifically "Jewish architecture," I would ask: What makes any expression of culture "Jewish"? I would follow this question (in good Jewish fashion) with several others: Toward what end are we defining Jewish culture? Are there essentially Jewish qualities to Jewish culture? Is Jewish culture something produced mostly in relationship to itself, its own traditions and texts? Or is Jewish culture necessarily constituted in the reciprocal exchange between Jewish and non-Jewish cultures? Indeed, can Jewish culture include works produced by Jews without explicit Jewish content, works inspired by Jewish texts or experiences, received by the Jewish world as Jewish texts, or codified and responded to as Jewish texts? In this vein, can Jewish culture include work produced by non-Jews for Jewish purposes, such as illuminated Hebrew manuscripts, synagogue buildings, or burial reliefs?[1]

It is with these questions in mind that one could turn to specifically Jewish forms of cultural production, such as Jewish literature, art, photography, or architecture. Can the stories of Franz Kafka be regarded as parables for Jewish experience, as might Sigmund Freud's meditations on dreams and monotheism? Did Jewish-born artists like Barnett Newman, Philip Guston, and Mark Rothko produce Jewish art? Were Newman's meditations on martyrdom suggestive of "Jewishness" in his work? Did Guston's reflections on Jewish identity and catastrophe in his paintings make him a "Jewish artist"? Was Rothko's iconoclastic insistence on the abstract color field after the Holocaust a gesture toward the second commandment's prohibition of images, and if so, did that give him a Jewish sensibility?

Would William Klein (b. 1928) be considered a Jewish photographer? Would Weegee (née Arthur Feelig, 1899–1968) or Robert Capa (née Andreas Friedmann, 1913–1954) or Brassaï (née Gyula Halász, 1899–1984)? Aside from its cheekiness, what are we to make of William Klein's mischievous remark that "there are two kinds of photography—Jewish photography and goyish photography. If you look at modern photography you find, on the one hand, the Weegees, the Diane Arbuses, the Robert Franks—funky photographers. And then you have people who go out in the woods. Ansel Adams, Weston. It's like black and white jazz."[2] Are William Klein's own photographs Jewish in their narrative, storytelling movement, figure to figure? Or would we consider these photographers Jewish because, in the words of the art historian and critic Max Kozloff (who was also a photographer himself), they are "restless, voracious . . . give the impression of being always in transit yet never arriving."[3] Did Jews invent "street photography," as Kozloff argues, or was this really an aesthetic common to all immigrants to any new land who see the street through new eyes?

Finally, back to the matter at hand: What is Jewish architecture? In its modern form, is it prophetic, iconoclastic, constitutively anti-classicizing and anti-authoritarian, as architectural theory's great advocate of rupture and fragmentation, Bruno Zevi, has suggested?

> . . . beneath the differences in the intentions [of modern architecture], the authentic reality comes to light, breaking the chains of classicistic slavery with its fetishes of dogmas, principles, rules, symmetries, assonances, harmonious accords and repressive monumentalisms. Modern architecture, with its pulsating territorial and urban tensions, incorporates a prophetic component, at any rate, a capacity for hope. Jewish novelists often allude to prophecy as a lost value. Jewish architects, on the other hand, implement their plans with Messianic force. They cultivate their Jewishness in a reserved area. But the ideal, the Jewish fight for the emancipation of the 'other', exerts a force, even in architecture.[4]

Or is it a breaking of architecture's traditional chains in the specific context of the modern era, a century when the adequacy and viability of all cultural expression were called into doubt after World War I and II and the Holocaust?

The current generation of Jewish-born architects has certainly achieved an unequaled prominence in the field—along with Daniel Libeskind, Frank Gehry, Richard Meier, Peter Eisenman, Santiago Calatrava, James Ingo Freed, Eric Owen Moss, Zvi Hecker, Moshe Safdie, and Robert A. M. Stern are just a few of the best known. Citing the works of these architects, as well as midcentury figures like Erich Mendelsohn, Richard Neutra, and Louis Kahn, the historian Gavriel Rosenfeld suggests that, even if there is no "monolithically Jewish style of

architecture," it is still true that what he calls "Jewish concerns" have "begun to inform both the theoretical and aesthetic agendas of Jewish architects."[5]

Indeed, Rosenfeld has even suggested that the entire "deconstructivist" architectural movement itself arose from the "massive rupture in Western civilization caused by the Holocaust" and the subsequent crisis of faith that led to a "rethinking and 'deconstructing' [of] the entire discipline of Western architecture." Here Rosenfeld elaborates: "Sharing the postmodern belief that the Holocaust's specifically modern origins require the abandonment of the 'project of modernity', Libeskind and Eisenman [in particular] . . . argue that the Nazi genocide provided compelling reason to abandon traditional architectural practice and to instead embrace an architecture of fragmentation, de-centeredness and loss that reflected the reality of the postmodern, post-humanist, post-Holocaust world." That is, it may not just be "Jewish concerns" that have informed the work of Jewish architects, but the historical experiences of Jews in the twentieth century that have begun to inform the discipline of architecture itself.

Here, in fact, I recall often being asked if Jewish architects were somehow predisposed toward articulating the memory of catastrophe in their work, in order to explain how Libeskind (original site designer of the World Trade Center complex), Calatrava (designer of the new World Trade Center Transportation Hub abutting Ground Zero), and now Michael Arad (designer of the memorial at Ground Zero) have become the architects of record in post-9/11 Lower Manhattan. I typically answer that, while I see no direct references to Jewish catastrophe in these designs for the reconstruction of Lower Manhattan, the forms of postwar architecture have surely been inflected by an entire generation's knowledge of the Holocaust.[6] After the Holocaust, artists and architects preoccupied with absence and irredeemable loss, a broken and irreparable world, have struggled to find an architectural vernacular that might express such breaches in civilization without mending them. Even if architecture is not a "Jewish art form" in its own right, as a discipline, it has certainly been shaped by Jewish experiences and history, by the Jewish identity of its practitioners.

The Jewish Museum in Berlin

It was with catastrophic timing that Berlin's first Jewish museum opened in January 1933, one week before Adolph Hitler was installed as chancellor. Housed in a series of refurbished exhibition halls at the Oranienburgerstrasse complex. which was already home to a spectacular synagogue as well as a Jewish community center and library, the Jewish Museum in Berlin opened quite deliberately in the

face of the Nazis' rise to power, with an exhibition of work by artists of the Berlin Secession led by the German Jewish artist, Max Liebermann.[7] It is almost as if the museum had hoped to establish the institutional fact of an inextricably linked German-Jewish culture, each a permutation of the other, as a challenge to the Nazis' assumption of an essential hostility between German and Jewish cultures.

But even here, the very notion of what constituted a "Jewish museum" would be a matter of contention within the community itself. Would the museum show art on Jewish religious themes by both Jewish and non-Jewish artists, its founders asked? Or would it show anything by Jewish artists? The question of what constituted "Jewish art" was thereby broached. Indeed, from the moment of its founding, questions of "Jewishness," "German-ness," and even "European-ness" in art exhibited by the museum began to undercut the case for something called a "Jewish Museum" in Berlin. So when the museum opened with a show of Max Liebermann's work in 1933, the very idea of a taxonomy of religious communities and their art seemed an affront to the most assimilated of Berlin's Jews.

The Jewish art historian and director of the Berlin Library of Arts, Curt Glaser, attacked both the idea of a "Jewish Museum" in Berlin and the presumption that Liebermann's work was, by dint of his Jewish birth only, somehow essentially Jewish even though there was nothing thematically Jewish in the work itself. Such an exhibition, Glaser wrote at the time, "leads to a split, which is totally undesirable, and from an academic point of view in no way justifiable. Liebermann, for example, is a European. He is a German, a Berlin artist. The fact that he belongs to a Jewish family is totally irrelevant with regards to the form and essence of his art."[8] Thus was an integrationist model for the Jewish Museum in Berlin first proposed and first challenged within days of the official opening.[9]

Despite constant pressure from the Nazis over the next five years, the Jewish Museum in Berlin went on to mount several more exhibitions of works by German-Jewish artists and their milieu. But with the advent of the Nuremberg Laws of 1935 defining "the Jew" as essentially "un-German," the Nazis effectively forbade all but Jews to visit the museum, and all but Jewish artists to exhibit there. With this sleight of legislative hand, the Nazis thus transformed the institutional "fact" of an inextricably linked German-Jewish culture into a segregated ghetto of art and culture by Jews for Jews. Moreover, since all "Jewish art" was considered "*entartete*" or decadent, by extension all art that was shown in the Jewish Museum was officially classified as decadent. Just as the Nazis would eventually collect Jewish artifacts to exhibit in a planned museum "to the extinct Jewish race," they turned Berlin's Jewish Museum into a de jure museum for *entartete Kunst*.

Whether assimilated to Nazi law or not, like the other Jewish institutions in its complex on Oranienburgerstrasse and throughout the Reich, the Jewish Museum

in Berlin was first damaged, then plundered during the pogrom on Kristallnacht, 10 November 1938. Its new director, Franz Landsberger, was arrested and sent to Sachsenhausen, before eventually emigrating to England and the United States. The museum itself was dismantled, and its entire collection of art and artifacts confiscated by Nazi authorities. After the war, some four hundred paintings from the collection were eventually found in the cellars of the Reich's former Ministry for Culture on Schlüterstrasse. According to Weinland and Winkler, the entire cache of paintings was seized by the Jewish Restitution Successor Organization (JRSO) and handed over to the Bezalel National Museum in Jerusalem, which would later become the Israel Museum.[10]

In 1988, after many years of debate over where and whether to reestablish a Jewish museum in Berlin, the Berlin Senate agreed to approve financing for a "Jewish Museum Department," which would remain administratively under the auspices of the Stadtmuseum, or Berlin Museum housed in the baroque Kollegienhaus on Lindenstrasse, but which would have its own, autonomous building. A prestigious international competition was announced in December 1988 for a project that would both "extend" the Berlin Museum and give the "Jewish Museum Department" its own space. According to planners, the Jewish department would be both autonomous and integrative, the difficulty being to link a museum of civic history with the altogether uncivil treatment of that city's Jews. Such questions were as daunting as they were potentially paralyzing: How to do this in a manner that would not suggest reconciliation and continuity? How to reunite Berlin and its Jewish part without suggesting a seamless rapprochement? How to show Jewish history and culture as part of German history without subsuming it altogether? How to show Jewish culture as part of *and* separate from German culture without recycling all the old canards of "a people apart?"

Rather than skirting such impossible questions, the planners confronted them unflinchingly in an extraordinary conceptual brief for the competition in which they literally became the heart of the design process. According to the text by Rolf Bothe (then director of the Berlin Museum) and Vera Bendt (then director of the Jewish Department of the Berlin Museum), a Jewish museum in Berlin would necessarily address three primary things: first, the Jewish religion, customs, and ritual objects; second, the history of the Jewish community in Germany, its rise and terrible destruction at the hands of the Nazis; and third, the lives and works of Jews who left their mark on the face and the history of Berlin over the centuries.[11] In setting forth these priorities, the authors of the conceptual brief also challenged potential designers to acknowledge the terrible void that made it so necessary for this museum to be installed. If in part their aim had been to reinscribe Jewish memory and the memory of the Jews' murder into Berlin's

otherwise indifferent civic culture, it was also to reveal the absence in postwar German culture which demanded this reinscription.

Most notably, in describing the history of Berlin's Jewish community, the authors made clear that not only were the history of the city and that of its Jews inseparable from one another, but that nothing (not even this museum) could redeem the expulsion and murder of Berlin's Jews—"a fate whose terrible significance should not be lost through any form of atonement, or even through the otherwise effective healing power of time. *Nothing in Berlin's history ever changed the city more than the persecution, expulsion, and murder of its own Jewish citizens. This change worked inwardly, affecting the very heart of the city.*"[12] In thus suggesting that the murder of Berlin's Jews had been the single greatest influence on the city, the planners also seemed to imply that the projected Jewish extension of the Berlin Museum might become the epicenter of Berlin's civic culture, a focal point for the city's historical self-understanding.

Guided by this conceptual brief, planners issued an open invitation to all architects of the Federal Republic of Germany in December 1988. In addition, they invited another twelve architects from outside Germany, among them the American Daniel Libeskind, who was then living in Milan. Born in Lodz, in 1946, to the survivors of a Polish-Jewish family largely decimated by the Holocaust, Libeskind had long wrestled with many of the brief's questions, finding them nearly insoluble at the architectural level. Trained first as a virtuoso keyboardist who came to the United States via Israel in 1960, he studied at Cooper Union in New York under the tutelage of John Hejduk and Peter Eisenman, two of the founders and practitioners of "deconstructivist architecture." Thus, in his design for a Jewish museum in Berlin, Libeskind proposed not so much a solution to the planners' conceptual conundrum as its architectural articulation.

Of the 165 designs submitted from around the world by the time the competition closed in June 1989, Daniel Libeskind's struck the jury as the most brilliant and complex, and quite possibly just as unbuildable. It was awarded first prize, and thereby became the first work of Libeskind's to be commissioned. As an example of process architecture, according to Libeskind, this building "is always on the verge of Becoming—no longer suggestive of a final solution."[13] In its series of complex trajectories, irregular linear structures, fragments, and displacements, this building is also always on the verge of unbecoming—projecting a breaking down of architectural assumptions, conventions, and expectations. His drawings for the museum thus look more like sketches of the museum's ruins, a house whose wings have been scrambled and reshaped by the jolt of genocide. Libeskind's investigations seemed to ask: if architecture can be representative of

Aerial view of the Jewish Museum Berlin, 1997. *Photo: Studio Daniel Libeskind.*

historical meaning, can it also represent un-meaning and the search for meaning? The result is an extended building broken in several places. The void straight line running through the plan violates every space through which it passes, turning otherwise conventional rooms and halls into misshapen anomalies, some too small to hold anything, others so oblique as to estrange anything housed within them. The original design also included walls inclined at angles too sharp for hanging or installing objects.

For Libeskind, it was the impossible questions that mattered most: How to give voice to an absent Jewish culture without presuming to speak for it? How to bridge an open wound without mending it? How to house under a single roof a panoply of diametric oppositions and contradictions? He thus allowed his drawings to work through the essential paradoxes at the heart of his project: How to give form to a void without filling it in? How to give architectural form to the formless and to challenge the very attempt to house such memory?

Exterior zinc facade of the Jewish Museum contrasts with the baroque facade of the adjacent Berlin Museum, 1997. *Photo: Bitter Bredt.*

Before beginning to work, Libeskind supplanted the very name used to describe the Senate's project, "Extension of the Berlin Museum with the Jewish Museum Department," with his own more poetic title, "Between the Lines." "I call it ["Between the Lines"] because it is a project about two lines of thinking, organization, and relationship," Libeskind wrote. "One is a straight line, but broken into many fragments; the other is a tortuous line, but continuing indefinitely. These two lines develop architecturally and programmatically through a limited but definite dialogue. They also fall apart, become disengaged, and are seen as separated. In this way, they expose a void that runs through this museum and through architecture, a discontinuous void."[14] Through a contorted and zigzagging lightning bolt of a building, Libeskind drove a void and unusable space that literally sliced through and beyond it. According to Libeskind, the extension was conceived "as an emblem where the not visible has made itself apparent as a void, an invisible. . . . The idea is very simple: to build the museum around a void that runs through it, a void that is to be experienced by the public."[15] As he makes clear, this void is indeed the building's structural rib, its main axis, a central bearing wall that bears only its own absence.

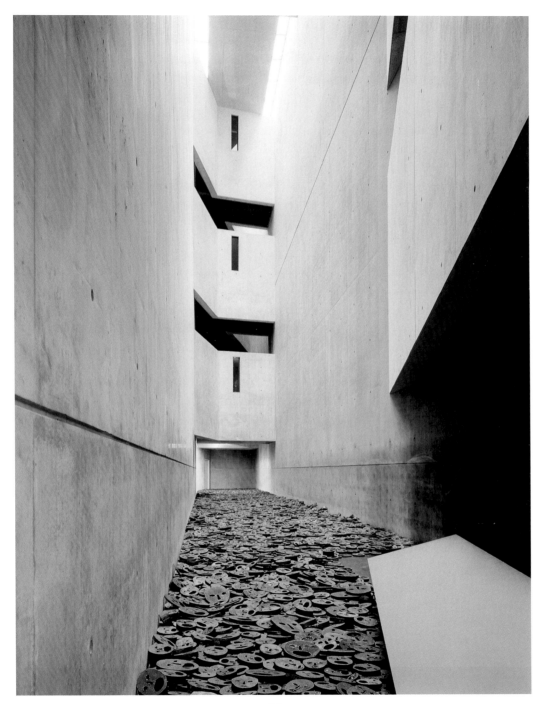

Bridges and voids of the interior. *Photo: Torsten Seidel.*

Indeed, as became clear in the public's first walk-through of the still-empty building in the late 1990s, it was not the building itself that constituted Libeskind's architecture, but the spaces inside the building, the voids and absence embodied by empty spaces: that which was constituted not by the lines of his drawings but by spaces between the lines. By building voids into the heart of his design, Libeskind thus highlighted the spaces between walls as the primary element of his architecture. The walls were important only insofar as they lent shape to these spaces and defined their borders. But ultimately, it was the void "between the lines" that Libeskind sought to capture here, a void so real, so palpable, and so elemental to Jewish history in Berlin as to be its focal point after the Holocaust—a negative center of gravity around which Jewish memory would now assemble.[16]

Implied in any museum's collection is that what you see is all there is to see, all that there ever was. By inserting architectural "voids" into the museum, Libeskind has reversed the terms of this museological assumption. What you see here, he seems to say, is actually only a mask for all that is missing, for the great absence of life that now makes a presentation of these artifacts a necessity. The voids make palpable the sense that much more is missing here than can ever be shown. As Vera Bendt aptly noted, it was destruction itself that caused the collection in this museum to come into being. Otherwise, these objects would all belong to living, breathing families; they would be installed in private homes, not the exhibition spaces of a museum. This is then an aggressively anti-redemptory design, literally built around an absence of meaning in history, the absence of the people whose lives gave meaning to these objects, and to their history.

But with its 30 connecting bridges, its 7,000 square meters of permanent exhibition space, 450 square meters of temporary exhibition space, and 4,000 square meters of storage, office, and auditorium spaces, the Jewish Museum Berlin occupies roughly three times the space of the Berlin Museum. Some have suggested that the Berlin Museum be allowed to spill into most of the newly available space, leaving the Jewish Museum Berlin the bottom floor only; others have suggested that the building in its entirety be designated the national "memorial to Europe's murdered Jews."[17] In any case, the attention this design has received since the museum was inaugurated in September 2001 has begun to generate a final historical irony. Where the city planners had hoped to return Jewish memory to the house of Berlin's own history, it now seems certain that Berlin's history faces the task of finding its place in the larger haunted house of Jewish memory. The Jewish extension to the Berlin Museum has become the prism through which the rest of the world will come to know Berlin's own past.

The Felix Nussbaum Haus in Osnabrück

Even though the Jewish Museum Berlin was Daniel Libeskind's first museum commission, it was not the first of his museums to be built. That was the Felix Nussbaum Haus in Osnabrück, Germany, proposed in 1995 and completed in 1998. Again, this began with a proposal for an extension to an existing museum, this time the Kulturgeschichtliches Museum, or Cultural History Museum of Osnabrück. Sharing the site with the 1888–89 building housing the Cultural History Museum was the Villa Schlikker of 1900–1901, which was appropriated as headquarters of the Nazi party from 1933 to 1945, today a museum of everyday life and culture, the House of Remembering. Libeskind's approach was to find a way to reconnect the town back to itself, to its history, its loss, the murder of one of its native Jewish sons, an artist, as emblematic of the larger mass murder perpetrated in Germany's name.

The discovery in the early 1970s of a trove of paintings by Felix Nussbaum, works produced in Berlin before World War II, prompted the small German industrial city of Osnabrück, his birthplace, to begin the process of establishing a permanent home for them. Nussbaum himself was barely known to the public until 1985, when New York's Jewish Museum presented a retrospective exhibition that traveled widely in Europe and Israel. Born in 1904 to a Jewish family in Osnabrück, Nussbaum enjoyed great success as a young artist, studying painting in Hamburg and Berlin before moving to Rome in 1932 when he was awarded the coveted two-year Villa Massimo Scholarship by the German Academy. By this time, Nussbaum had produced a remarkable body of self- and family portraits, landscapes, and city views, many of which were lost in a fire in his Berlin atelier in 1932 while he was living abroad.

With the rise to power of Hitler and the Nazi party in 1933, Nussbaum never set foot in Germany again. He was forced to move from Rome to Monte Carlo, then to Paris. In 1934, he and the love of his life, Felka Platek, the painter with whom he set off for Rome, were granted tourist visas to Belgium for the following year. They settled first in Ostend, then married in 1937 and moved to Brussels. He continued to paint, but his horizons had begun to narrow with the outbreak of war in 1939. With the German invasion of Belgium in 1940, Nussbaum was arrested and imprisoned at the internment camp at Saint Cyprien in the south of France. He escaped and made his way back to Brussels, but now had to go into hiding to avoid discovery by the Germans. His paintings of 1935 began to mirror his increasingly desperate and ever-more constrained circumstances. By the time of his second arrest by the Nazis and his eventual deportation to Auschwitz in 1944, Nussbaum had amassed an unparalleled

corpus of work which today is considered emblematic of the plight of European Jews during World War II.

"How does one express architecturally the aspirations, the realities, the despair of a Jewish painter from Osnabrück in those years ending in tragedy?" Libeskind asked in his 1995 project description for the museum. How to represent such a life in architecture? In a 1995 lecture titled "Museum without Exit," Libeskind answered by describing his design for a museum composed of three volumes, the German oak-clad Nussbaum House, the concrete Nussbaum Corridor, and the zinc-clad Nussbaum Bridge:

> The first is a very traditional wooden building which stands on the site in a special relationship to the old synagogue on Rolandstrasse, which was burned in 1938 [during Kristallnacht]. I made a kind of traditional wooden building for about 300 works painted in the 1920s and early 1930s. That wooden space is violently cut by a dramatic volume standing 11 meters high, 50 meters long: the *Nussbaum Gang* or corridor. It is only two meters in width, the narrowest volume that can be built as a public space under German regulations. It is made of concrete, has no windows of any sort. And there I proposed to show the works of Nussbaum created during his race through Europe. Whilst a fugitive, he lived in tiny rooms and painted in very close quarters. He could not stand back from the works to look at them. He painted in secret in a kind of delirium. . . . These paintings and drawings, sometimes created by [him] inches away, have only been viewed close up, never from some aesthetic distancing.[18]

There is a stark contrast between the Nussbaum House installation of paintings dating from before 1932, and Libeskind's concept for the Nussbaum Corridor, where he reproduced the claustrophobic quarters of the artist's own work space and the diminishing horizons experienced in his flight from the Nazis. This stark volume has the effect of forcing visitors to experience these paintings and the life they represent from an uncomfortably close, personal range. The Nussbaum Corridor funnels visitors into the museum's third volume, what Libeskind calls the *Nussbaum Brücke* or bridge, a long, zinc-clad building suspended aboveground and connected to the adjacent Cultural History Museum. In descriptions of the project, Libeskind wrote:

> This "bridge-building" houses the recently discovered paintings of Nussbaum, works from which even the signature of Nussbaum had been erased. The gallery spaces are on two levels opening from the corridor. The *Nussbaum Brücke* brings the past into the future, spanning the gaps and hollows traced by the two other building volumes. It physically connects Nussbaum to the Cultural History Museum. The *Felix-Nussbaum-Haus* incorporates not only the spirit of the artist, but also the physical and kinetic enclosure of the fragmented, broken, cut, light-dark world of Felix Nussbaum, the Jew, the painter, the Osnabrücker, the citizen of Germany and Europe.

Exterior of the Felix Nussbaum Haus, Osnabrück, 1998. *Photo: Bitter Bredt.*

Interior gallery space of the Nussbaum Corridor. *Photo: Bitter Bredt.*

The sequence of materials similarly reflects the stages of the artist's life: the native German oak of *Nussbaum Haus,* the blank of the concrete *Nussbaum Gang,* the cold metal cladding of the *Nussbaum Brücke* together represent the journey from Nussbaum's birthplace to a cold and indifferent exile, and back again. Where the installation abruptly ends on the second floor of the Nussbaum Bridge, Libeskind invokes the artist's thwarted path to safety and refuge, literally a life-path cut short. The rupture occurs where Felix Nussbaum Haus connects to the Cultural History Museum, in which Osnabrück's history is narrated and documented. Thus does Libeskind's building attempt to reincorporate the town's native son and artist into the town's history and memory, but also to represent by its spatial disjunctures the impossibility of completing that gesture—not unlike Libeskind's strategy for the Jewish Museum Berlin.

At its heart, this complex has no structural center of gravity, but is rather a loose aggregate of old and new buildings, linked but also separate. The complex is not legible from any single vantage point, being an ensemble of disparate parts that cohere only in the visitor's memory. This coherence is predicated on the power of the three volumes of Felix Nussbaum House to prevent the whole from falling apart. Libeskind sought to connect the two existing and three new buildings and simultaneously to evoke the lost life of an exiled son returned to his birthplace, a nation burdened with the indelible memory of its crimes—but always in a way that attempts and thwarts or renders impossible full reconciliation.

Here, in fact, Libeskind's architecture, like Nussbaum's paintings, expresses a resistance to classical notions of harmony and balance. The aggressively acute, almost jagged angles serve as reminders of senseless destruction and echo the artist's own increasingly anguished soul. Both the paintings and the spaces that contain them remain radically out-of-balance and jarring in their disharmonies. In such architecture, there is no pretense to the restoration of a ruptured civilization, by which the signs of death and destruction are rendered invisible.

In the Japanese tradition of *kintsugi,* broken crockery is repaired by using gold inlay or *urushi laquer* to make visible, even to highlight, the damage, which shows that a household object has lived, weathered life, survived, and wears its scars with dignity. In the artist Barbara Bloom's wise meditation on *kintsugi,* she describes how she was "struck by the beauty of an accepted and accentuated imperfection with no attempt to cover up damage or disappear history."[19] As an aesthetic strategy, privileging the visibility of a repair rather than repressing it seems to be a gesture that embraces life in all of its dislocations and breaches and offers the redemption of destruction through beauty. Our post-Holocaust eyes see only the irreparability of the Holocaust, the irredeemable destruction of Europe's Jews, the forever shattered vessel. Any attempted repair must make itself

felt as pain and breach. It is a subtle difference, but one Libeskind has navigated very deliberately: how to reveal the break without appearing to mend it, how to give form to brokenness without beautifying it, how to articulate loss without filling it in. How to acknowledge the brokenness in life and the beauty of its attempted repair, which makes life ongoing?

The Danish Jewish Museum

Throughout Europe, where vibrant Jewish communities have lived for centuries, there are only museums to their destruction. And although museums dedicated to the memory of the Jewish past have come into being to tell the stories of those communities, in countries where few Jews survived, they may also constitute the only remaining Jewish presence. Theodor Adorno's melancholy observation that "the German word *museal* . . . describes objects to which the observer no longer has a vital relationship and which are in the process of dying" seems all too apt a description of Jewish museums in Europe.[20] Premised as they are on the violent extirpation of Jewish life on European soil which reduced a thousand-year-old civilization to a few scattered artifacts, these museums indeed view the Jewish past through its broken vessels.

The exception that seems to prove this rule, of course, is Denmark, whose mobilization to rescue its Jewish citizens from Nazi capture and deportation still serves as a beacon for what "might have been done" anywhere else. Tipped off in the last days of September 1943 that the Nazi SS were about to begin a roundup of Denmark's 8,000 Jews, local Danish and Jewish resistance organizers under the umbrella of the Danish Freedom Council evacuated all but 485 Danish Jews from their homes. By the time the Germans began their sweep on the night of October 2, 1943, most of Denmark's Jews had been secretly shuttled to the coast, where Danish fishing boats ferried them, making some seven hundred voyages back and forth, to Sweden, where they were given refuge. Denmark's four-hundred-year old Jewish community, long-integrated into Danish society, was thus preserved in one of the most stunning humanitarian operations of World War II.[21]

Though the rescue of Danish Jewry occupies a singular place in Holocaust and European Jewish history, it was never intended by the founders of the Danish Jewish Museum to be a locus for housing the culture, art, and history of Denmark's Jewish community. In fact, the idea of a Jewish museum in Denmark had been bruited about for nearly a century, and several exhibitions of art and artifacts from the Royal Library's mammoth and well-preserved collections of Judaica were mounted between 1908 and 1984, when the present museum was first proposed by the Society for Danish Jewish History. Several possible locations for

the Danish Jewish Museum were discussed. One of the founding board members suggested the soaring vaulted spaces of the sixteenth-century Royal Boathouse in Copenhagen, originally built to store the Royal Navy's fleet, but mainly used as a storehouse for cannons until 1902, when its upper floors were removed and the vaulted ground floor was incorporated into the Royal Library. The Danish Ministry of Culture and the Royal Library agreed, and granted tenancy to the newly constituted Danish Jewish Museum, allowing it to occupy two of the building's five vaulted bays.

It was with this maritime history in mind that Daniel Libeskind accepted the commission of the Danish Jewish Museum in the early 1990s. Several of Denmark's schools of architecture as well as the Royal Danish Academy of Fine Arts had already invited Libeskind as a visiting professor. Thus, he was already known and admired by the museum's founding board when they invited him to design the new Danish Jewish Museum. It was also clear to him that the site was perfect in both its location and its maritime references, which for him resonated most poignantly with the boat rescue of Denmark's Jews during World War II. As Libeskind has explained in his text describing the design process, because this extraordinarily great deed distinguishes Denmark's past and present from other European Jewish histories, the "organizing principle" of Danish Jewish Museum is the concept of *Mitzvah*—the Hebrew word meaning "a fundamental good deed." While most of what "happens" in Libeskind's design takes place inside the exhibition halls, which are "both written and read like a text within a text within a text," invoking the structure of the Talmud, whose central text is surrounded by layer upon layer of intertextual commentary, he also talks about its "urban and architectural aspects," how it ties the adjacent Black Diamond, the new library building completed in 1999, to the old Royal Library building by activating the pedestrian walk along the former Victualing Yard or Proviantgarden in the interior courtyard of the Royal Library, where, for Libeskind, "water and a symbolic rowboat dramatically speak to the uniqueness of the survival of the Danish Jewish community."[22]

In stark contrast to the broken paths, interrupted narratives, and dead ends that characterize his Jewish museums in Berlin and Osnabrück, Libeskind strove to make the organization of artifacts and the visitor's path "seamless," invoking the fundamental integration of the Danish Jewish community into its larger cultural and urban surroundings. However, despite its "seamless" narrative structure, Libeskind's Danish Jewish Museum nevertheless surprises visitors as they traverse its highly idiosyncratic matrix of four slightly sloping floor planes (not unlike standing on a ship moving through rolling waves), which are bathed in angled deltas of light—all penetrated by a unifying "virtual plane" that becomes

Exterior of the Danish Jewish Museum, Copenhagen. *Photo: Bitter Bredt.*

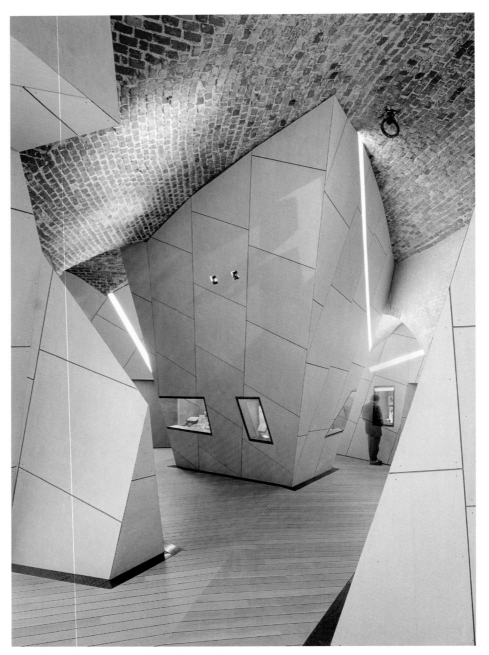

Interior exhibition space. *Photo: Michele Nastasi.*

actual surface for exhibition purposes. Libeskind has noted that this is a "visual vector that extends the visitor's experience beyond the walls of the museum:" in this sense, the entire sensory and spatial experience of the museum is conceived as seamless and surprising, a fitting counterpart to the history of Denmark's Jews. This is an architecture of discovery—framed, and thus informed, by the history of a seafaring people, and by the memory of an astonishing sea rescue that has resulted, over all these many years, in an unbroken chain of Jewish life, culture, and art in a small Scandinavian country where Jews have long been at home.

The Contemporary Jewish Museum of San Francisco

Libeskind's Contemporary Jewish Museum marks yet another shift in the paradigm of Jewish museums. From the time of its founding in 1984 as the Jewish Community Museum, later renamed the Jewish Museum San Francisco, it has hosted dozens of original and traveling exhibitions of Jewish art and culture as well as other types of events and programming. Without a permanent collection of art or artifacts to weigh it down, it was always "of-the-moment"—even when its shows examined the Jewish past. For a brief period in the early 1990s, the Jewish Museum San Francisco merged with the Judah Magnes Museum in Berkeley, with its extensive collection of Judaica from California and the American West. The two institutions eventually separated, and the Contemporary Jewish Museum (CJM) emerged, affirming in its new name the mission of a museum dedicated to the Jewish present. Without a permanent collection to house, to cultivate, or to influence the nature of its programming, the CJM regained its identity as an institution ever responsive to its place in the cultural dialogue between Jewish and non-Jewish worlds. In its celebration of this contemporary give-and-take, it would eventually affirm its core identity as a space for contemporary Jewish life.

In 1995 the city of San Francisco awarded the museum one of its prized landmark buildings, the 1881 Jessie Street Power Substation, renovated in 1906 by Willis Polk. Proposing this site in the heart of the Yerba Buena redevelopment district, which was fast attracting other cultural institutions, in the vicinity of the soon-to-be-completed Museum of Modern Art and the evolving Moscone Convention Center, city planners could not possibly have known at the time that they would receive such a gem of a building in return. Guided by clear-eyed recommendations for the preservation of a highly admired building in the tradition of the City Beautiful movement, which aimed "to transform utilitarian structures into handsome civic ornaments," the museum's building committee decided right at the start that this was going to be something new from something old.

In fact, the museum was awarded the landmark building at least partly because planners recognized that its central mission was to preserve the past and assimilate it to the present, thereby bringing it back to life. In the words of one of its earliest drafts, the museum's Architectural Building Program suggested that "the idea of 'dialogue' plays an important role in Jewish culture; it is the mode of narration of the Bible—the dialectic between man and God. . . . Spaces which evoke dynamic tension, which contain inter-playing forms, which convey the distance and connection of the earthly and spiritual—all these might reflect the 'dialectic.' The inter-relation of creator and creation / artist and art is another manifestation."[23] With the preservation philosophies of both the museum and the city in such accord, it seemed like a perfect match. Three years later, in 1998, Daniel Libeskind was awarded his first American building commission.

The Jessie Street Power Substation was not, in fact, preserved in its entirety, but the shell and a number of other features were restored or adapted—in particular, the aspect that architectural historians such as Paul Turner have regarded as the most brilliant feature of the building: its great south-facing facade, "the wall." As Turner made clear in his 1974 report on the architectural significance of the building, the original commission's call "for a large simple mass and unencumbered wall-surfaces gave Polk the perfect opportunity to concentrate on an eminently Classical problem: the design of a wall, as an abstract and highly sophisticated composition of architectural elements."[24] With its "large arch, the seven elegantly detailed windows at the right, the smaller doorway with its consoled entablature supporting a sculptural grouping of *putti* with garlands, the cornices and dentil-courses at the top of the façade, and the expanses of the plain brick wall itself," Turner concluded that Polk's facade "could be thought of as an excellent case-study of the monumental possibilities in the design of a mere wall." The building was deemed worthy of preservation not owing to the memory of its function as a power plant, but because it embodied so exquisitely the City Beautiful credo of that era. Polk's south facade had come to represent an architectural moment of awakening, a civic impulse to turn all buildings—no matter how utilitarian—into beautiful objects.

Quoting a Getty Conservation Institute report published at about the same time that the Jessie Street Power Substation was granted to the museum, the building committee expressed their thinking about preservation issues: "We would not have the monument of old but a monument that emerges anew—an independent architectural expression, even if fragmentary, that respects the basic integrity of what the past has handed down to us."[25] According to the structure report on Polk's facade, as difficult as it may be to integrate a monumental relic

into a new building, the possible rewards are great. Here again the museum cited the GCI report to make their case:

> It is a matter of giving back to the object or to the architectural element to be restored not only a worthy physical context, but a figurative context—no longer the original one that is lost or irrecoverable, nor the atrophied and incomprehensible one of a too-badly damaged image. The new context has to derive from placing the object in a new 'artistic work', so the object becomes part of the structure into which it is inserted, by maintaining an independent legibility and by joining with other new elements. . . . The result would certainly be a different image, and not a substitute for the lost original. It would be a redesigned image with the existing remains used and reinserted next to new elements, creating a figurative 'circuit'. We would not have the monument of old but a monument that emerges anew—an independent architectural expression even if fragmentary, that respects the basic integrity of what the past has handed down to us.[26]

As becomes clear when standing in the plaza facing the wall, both the museum's building committee and the architect took these ideas to heart. The wall maintains both an "independent legibility" and "emerges anew"—even as it serves formally as both screen and gateway for Libeskind's new building.

I wondered if this wall was what attracted Libeskind to the site in the first place. He admitted that it was part of the attraction, especially as an abstract form that could both join and divide, hide and reveal. And what about its origin as an exemplar of the City Beautiful movement? I asked. What would it mean to preserve it as a remnant of another time altogether? This, too, he thought was intriguing. In Jewish tradition, after all, attention is paid to remnant walls (think of the Western Wall in Jerusalem). Indeed, it was while Libeskind was designing the CJM in its relation to Polk's south facade that he was suddenly pulled into a new project as master designer of the new World Trade Center complex after 9/11. One of the most powerful elements of his winning design for the Freedom Tower and "Memory Foundations" was his commitment to preserve and prominently feature the slurry walls of the World Trade Center site, to remember how they held back the harbor waters despite the mammoth collapse of the towers. Derisively called a "wailing wall" by Rafael Viñoly during the presentation of his and Libeskind's site plan proposals for Lower Manhattan, the focus on the wall and all its traditional, literal, and figurative echoes made perfect sense to Libeskind at the time. Whether consciously or not, the architect's preoccupation with the idea of the wall has informed both projects—as different as they are.

In his review of Libeskind's early scheme for the Contemporary Jewish Museum, Nicolai Ouroussoff wrote, "Rather than try to smooth over the forces that shape a modern metropolis, [Libeskind's building] seeks to express them in

architectural form."[27] That is, even the messiness of urban renewal is given formal recognition here. In words that echo the very mission of the CJM, Libeskind has commented that "no one can survive isolated from the culture that surrounds them." Moreover, by proposing a design that tucks his building behind the existing facade, into a small space, making no attempt to dominate surrounding buildings, Libeskind has taken what could have been just another constraint, the lack of space in a dense urban site, and made of it a benevolent gesture to the building's neighbors. In this vein, Ouroussoff also pointed out that the decision to preserve the original shell and facade of the Jessie Street Power Substation loads the museum with multiple meanings, a parable for aspects of the modern Jewish condition: "The desire to conform to existing conditions and rebel against them can be read as a metaphor for the Jewish struggle with issues of identity and assimilation."[28]

The result may be Daniel Libeskind's most self-effacing but most "neighborly" building yet. Make no mistake, it is audacious in its angled and animated exterior planes, very much its own jewel in the urban firmament. But it is also under-stated, content in its relatively small scale, dwarfed by the Four Seasons Hotel abutting its north side, and partially hidden by the historic red-brick walls out of which it peeks, almost as if the earth buckled and pushed up a polished and faceted blue-steel gemstone. As a diamond is produced by the super-compression of gigantic earth forces, this gem of a building emerges from what the architect calls "the energy of a complex urban center."

Because of its location, tucked tightly behind the brick facade of the former power substation and wedged against the Four Seasons Hotel next to a pedestrian passageway and across from what will be the Mexican Museum, the CJM is not wholly visible from anywhere but seen from everywhere in context with its neighbors. As a model for Jewish integration, the building and its location speak volumes. In other words, it is not part of the San Francisco skyline, but more a treasure tucked into a pocket of Yerba Buena's museum district. Conversely, its interior sight lines take in nearly every gallery, window, and wall of the museum. It is, in effect, a self-effacing building that brings its surroundings inside, rather than projecting itself front and center onto the city's architectural stage.

Referring to its tight quarters, the architect remarked that "there's almost no space for this building," and he's right.[29] The building's space is all on the inside, looking out at its urban surroundings: St. Patrick's Catholic Church, the Martin Luther King Memorial, the pedestrian walkway, the future Mexican Museum, and the Yerba Buena Gardens across the street. The historic facade functions as a portal into the museum's inner space, where life, culture, and memory are lived.

When viewed from the plaza on the site's south side, the wall functions as both scrim and portal, creating the illusion of a relatively modest exterior housing an enormous set of interior galleries.

At first glance, the core gallery seems to echo the jagged lines and angles that slice through the galleries of the Jewish Museum Berlin. But as Ouroussoff points out, "Internal terraces are cut out of the upper portion, allowing you to see into the entry hall and visually linking past and present." That is, these jagged cuts and angles create and open up volume, unlike the slashing voids designed to interrupt and cut off any open, narrative flow in the Jewish Museum Berlin, constant reminders of the historical breach of the Holocaust.

In stark contrast to the interrupted and occluded sight lines of the Jewish museums in Berlin and Osnabrück, almost every place in the interior of the CJM is visible from any other place. All can be seen at once as an integrated and transparent whole, with unobstructed sight lines. Unlike the explicitly Holocaust-inflected museums of Berlin, Osnabrück, and to a lesser extent, Copenhagen—which are cut through with sharp angles, architectural gestures that invoke violent deeds—San Francisco's Contemporary Jewish Museum is designed as an unbroken or "whole space." Whereas the signature features of his previous Jewish museums have been what one critic called the "absence of rectilinear space, [t]he anonymous box replaced by colliding forms, tilted floors, and canted walls," the most significant element of the CJM may be the fluid openness created by still-angled but now voluminous gallery spaces that all connect and flow into one another.[30]

As such, it becomes a spatial metaphor for the integration of Jewish and non-Jewish cultures and the free exchange between old and new. In its outward-looking spaces, the CJM reminds us that Jewish culture is always produced in dialogue with surrounding cultures, just as surrounding cultures have always been constituted in their exchanges with Jewish culture. In this view, Jewish culture is constantly created in the reciprocal exchange with other cultures, rather than in a hermetically sealed monologue with itself. By letting in the light of its surroundings, the CJM is vivified and sustained by exchange with the community as much with as its architectural neighbors.

In his review of the Contemporary Jewish Museum in *The Forward,* Gabriel Sanders aptly cited a groundbreaking sociological study by Steven M. Cohen and Ari Kelman describing the current mind-set of young, largely unaffiliated Jews. "From our interviews with Jewish young adults," Cohen and Kelman reported, "we learned how 'engaged, but unaffiliated' Jews seek cultural experiences that offer alternatives to an institutional world they see as bland, conformist,

conservative and alien. Instead, they are drawn to events that promise to cross boundaries between Jews and non-Jews, Jews and Jews, Jewish space and non-Jewish space, and distinctively Jewish culture with putatively non-Jewish culture, effecting a 'cultural hybridity'."[31] In this extraordinary statement, they captured the goal of the museum, which is to offer space where Jewish and non-Jewish cultures coexist, reciprocally nourish, and inspire one another. Rather than definitively resolving the issue of what constitutes Jewish art, the CJM becomes a space where both Jewish and non-Jewish visitors ponder the question. In its first show, organized around the book of Genesis, Jewish and non-Jewish artists were invited to explore their relations to what might be regarded as the Jewish ur-text.

With the mandate to design a museum focused on Jewish life and culture in the present, rather than the past, Libeskind has incorporated into the design two Hebrew letters, *chet* and *yud,* which make up the word for life, *chai*—expressing through these abstractions the spirit of life lived in the present moment, inflected (but not oppressed) by memory of the past. The life of this building does not depend on the symbolic significance of the Hebrew letters; rather, the letters animate the spaces which are themselves designed for life. "In the Jewish tradition," Libeskind reminds us, "letters are not mere signs, but are substantial participants in the story they create."[32]

In this case, of course, it is their literal spatiality that bestows meaning on the kind of story being told. As Libeskind explained in his description of the project, "the *chet* provides an overall continuity for the exhibition and educational spaces, and the *yud* . . . gives a new identity to the Power Substation." The *yud* is, of course, the flying first letter of the sacred tetragrammaton (YHVH)—the unutterable name of God and the last letter in the Hebrew word for life (*chet-yud*). According to the philosopher Eliott Wolfson, "The image of the *yud* in the brain to symbolize the attribute of wisdom set in the middle and encompassing everything is found in the commentary of Sefer Yesirah that preserves the teachings of Isaac the Blind."[33] In the context of Libeskind's new building, the *yud* actually lodges its wondrously voluminous and tranquil space within the minds of those inside it. It is as if the smallest letter of the alphabet has been miraculously inflated, expanded into the largest single space in the museum, an open space inviting near-mystical contemplation and wonder.

Just as sometimes a poem isn't all about meaning but about sound and sense, space and the inward search for meaning, Libeskind's architecture is not just about housing life or culture, or even about making life and culture meaningful. It is also about making space in which we find ourselves unexpectedly transported, without ever leaving; it reveals juxtapositions of time and space, and generates visual dialogues we have never before seen or imagined.

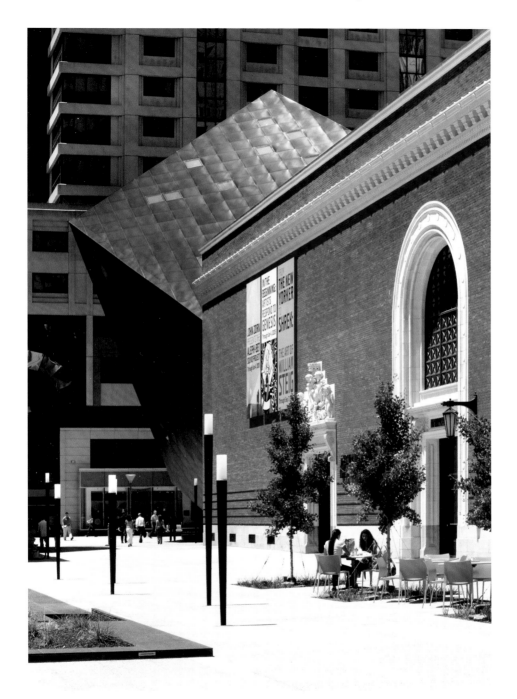

Exterior of the Contemporary Jewish Museum, San Francisco, looking west toward the *yud*.
Photo: Bitter Bredt.

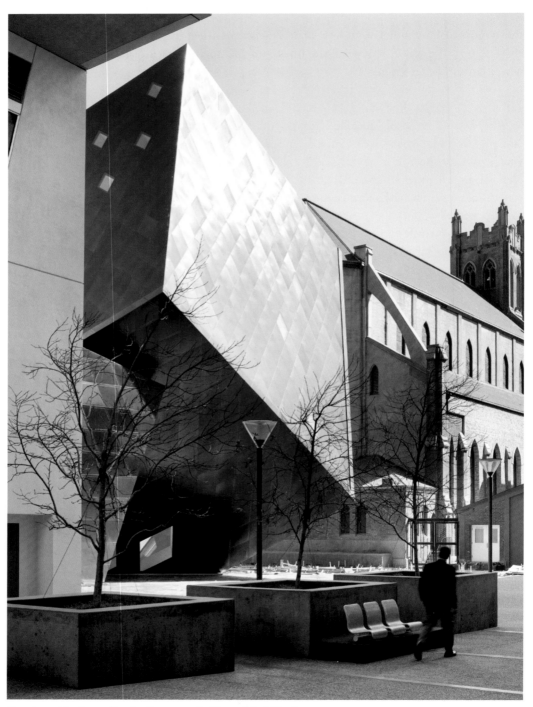

Exterior with the *yud* in the foreground. *Photo: Mark Darley.*

Daniel Libeskind's Jewish museum designs, to my mind, signal a return to the conceptual religious foundations of Jewish architecture. With his formal emphasis on the spaces "between the lines," on the opening of internal volumes where communities gather to explore cultural expression, the architect reinforces Judaism's starting point for sacred space, the minyan, or quorum, of ten Jews gathered to pray, rather than a building in and of itself.[34] Likewise, as the architectural historian Carol Herselle Krinsky reminds us, "the very word *synagogue* comes from the Greek *synagein,* to bring together."[35] That is, just as a prayer minyan turns any space into Jewish sacred space, akin to the Temple of Jerusalem, "Jewish architecture" is rooted in conceptual space, constituted not by formal structural elements, walls and cornices, but by what goes on within the volume of that space.

Moreover, Krinsky notes, even the Temple of Jerusalem is figured in the Bible both as a physical place and more abstractly as a space carried within oneself: "When the captives mourned their loss of the Temple [in Jerusalem], the prophet Ezekiel consoled them with the words that the Lord had spoken to him: 'Thus says the Lord God: Although I removed them far off among the nations, and although I have scattered them among the countries, yet have I been as a little sanctuary in the countries where they are come.'"[36] Though Jews may build sacrificial shrines to imitate the lost one in Jerusalem, according to Krinsky, "spiritual sanctuary" was always more an abstract figure than a literal building, carried in the hearts and minds of the faithful. In this view, God's sanctuary is carried within Jews who keep faith, embodied by the assembly of prayer—not by the house in which they profess such faith.

In this light, Jewish architecture is less about the building's space in the landscape and more about the space such buildings open up inside us for prayer and contemplation, for our individual contemplation of the Jewish relationship to God, life, history, culture, and identity. Jewish architecture consists of this exchange between Jews and the buildings they inhabit, not in a particular building design. As such, Jewish architecture remains unfixed, underdetermined, contingent on new times, inhabitants, meanings, and uses. In the absence of the vitality and memory of Jewish lives that have inhabited it, however, Jewish architecture can also revert to the status of monument only—ossified in time and space, without Jewish meaning.

Women forced to pose before being shot, Liepaja, Latvia, December 15–17, 1941. *Photo: USHMM.*

3

Regarding the Pain of Women

Gender and the Arts of Holocaust Memory

My title is a deliberate variation on Susan Sontag's *Regarding the Pain of Others*. I mean this both as a homage to Sontag and as an extension of her searing critique of war photography and its reflexive objectification of suffering, its conversion of victims into objets d'art. But why, in particular, the pain of women Holocaust victims here? Because we have finally begun to amass a large and profound critical literature on gender and the Holocaust, which alongside Sontag's work on photography, might now help us look at how and why the public gaze of photographers, curators, historians, and museum-goers continues to turn women into objects of memory, idealized casts of perfect suffering and victimization, even as emblematic of larger Jewish suffering during the Holocaust.

Here I explore our relationship to these hardened idealizations of women in the arts of Holocaust memory, for I have found that in "regarding the pain of women," we often split these women off from their own lives and deaths, their own stories and experiences. We may hold the pain of women in high regard, perhaps, but when we regard it, we also find spectacle in it, converting their suffering into cultural, even psychological objects around which we tell our own stories, find large meanings, fixed and full of symbolic portent. As a result, particular parts of women's experiences as women remain unexpressed, unregarded, and even negated. Moreover, as objects in museums necessarily fix otherwise fluid and changing life into emblematic illustrations of their explanatory theses, I find that these idealized icons of victimization, innocence, or even resistance come to substitute for the stories women might be telling about themselves. They serve as fixed objects around which other survivors' stories are told, around which cultures and nations may even tell their own stories. But there are stories about women in the Holocaust, and there are stories the women have to tell. Too often,

our stories about these women have left no space for the stories women have to tell, stories which seem to have no place in the fixed field of the Holocaust canon.

The problem is that the actual experiences of women—as told by the women themselves—are often on being regarded converted almost immediately into symbolic significance, or are hardly regarded at all. Feelings of helplessness, vulnerability, and physical torment are often masked immediately by the icon of resistance, of heroism, or of martyrdom (think of the photograph of Mariya (Masha) Bruskina being hanged as a partisan in Minsk, of Hannah Senesh as heroic paratrooper, or of Anne Frank as universal beacon of hope, according to her father Otto Frank's protective editing of his daughter's diary). Once objectified, the pain of these women assumes iconic proportions, which is to say a completely overdetermined meaning. Though the scholarship of numerous critics and historians has effectively debunked the taboo of gender-based study of the Holocaust, the absence of women's voices and their experiences as women is still all too emblematic of the ways gender and sexuality have been split off from Holocaust history and memory.[1]

The question is: Do we actually ever see the pain of women, or do we see only our own reflections in the shiny veneer of women as symbols of resistance, of innocence, of regeneration? Toward what end do we regard, represent, or even reproduce the pain of women in the Holocaust? To show how evil the Nazi killers were? To show how innocent the victims were? To strive to abolish such suffering altogether, as Susan Sontag would suggest?[2] To the extent that all photographs objectify, in Sontag's words, turning their subjects into objects which can then be owned and made meaningful by those who "own" them, how should we now regard them?

As Jews were culled from the general population for "special handling" by the Nazis, Jewish women were further singled out from among Jewish prisoners for a kind of "priority" special handling. As the bearers of the next generation of Jews, they were murdered both as Jews and as biological carriers of the Jewish race. As Jews were singled out for total annihilation, women among the Jews were singled out to be killed first and in greater numbers and proportions than men, for reasons articulated most chillingly by the Nazi leadership itself. In the words of Heinrich Himmler, women were to be accorded special treatment, that is, killed without delay, in order to "obliterate the biological basis of Jewry." Or as described in the Wannsee Protocol, women and children had to be killed in order to eliminate "the germ cell of a new Jewish revival." Or in the words of Otto Six of the Reich Security Central Office (RSHA), to "deprive Jewry of its biological reserves." It was with all this in mind that Himmler elaborated what he called the "logic" of killing women and children during the Einsatzgruppen actions in the east:

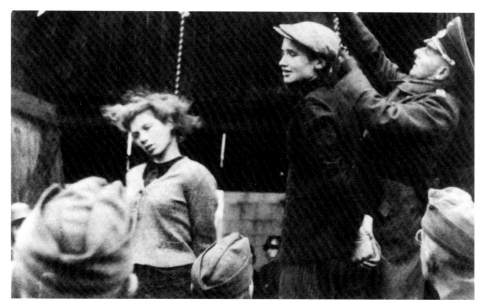

The German execution of Mariya (Masha) Bruskina in Minsk on October 26, 1941. Referred to officially in Soviet texts as "the unknown girl," she was remembered for decades after the war as a seventeen-year-old Soviet Communist partisan who helped injured Soviet soldiers escape hospital captivity. She was identified in the 1960s by name and as a Jewish member of the Minsk resistance. In 2009, she was identified on a plaque near the site of her execution as M. B. Bruskina, hanged as a Soviet patriot by the Fascists. Eventually, a monument was erected in her honor in Kfar Hayarok in Israel, and a street was named after her in Jerusalem. *Photo: RIA Novosti.*

The sign Masha Bruskina was forced to wear read (in German and Russian): "We are partisans who shot at German soldiers." *Photo: RIA Novosti.*

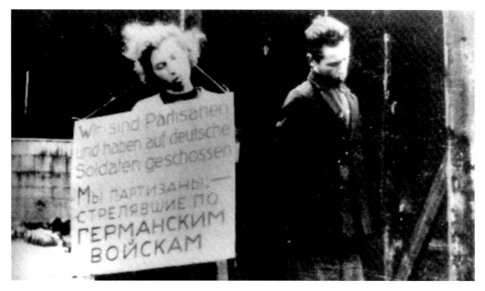

When I was forced in some village to act against partisans and Jewish Commissars . . . then as a principal I gave the order to kill the women and children of those partisans and Commissars, too. . . . Believe me, that order was not so easy to carry out as it was logically thought out and can be stated in this hall. But we must constantly recognize what kind of primitive, primordial, natural race struggle we are engaged in.

We came to the question: what about the women and children? I have decided to find a clear solution here, too. In fact, I did not regard myself as justified in exterminating the men [only], while letting avengers in the shape of children . . . grow up. The difficult decision had to be taken to make this people disappear from the face of the earth.[3]

That is, built into the Nazi genocide of the Jews was the gender-specific mass murder of Jewish women, deemed the procreators of the Jewish race, a predicate of the genocide. In fact, this is where, I believe, gender and sexuality are split off together from the larger history of the Holocaust, from the larger reservoir of collected memory. Whereas the women's sexuality played a paramount role in both the Nazis' rationale for their mass murder and in the specific ways women were degraded, humiliated, and violated as women, there was almost no parallel experience in the stories of Jewish men at the hands of their captors. Men and women shared stories of resistance, deprivation, pain, starvation, deportation, separation from families, and mass murder. But they did not share stories of sexual exploitation, violations of religious modesty and decorum, of rape, of childbirth, or abortions—none of which had a place in traditional histories of the Holocaust until pioneers such as Joan Ringelheim pointed out what she called the "split between gender and genocide."[4]

Just as starvation, beatings, and dehumanization were part of all the prisoners' experiences, so were rape, threats of rape, sexual humiliation, and childbirth also part of the female victims' experiences. Without a place or conceptual framework for such memory, as Ringelheim suggests, these experience are almost never voiced.[5] In fact, it is often this voicelessness itself that endures as a theme in art and writing about the Holocaust.

Sometimes, as in the case of Pauline, from Ringelheim's early oral archives, it is the survivor who splits the sexual abuse she suffered during the Holocaust (in hiding, in this particular case) from what she came to regard after the war as "acceptable" Holocaust history. After relating in uncomfortable detail instances of being molested by the men and boys who were also hiding her from the Nazis, Pauline asked her interviewer, Ringelheim, a question: "[In light] of what happened, [what] we suffered and saw—the humiliation in the ghetto, seeing our relatives dying and taken away . . . seeing the ghetto burn and seeing people

jumping out and burned—is this [sexual abuse] important?" Or as Ringelheim asked, "Was this part of her story also a part of the Holocaust story?" Ringelheim answers aptly, I think, that for Pauline and many other women, memory itself had been split between "traditional versions of Holocaust history and her own experience." [6]

But in other cases, it is the readers and editors of a work, like Anne Frank's diary, who do the splitting for their own related reasons. "The Diary of a Young Girl," as the world came to know Anne Frank's diary from the annex in the early and mid-fifties, was in fact the literary creation of a devoted and grief-stricken father trying to salvage universal meaning from his daughter's death in Bergen-Belsen.[7] As a loving and protective father who could not ultimately protect his family from the wrath of the Nazis, Otto Frank finally sought to protect all that remained of his second daughter—that is, her image, her diary—from all impertinent readings, editing out all references to fights with her mother, her sexual awakening, her own grave and profound doubts about her fate. In effect, his preservation of her memory and her diary was inseparable from the solace and hope he needed to find in her memory and diary. Otto's version ensured that the diary of a young woman coming of age would remain "the diary of a young girl"—his little girl, whom he could not protect, but whose memory he now protected so ferociously.

As the unexpurgated, critical edition of Anne Frank's diary reveals, the early published version of the diary, as well as stage and film spin-offs, were less historical documents of Anne's inner-life and more the testament to the universal values of hope and tolerance idealized by Anne's father.[8] Unlike, say, Ruth Kluger's unremittingly frank remembrance of her own "Holocaust girlhood,"[9] a period of intense feelings for and conflict with her mother and father, there was no space in Otto Frank's story of his daughter for the parts of her story that did not accord with his own highly idealized remembrance of his family and his own need to fix her diary as a beacon of hope. There was also no place for Anne's early sexualization in her father's nonsexual remembrance of her. But it is also true that Otto merely did for Anne what many female survivors often did for themselves: in Ringelheim's terms, he split off her necessarily gendered experiences from the universally idealized notion of her martyrdom. In Otto's case, it may also have been a matter of splitting off Anne's sexual experiences from the rest of her reflections as a way to preserve, even instantiate the ideal of the presexualized child as innocent victim, an image meant to stand in for the innocence of all Jewish victims.

Nor is Otto Frank the only father and husband in the literature to substitute his story for that of a lost loved one. Indeed, some of the most interesting

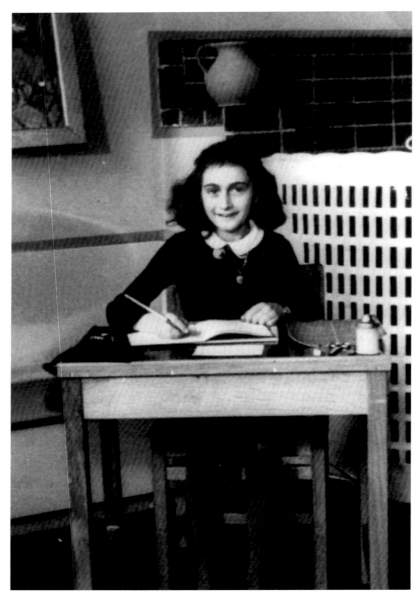

Anne Frank at her writing desk. *Photo: Universal History Archive / Universal Images Group / REX.*

portrayals of women are the "missing" or absent voices of women and their stories, the ways they are either blocked or expurgated, shown as missing—thereby assigning significance to the silence or absence. In *Maus: A Survivor's Tale,* Art Spiegelman shows both the voicelessness of his mother and the ways he and his father have collaborated to fill her absence with their own words—the ways his father would in speaking about her also presume to speak for her. Having destroyed her notebooks in a fit of grief and sadness, Spiegelman's father, Vladek, would now fill the space left behind with his own story.[10]

In fact, Art's own story might even be said to begin literally on the premise of his mother's missing and longed-for voice. Where should Vladek begin his story, he asks his son. "Start with Mom," Art coaxes. The entire subsequent cotelling is basically structured around the missing mother, as Nancy Miller has pointed out.[11] And then, by making the recovery of the story itself a visible part of *Maus,* Spiegelman can also hint darkly at the story not being recovered here, the ways that telling one story always leaves another untold. In Spiegelman's case, this deep, unrecoverable story is his mother's memory of her experiences during the Holocaust. Vladek does not, cannot volunteer this story. It takes Artie to ask what Anja was doing all this time. "Housework . . . and knitting . . . reading . . . and she was writing always in her diary," Vladek answers. The diaries did not survive the war, Vladek says, but she did write her memoirs afterward. "Ohmigod! Where are they? I need those for this book!" Artie exclaims.[12] Instead of answering, Vladek coughs and asks Artie to stop with the smoking. It's making him short of breath. What seems to be a mere interruption turns out to be a prescient delaying tactic. Vladek had, after all, burned Anja's memoirs in a fit of grief after her suicide. Was it the memory of smoke from the burned memoirs or Artie's cigarettes that now made him short of breath?

At the end of the first volume, Spiegelman depicts the moment at which his father admits not only destroying his mother's memoirs but leaving them unread. "Murderer," the son mutters. Here he seems to realize that his father's entire story is haunted by Anja's lost story. But worse, it dawns on the son that his entire project may itself be premised on the destruction of his mother's memoirs, their displacement and violation. "I'll tell it for her," says the father.[13] Spiegelman does not attempt to retell Anja's story at all, but leaves it known only by its absence; he is an accomplice to the usurpation of his dead mother's voice. It is a blank page, to be presented as blank. Nancy Miller has suggested, profoundly: "It's as if at the heart of *Maus*'s dare is the wish to save the mother by retrieving her narrative; as if the comic book version of Auschwitz were the son's normalization of another impossible reality: restoring the missing word, the Polish notebooks."[14] As a void

at the heart of *Maus,* the mother's lost story may be *Maus's* negative center of gravity, the invisible planet around which both the father's telling and Spiegelman's recovery of it revolve.

Moreover, as was the case for Otto Frank, Vladek's inability to protect his first child, Richieu, who died in hiding, is literally unspeakable. The result is a fixed image, a photograph, of his murdered child as a perfect victim in the father's version of the story. It is the preservation of objectified memory when life itself could not be preserved. The unspeakability of male helplessness is both relieved by and expressed in both Otto's and Vladek's objectification of even their own loved ones as perfectly idealized victims.

Neither is the propensity to fix such idealizations limited to self-expurgated or father-expurgated narratives. Several widely circulated images of women being attacked, photographed by the Nazi soldiers themselves, have also begun to assume a certain canonical (i.e., fixed) status in museums and illustrated histories of the Holocaust. I refer here specifically to photographs taken by SS photographers on the eastern front: one of a woman cradling a child and whirling away from a Nazi rifleman taking aim at her near Ivangorod, Ukraine, in 1942, and the other of a group of women, forced to strip naked before being marched to the shooting pits outside of Liepaja, Latvia, in December, 1941.[15] In the first image's recirculation and exhibition in museums (including Yad Vashem and the U.S. Holocaust Memorial Museum, among others), we find that this SS photograph has itself become part of the iconic currency of the Holocaust—and has thus taken on a life of its own. Beyond its status as a Nazi artifact, it resonates with a conglomerate of axiomatic truisms, so that the image has become emblematic of killers and victims: the woman and child represent the vulnerability and blamelessness of the victims, the generations of Jewish life that would be wiped out in a single blow, a grotesque pietà in which both mother and child are murdered, a certain sacrifice.

The resonances of the second image, however, play out much differently. For they echo, however faintly, an area in which artists are practically forbidden to tread—that is, the sexuality of victims, the possible sado-sexuality of the killers. The taboo on this subject explains why so many, including myself, had trouble assimilating images from David Levinthal's series of staged Polaroid photographs, from *Mein Kampf,* of crematoria stuffed with bodies of women in glaringly sexual poses. Here, I too have been forced to revisit some of my own strong objections to what I regarded as a deliberate eroticization of the murder process. I even tried to talk the artist into eliding from the exhibition several images of naked Japanese dolls with gaudy red nipples. As I voiced my qualms, the artist responded that Art Spiegelman had also tried to talk him out of showing these particular images.

Iconic image of woman and child being shot by SS gunman in Ivangorod, Ukraine, 1942. *Photo: Yad Vashem.*

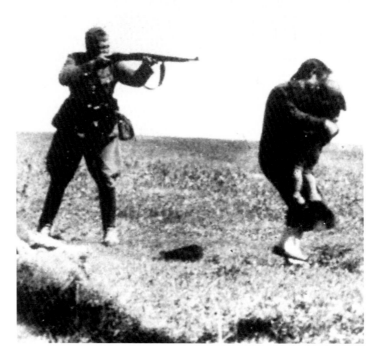

I remember telling the artist, "Nowhere in the literature have I found anything to suggest an erotic component to the killing process," that I had encountered it only in the imaginations of those who weren't there, like D. M. Thomas in his novel *The White Hotel* or William Styron in *Sophie's Choice.* Now I realize that I was missing the point, that both Spiegelman and I had reflexively split off an aspect of the killing which we had difficulty assimilating.

David Levinthal replied on two levels, which took a few moments to sink in. First, he said, whether or not there was actually a sexual, erotic component to the murder process, it remains certainly—if unfortunately—true that in many of its popular representations, the Holocaust has been eroticized, whether we like it or not. Since his subject was not "what happened" but rather our culture's hyper-mediated simulations of the Holocaust, he was attempting to show a Holocaust porno-kitsch already at play in the cultural transformations of these terrible scenes. In popular movies such as Steven Spielberg's *Schindler's List* or Liliana

Cavani's *The Night Porter,* or novels like *The White Hotel,* for example, Eros and Thanatos are twinned as constituent elements of Holocaust victimization, projected reflexively onto victims by a culture obsessed with both, a culture that has long linked the two as fatally interconnected—a culture that has eventually grown dependent on their union for commercial and entertainment success.[16] Rather than ignoring them, Levinthal made a place, however ambiguous it may seem, for what Georges Bataille has described as the dual impulses underpinning our gaze, "desire and violence."[17]

This I could swallow, if with some difficulty. But it was Levinthal's second, implied proposition that flew in the face of all that I then considered conventional wisdom. That is, he believed that both killers and victims understood that part of the dehumanization of the Jews included their sexual degradation in the moments before death—that part of the violence against the Jews, notable by its absence in survivor literature, he believed, was the sexual abuse of women, their rough handling by the Nazis during the killing process. Was this something he knew that I didn't know? As it turns out, it was.[18]

As women have been objectified in these toys and the Jews were objectified by the Nazis, the victims would here be presented as objectified twice over. Designed as sexual objects to begin with, the artist's Japanese dolls are used to recapitulate not only the relationship between killers and victims but also, if more implicitly, that between contemporary viewers and these very images. With them, Levinthal suggests that with every representation of their murder, the Jews are in some sense murdered again and again. Robbed of life by the Nazi gunmen, the victims are robbed of their dignity by the observing photographer—and then again with the recirculation of such images. Only now, we are the passive bystanders, and maybe not all so innocent at that.

At least part of what makes these images so unnerving for viewers is their suggestion that we, as viewers, may be no less complicit in the continuing degradation of the victim than the original Nazi photographer. In another calculatedly disturbing image in this series, it is Levinthal's formal design and composition that foists this realization on viewers, leaving little room in which to escape such conclusions. In this photograph, four women (portrayed by sexy dolls with porcelain white skin) are being shot by two SS gunmen. Their rifles aim into a perspectival vortex at the center of the image: we look over the shoulders of both gunmen, right into the center of the V. Three women have their arms up, as if to ward off the bullets, and one woman is already falling down. Only the muzzle of one of the rifles is in focus, though the colors of bodies are bright and sharp, a swirl of whites, blues, and gun-metal grey, all tinged by red smoke and glare.

Women in the sights of SS gunmen, view from between gunmen. *Photo from David Levinthal's* Mein Kampf *exhibition. Courtesy David Levinthal.*

From our vicarious but central vantage point, we too are implicated in this shooting—as is the photographer, who seems passively to be watching the scene, a participant inspired by the SS photographers who recorded but did not prevent similar shootings. As Susan Sontag has made so painfully explicit, "Photography is essentially an art of non-intervention. . . . The person who intervenes cannot record; the person who is recording cannot intervene."[19] That is, even as a passive spectator, the photographer plays a role, if by default, in the events he would capture: to some extent, every photographer is both choreographer and representer of the event. In the case of Levinthal's image, which he has literally choreographed before shooting, such a truism is made palpable. And by forcing us to view the shooting from a vantage point between the two gunmen, the artist has, in effect, made us the implied third gun.

The complicated role such images play in the public sphere came into especially sharp relief in a slightly different context a few years ago in Jerusalem. As

visitors entered the former public plaza at Yad Vashem, Israel's national Holocaust memorial museum, they came upon a full-scale reproduction of Nathan Rapoport's Warsaw Ghetto Monument, opened up booklike—front and back standing side by side. In a further modification of the original, the Liberté figure's right breast was covered modestly, a respectful gesture to Jerusalem's religious community. Rapoport's heroic Liberté icon is meant to lead: no victim she. Visitors entering the historical galleries of the old museum, however, found themselves face to face with wall-sized photographs depicting the Jewish women of Liepaja stripped, naked, shivering in fear, staring back at the German photographer's lens as he shot their picture moments before his cohort shot these women dead. When confronted by leaders of the ultra-Orthodox community in Jerusalem, the curators at Yad Vashem refused to remove the photographs taken by the Nazis of naked Jewish women (many of them orthodox, their strict codes of sexual modesty violated unequivocally by the SS photographer) on their way to the killing pits in Latvia and German-occupied Poland. The curators reasoned that because this degradation, too, was part of the reality of the Holocaust, it had to be shown as part of the historical record—whether or not it offended the religious community's own rigorous sense of modesty. In the view of the religious community, however, the humiliation and violation of these women's modesty was as much a part of the crime as their eventual murder; that their modesty would be violated yet again by museum visitors was not so much a representation of the crime as it was an extension of it.

At the same time, despite the curators' stated aim of maintaining the exhibit's historical integrity, the museum may have refused to acknowledge another historical reality: the possibility of their visitors' prurient gaze. Will we ever know all the reasons why people are transfixed by these images? Is the historical record of past travesties enough to blind us to the possibility of present travesties on the part of viewers? Can we say with certainty that every museum visitor's gaze is as pure as the curators' historical intent? For the fine line between exhibition and exhibitionistic remains as fragile as it is necessary, even in the hands of scrupulous historians and curators.

Where is the line between historical documentation of degradation and the re-degradation of victims? Can curators actually vouch for the integrity of every museum-visitor's gaze? Almost from the first showing of photographs from the concentration camps, artists have attempted to plumb this question—or at least to ask it. Perhaps the earliest and most notorious were the survivor Boris Lurie's inflammatory installations and collages immediately after the war, including *Flatcar Assemblage by Adolf Hitler* (1945) and this work's elaboration in *Railroad*

Jewish women of Liepaja, Latvia, forced to undress before SS photographers minutes before their mass murder, December 15–17, 1941. *Photo: Yad Vashem.*

The women just before their mass murder in Liepaja. *Photo: Yad Vashem.*

Jewish women and children from Mizocz, German-occupied Poland, lined up by the SS moments before they were shot, October 14, 1942. *Photo: Institut für Zeitgeschichte.*

The women and children shortly after their mass murder at Mizocz. *Photo: Institut für Zeitgeschichte.*

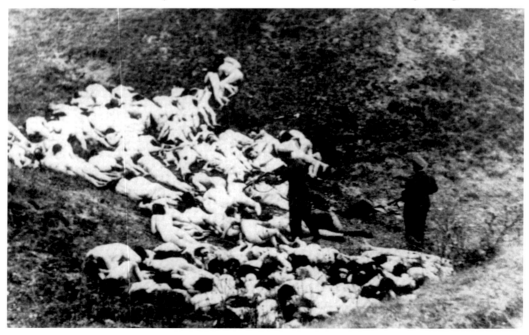

Collage (1959) and *Saturation Painting BUCHENWALD* (1959). In these works, the artist juxtaposed Margaret Bourke-White's iconic images of emaciated death camp survivors and piles of corpses stacked on a flatcar with other images of nudie pin-ups of the day. Here he suggests, at least on the surface, that it is all pornography—but in so doing, he forces viewers to reevaluate their own reasons for looking at such images altogether. As Norman Kleeblatt has noted, Lurie forces viewers to confront their own "voyeurism," which I take as their desire to regard the pain of others without being so regarded, their need to keep their reasons for looking at such images to themselves.[20]

As Boris Lurie makes explicitly clear in his various manifestoes for the NO!art Movement, the line between our gaze and the commodification of such images is almost nonexistent. Once produced and recirculated, these images become cultural commodities to be traded, valued, and paid for. The potential for turning the suffering of women—or anyone—into so much "art for sale" or into so much capital, or cultural currency, is also part of the photographic act. Strangely, it seems to take a conflating of sexuality and violence to bring this home to many people—as Lurie surely knew when he assembled collages of death camp images surrounded by porn magazine nudes and pin-ups of the 1950s.[21]

A few years later, the German artist Gerhard Richter similarly broached the question of whether the popular dissemination of Holocaust images amounted to a new, respectable kind of pornography. In his installation *Atlas,* Richter juxtaposed photographs of naked, tangled corpses next to sexually explicit images of naked and tangled bodies copulating.[22] His aim was not to eroticize the death camp scenes so much as to force viewers to ask uncomfortable questions of themselves: Where is the line between the historically inquiring and the erotically preoccupied gaze? Where is the line between historical exhibition and sensationalistic exhibitionism? In fact, here we might even step back to ask whether any exhibition, even the most rigorously framed, can ever merely show such sensationalist imagery without descending into sensationalism. Can the artists, curators, or even we as viewers objectively critique such sensationalist images without participating in the sensation itself?

Is it also possible that insofar as Holocaust-era prisoners are regarded as powerless, humiliated, and dehumanized, they are also on some level regarded emblematically as women? To the extent that Jews as victims are often represented universally in the figure of the woman or the child (I would argue that to some extent, all prepubescent children are regarded as feminine, as more female than male, even the little boy in the Warsaw Ghetto with his arms upraised, in his knee socks and short tunic), the victim is regarded as classically feminine. When this is so, however, little room is left in the story for women as women.

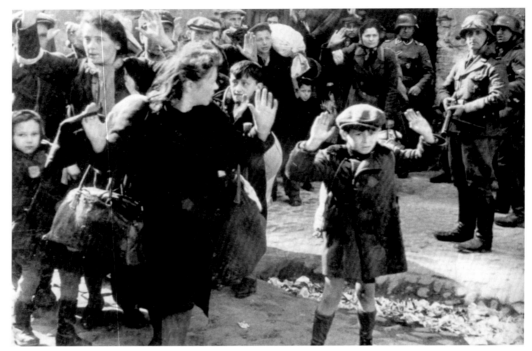

Boy with hand raised in the Warsaw Ghetto. *Photo: Yad Vashem.*

The literary historian Sara Horowitz has argued persuasively that in many male Holocaust narratives, "women are presented as helpless (although the men were no less helpless), as absent loved ones (although the men, too, were absent), and as needing rescue (although the men, too, needed rescue)."[23] Though Horowitz stops here with the fact of such representations, I believe she also hints at why men may have represented women in this way, without saying so explicitly. Because men have been constitutively unable to speak of their own helplessness, of their absence as loved ones, of their need to be rescued, of their inability to fulfill their masculine need to protect family, perhaps they have displaced their unspeakable condition onto their iconic representations of women as emblematic of all these conditions.

Moreover, I believe that many of these male writers' constitutive inability to see their own oppression of women results in a parallel inability to see, or even to regard, the sexual abuse of Jewish women by the Nazis, thereby splitting off women's sexual violation during the Holocaust from their own master narrative of events. Or as the historian and survivor Irene Eber once told Joan Ringelheim, "Male memory can confront women as victims, but cannot confront male oppression." That is, there seems to be neither language nor conceptual frame

for articulating one's own oppression of the other sex. Conversely, according to Eber, "The same may be true for women survivors. They can see themselves as Nazi victims, but not as victims of Jewish men or even Nazi men, except perhaps as non-female victims."[24] Similarly, it may also be difficult for women to describe their female oppressors without figuring them as masculine. I think here of Sarah Nomberg-Przytyk's depiction of the female Kapos in her barracks, the *stubowe,* who "in most instances were vulgar and coarse . . . [who] marched with a man-nish step, their arms swinging at their sides."[25] Literally, both men and women have difficulty "regarding" the pain of women, except insofar as it is inflicted by the Nazis or by "mannish" women, and I would add, except when the women are portrayed as victims-ideal. That is, again, there may be no place in traditional, governing paradigms for sexual victimization, certainly not in male memory—but not even perhaps in female memory.

Why the sexual and gender-specific atrocities of the Holocaust should be split off from our so-called master narratives of the Nazi genocide, when such experiences have long found expression in the antecedent literatures of destruc-tion (such as the biblical book of Lamentations and early twentieth-century pogrom poetry) is still not completely clear to me. In Lamentations, for example, a destroyed and vanquished Jerusalem is figured as a weeping woman, whose "sanctuaries have been entered and treasures looted," whose children and hus-bands have been taken from her, but who is also to blame for her plight by her wanton behavior (in the tradition of *mipnei hata'enu,* or because of our sins). So even as we have the ultimate destruction in Jewish tradition represented in the archetype of the suffering woman, the figure itself includes at least a reference to sexual violation as part of its internal logic (Lam.1:8).

Even more striking are the brutally raw depictions of sexual violation in Chaim Nachman Bialik's widely circulated, iconic 1903 Kishinev pogrom poem, "Ba'ir ha'regah" ("In the City of the Killing"), in which the menfolk are depicted as watching helplessly and voyeuristically while their wives, daughters, and mothers are raped and murdered by marauding Gentiles. Husbands, bridegrooms, and brothers hide in the shadows and in the poet's language are even perhaps titillated as they "peeped" (*hetzitzu min ha'chorim*) through the holes of their hiding places:

> And behold, yea behold: In the darkness of that corner,
> Beneath this matzah-trough and behind that cask,
> Lay husbands, bridegrooms, brothers, peeping from the holes
> While holy bodies quivered beneath asses' flesh,
> Being strangled in their impurity and swallowing the blood of their throats
> And like a man dividing his delicacies, so the abominable goy divides their flesh—
> Lying down in their shame and seeing—neither stirring nor moving.[26]

Of course, Bialik's poem was also a call to arms in which he rejected all traditional responses to such attacks. Instead of rising up to protect their women, the men only continued to "regard the pain of their women," which for Bialik amounted to a vicarious participation in the sexual violation of their women, even a substitute for preventing it. Part of the crime, in Bialik's radically subversive view here, was just this passive regard of women's suffering, which did not move them to question God's justice or to gouge their eyes out or go out of their minds, but only to pray to God for a miracle—"and not let such evil come upon me." Another part of the crime was the men's traditional religious response to the suffering of their women. Finally, when it was safe to come out, the husbands "burst forth from their holes" and rushed not to their women's aid, but straight to their rabbis with the question, "Rabbi, my wife, what is she? Permitted or forbidden?"[27] That is, now that our wives have been raped, are they still sexually available to us?

Kishinev is attacked as a Jewish shtetl, Jewish women of the town are raped as women, and Jewish men "regard" the pain of Jewish women through the prism of Halacha (Jewish law). Thirty-eight years later, a Jewish girl goes into hiding as a Jew but is abused as a woman by non-Jews who are hiding her from the Nazis. The girl asks years later whether her experience as a Jew was thus to include her experiences as a woman, whether her experience of sexual abuse counted as part of her Holocaust story. The answer is that one experience is necessarily part of the other, and to split one from the other is to dis-integrate this Jewish woman's experience during the Holocaust.

In Bialik's integrated view, the sexual violation of women during pogroms and the men's response to it were part and parcel of the pogrom. Part of the terror of pogroms was the absolute sexual violence against women, and here is Bialik in 1903 facing explicitly both the gendered responses of men and women to this terror and the implications in our regard of it—at the moment and afterward. Remember how in Chaim Kaplan's diary, Kaplan asked plaintively at one point, referring to Bialik, "Oh poet of the people, where are you now?" For a long time after the Holocaust, poets like Bialik were hard to come by.

The proximity of death and sex as explored in the arts of Holocaust memory has mostly scandalized readers after World War II in ways that Bialik's inflammatory poem did not scandalize Jews in the Pale of Settlement. In fact, images of rape and bayoneted pregnant women stuffed with feather bedding by the killers were rife in pogrom poetry and theater. Why then has there been so little place for sexual violation in Holocaust literature and poetry? Why have historians and critics so often assumed (as Joan Ringelheim relates) that it is the sensationalizing media that has sexualized the Holocaust, as if sexual experience in the Holocaust was only rare and incidental and not somehow intrinsic to the suffering of so

many women in the camps and ghettos?[28] Ringelheim notes accurately, I think, that for some reason we can make mass rape an integral part of the genocide of Bosnian Muslims by Serbs in the 1990s. And as I have suggested, Bialik depicted rape as integral to the Kishinev pogrom. Why then are the explicitly gendered and sexual experiences of women during the Holocaust only now being made part of its history and memory?

"Their secret was death, not sex." So begins Ruth Kluger's powerfully clear-eyed memoir, *Weiter Leben,* what she calls "A Holocaust Girlhood Remembered."[29] Kluger refers here to the "forbidden news" she strained to overhear as a child eavesdropping on her parents' salon in the days after her hometown Vienna's annexation by the Nazis. These horror stories were fascinating—even titillating for their opaqueness and what she called their "whiff of fantasy." Unlike most all male survivor accounts, and nearly all female survivors' remembrances, Kluger opens her remembrance by associating death and sex, not because they intrinsically belong together but because they were both unspeakable secrets. What sets Kluger's memoir apart from the others is her relentless integration of the unspeakable into life, into her attempts at "going on living." Whether it's anger at her mother and father or love for her German friends—it all gets spoken, leaving none of it fixed. Her story, unlike so many others, leaves room for all other stories, all of which go on living in hers.

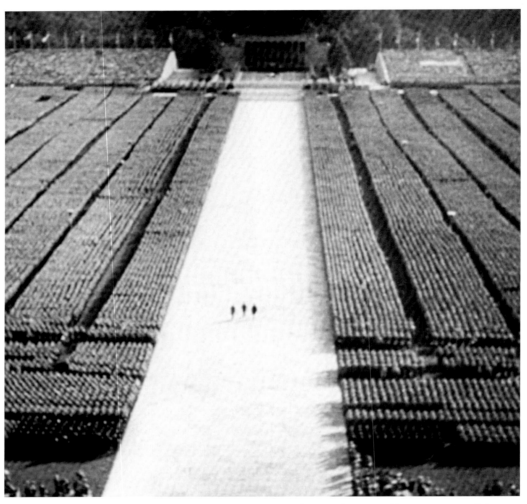

Hitler and the heads of the SS and SA approach the "blood flag" in the Luitpold Arena at one of the 1936 Nuremberg rallies. Still from *The Triumph of the Will*.

4

The Terrible Beauty
of Nazi Aesthetics

Something in the study of Hitler repels us. Whether it is our own traditional reflex to blot out the memory of our enemies (or to remember them as blotted out, as we do Haman and Amalek), or just the queasy sense that too much time spent in his company cannot be a good thing, I'm not sure. Or maybe we fear that by understanding Hitler and his Nazi cohort too well, explaining them, we come perilously close to justifying and rationalizing their evil deeds—akin to asking "why" of the Nazis and receiving their own self-aggrandizing, exculpatory explanations in turn.

For this writer, at least, it has always been easier to empathize with the victims of history than with the killers. As it turns out, it has also been easier to study the aesthetic responses of victims to their suffering than to explore the aesthetic preoccupations of the killers or, worse, the aesthetic principles on which the killers may have based their policies of war and mass murder. It is almost as if our own romantic notions of art and its transcendent link to beauty have led us to protect both art and beauty from the barbaric claims made on them by the Nazis, from the evil acts committed in their name. A "Nazi aesthetic," in this view, seems to be a veritable contradiction in terms. If "beauty is truth, and truth beauty," as Keats would have it, then Nazis and art are mutually exclusive categories.

But, in fact, as historians such as George Mosse, Peter Viereck, and Saul Friedländer (among others) have long known, the Nazis not only possessed a highly refined aesthetic sensibility, but unlike most political leaders, enacted their aesthetic at every level of politics and policy. Moreover, they not only believed themselves to be artists, but were regarded by others at the time as artists, whose very ideology was founded in an essentially aesthetic logic. "Like it or not,"

Thomas Mann wrote in his 1938 essay "Brother Hitler," "how can we fail to recognize in this phenomenon [of Hitler and his spell over the Germans] a sign of artistry?"[1] As Frederic Spotts has pointed out in his riveting study *Hitler and the Power of Aesthetics,* the late George Mosse lamented how belatedly he and other liberals came to understand that not only were these artistic ambitions part of their personalities, they were also part and parcel of Nazi ideology. "We failed to see," Mosse once wrote, "that the fascist aesthetic itself reflected the needs and hopes of contemporary society, that what we brushed aside as the so-called superstructure was in reality the means through which most people grasped the fascist message, transforming politics into a civic religion."[2] As such, this fascist aesthetic had earth-shattering consequences, which we now dismiss at the peril of our historical understanding.

What, then, is this Nazi aesthetic, what kind of "art" came of it, and why do we concern ourselves with it now? As made abundantly clear in the exhibition *Prelude to a Nightmare: Art, Politics, and Hitler's Early Years in Vienna, 1906–1913,* and as suggested in Spotts's work, not only did the Nazi aesthetic have several interpenetrating parts, including idealizations of purity, violence, and the human form.[3] But, in fact, the resulting "art" encompassed much more than the kitsch statuary and paintings so easy to dismiss now: it also included Nazi pageantry and regalia, films and political choreography, architecture and, without too much of a stretch, even the so-called theaters of war and mass murder, as well. What Spotts's book does so well, along with *Prelude to a Nightmare* and foundational books in this area by Jonathan Petropoulos (*Art as Politics in the Third Reich,* 1996) and Brigitte Hamann (*Hitler's Vienna: A Dictator's Apprenticeship,* 1998), is that it restores to the historical record the role aesthetics actually played in the Nazi Reich and its policies, the ways a Nazi aesthetic was part and parcel of Nazi ideology, and not just an ornamental by-product of it.[4]

In other words, the Nazis' meticulously choreographed party events and exhibitions of art were not just means by which to deliver the Nazi message but were very much part of the message itself, even fundamental pillars of their rule and power. From the monumental scale of their buildings and rallies to the spectacular cinematic records they commissioned of these rallies and buildings, every production was expertly composed and, I believe, embodied a very carefully orchestrated aesthetic impulse, which in the end served as both a source and a reflection of Nazi power at its height.

For example, one of the most brilliant "documentary films" ever made, of course, was no mere documentary, but was this last century's benchmark for cinematic propaganda. In the opening moments of *Triumph of the Will,* Leni

The shadow of the Führer's plane forms the shape of a cross. Still from *The Triumph of the Will.*

Riefenstahl's Nazi-commissioned record of the 1934 Nuremberg rallies, we find an object lesson in what I would call the Nazis' "aesthetics of redemption." A plane is carrying the Führer and his entourage over the picturesque landscape of hills, valleys, and churches on its way to Nuremberg. A strident voiceover narrative introduces the scene: "Twenty years after the World War [I], sixteen years after the crucifixion of Germany, nineteen months after the beginning of Germany's Renaissance, Hitler flew to Nuremberg to greet his columns of followers." The plane suddenly appears from the clouds and glides over the landscape, its shadow in the form of a cross. As if in a Second Coming, a Führer has arisen who will save and redeem Germany. As Hitler did so brilliantly in his speeches' transvaluation of religious terms, when he invoked the Christian language of *Gnade* (grace), *Glaube* (belief), and *Unsterblichkeit* (immortality) toward expressly political ends, Riefenstahl just as brilliantly framed Hitler's arrival in the explicit iconography of Christian redemption and messianic deliverance. The rest of the film both captured and created the immense sense of Nazi pageantry and monumentality, both further cornerstones of the Nazi aesthetic.

Of course, Riefenstahl always insisted that her film was pure documentary, an objective lens through which Hitler's ascension was merely recorded, not glorified. But this denial of human agency, of the individual's hand in shaping such idealized images, as if such idealizations were in themselves eternal and historically transcendent, was also part of her Nazi aesthetic. The notion that her filmmaking merely captured the genius of Hitler for all to see, that this film somehow made itself and did not depict Hitler as the messianic figure so apparent in the film, was in keeping with the Nazis' powerful self-portrayal as an invincible force of nature. To her dying day, the filmmaker denied any role in shaping and reflecting the Nazi aesthetic: but Leni Riefenstahl was no more a mere documentarian than Hitler was a mere politician. And both of their creations—from the Nazi Reich to its filmic representation—issued from a strict aesthetic logic. One of the reasons both Hitler and Riefenstahl could exploit the language and imagery of messianic redemption so adroitly, it turns out, is that both regarded the logic of redemption as a universal tenet, and in fact it was one they shared not only with each other but with the rest of Germany and with much of the western world, as well.

For Hitler, redemption was not only the compensation of some earlier loss, the necessary destruction of the old Germany to make way for the new Germany he envisioned; it was also part of what he regarded as a sacrificial offering. "If at the beginning of the [world] War," Hitler wrote in *Mein Kampf,* "twelve or fifteen thousand of these Hebrew corrupters of the people had been held under poison gas, as happened to hundreds of thousands of our very best German workers in the field, the sacrifice of millions at the front would not have been in vain."[5] That is, the deaths of millions of Germans could be redeemed or compensated by the deaths of Jews killed in Germany's name.

In fact, the historian Saul Friedländer has argued compellingly that the very notion of redemption actually played a central role in the Nazis' particular brand of anti-Semitism, what Friedländer has termed "redemptive anti-Semitism": "born from the fear of racial degeneration and the religious belief in redemption." Friedländer elaborates here: "The main cause of degeneration was the penetration of the Jews into the German body politic, into German society, and into the German bloodstream. Germanhood and the Aryan world were on the path to perdition if the struggle against the Jews was not joined; this was to be a struggle to the death. Redemption would come as liberation from the Jews—as their expulsion, possibly their annihilation."[6] Just as Germany's disastrous defeat in World War I was to be "redeemed" by the messianic advent of the Führer, in Riefenstahl's version, so would the war effort here, no matter how terrible the costs, be redeemed by Germany's "liberation" from the Jews. In Friedländer's

SS Honor Guards at the Temple of Honor in Munich, 1936. *Photo: Sueddeutsche Zeitung / Alamy.*

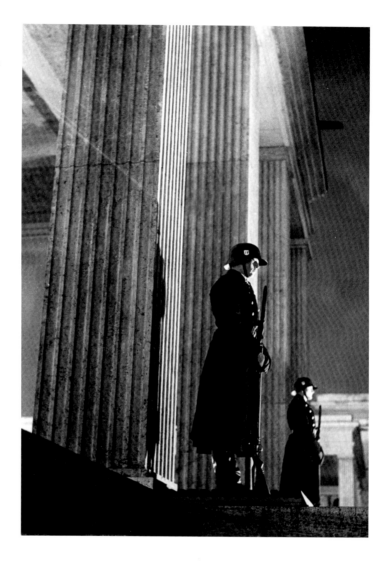

words, "It was this redemptive dimension, this synthesis of a murderous rage and an 'idealistic' goal, shared by the Nazi leader and the hard core of the party, that led to Hitler's ultimate decision to exterminate the Jews."[7]

And as Frederic Spotts shows so well, the principle of redemptory "sacrifice" also played a primary role in the memorial landscape Hitler introduced into the Nazi topography. From the "Eternal Guard" at the Temples of Honor in Munich, which held the sarcophagi of eight "Martyrs of the Movement" killed in the 1923 putsch attempt to the *Totenburgen*—or Citadels of the Dead—to be built as mass

Wilhelm Kreis's design for the *Totenburgen,* 1941. *Photo: Bundesarchiv Koblenz.*

burial grounds for thousands of prospective fallen German soldiers, Hitler made redemptory sacrifice one of the aesthetic architectural pillars of his Reich. As Spotts points out, even the Nazis' elaborately choreographed party rallies, during which Hitler would salute a "blood flag" included scenes of "almost pagan ritual, [in which] animal sacrifice has been replaced by the prospective human sacrifice of wars to come."[8]

Of course, this aesthetic of redemption is also why a new generation of artists in Germany is loath to find any redeeming aspects of any sort in national memory of Hitler's mass murder of Europe's Jews. To their minds, making an art out of this catastrophe, finding consoling meaning in this catastrophe, compensating this catastrophe with beauty of any sort, would be not just a betrayal of the Jews' experiences during the war, but an extension of the crime itself, of the redemptive cast of mind that led to mass murder.

Indeed, here we are reminded of Hitler's own absolute indifference to individual human lives, especially as they paled in significance to the larger cause and idealizations of race and nation, and the way this diminution of the individual underpinned his aesthetic embrace of the monumental. Here Spotts cites Hitler's chilling meditation on the value of individual human life, "which should not be given such a high value," in Hitler's words. "A fly lays a million

eggs; they all die. But the flies survive." Spotts then suggests that Hitler's "lack of feeling for humans, even for fanatical party members, was already evident at the Nuremberg rallies and other spectacles when his 'architecturalizing' of the participants and his deployment of them in geometrical patterns reduced them to noctambulent creatures."[9] At first, I doubted such a simple conclusion, this reduction of individuals to mere props in one of his apocalyptic stage sets. But as I looked further into Hitler's aesthetic embrace of monumentality, I had to agree that it was tied to his fundamental conviction that the private or individual consciousness must always be made subservient to larger idealized aims of the nation-state.

Thus the particular kind of monumentality Hitler embraced in his aesthetic also included a side of it he abhorred: "How truly deplorable the relation between state buildings and private building has become today," he wrote in *Mein Kampf*. "The sum of money spent on state buildings is usually laughable and inadequate," which was to say, that too much of the era's most prominent architecture was being built for private clients, monuments to individuals as opposed to communities and ideas. "If the fate of Rome should strike Berlin," Hitler continued, "future generations would some day admire the department stores of a few Jews as the mightiest works of our era and the hotels of a few corporations as the

A view across Zeppelin field to the grandstand, designed in 1934 by Albert Speer.
Photo: Süddeutsche Zeitung Photo / Alamy.

Hitler views his Monument of the Movement, planned as the centerpiece of his "new Munich."
Photo: Bundesarchiv Nürnberg.

characteristic expression of the culture of our times." For Hitler, the problem was
that

> our big cities of today possess no monuments dominating the city picture, which
> might somehow be regarded as symbols of the whole epoch. This was true in the
> cities of antiquity, since nearly every one possessed a special monument in which it
> took pride. The characteristic aspect of the ancient city did not lie in private build-
> ings, but in the community monuments which seemed made, not for the moment,
> but for eternity, because they were intended to reflect, not the wealth of an individ-
> ual owner, but the greatness and wealth of the community. Thus arose monuments
> which were very well suited to unite the individual inhabitant with his city. . . . For
> what the ancient had before his eyes was less the humble houses of private own-
> ers than the magnificent edifices of the whole community. Compared to them the
> dwelling house sank to the level of an insignificant object of secondary importance.[10]

That is, individuals could come and go, as well as their humanly scaled dwelling
places, their sites of life. What his monumental aesthetic would leave behind,
therefore, was not the uniqueness of individual human experience, or the messy
heterogeneity of life itself, but monolithic forms that imposed singular meaning
on disparate deeds, experiences, and lives.

It is a monumentality that denies the multiplicity of experience and forces all to adopt one vision of the world as their own. This is, of course, precisely the monumental aesthetic that is so completely rejected by a postwar generation of German artists in particular, who remain deeply suspicious of a monumentality still redolent of fascist tenets: the didactic logic of monuments that turns people into passive spectators, their demagogical rigidity and certainty of history that imposes singular meaning on complex times and events, that would dwarf and subjugate a population now made to feel insignificant by an entire nation's reason for being. The multiple, competing stories are lost to such monumentality, of course, all supposedly for the unity and well-being of a polity. But such an aesthetics presumes not only the unity of being that can only be imposed from on high, but the complete disregard for noisy, democratic dissent and debate.

The monumental in Hitler's eyes was not only an end result, however, but also a means by which he could reduce the individual to insignificance, thereby making all appear as one. Specifically, he did this in his elaborately choreographed spectacles and pageants, against which the individual seemed helpless to act. Witness his dozens of gargantuan productions: the Nuremberg rallies, the colossal stadiums and political arenas designed to hold 500,000 people, or even the North-South Axis he and his architect Albert Speer designed for Berlin, an impassable 50 meters wide. On a commemorative "Day of the Political Leaders," in 1936, over 110,000 men marched onto the review field, while another 100,000 spectators watched from the stands. "Once darkness fell," in Spotts's words, "the space was suddenly encircled by a ring of light, with 30,000 flags and standards glistening in the illumination. Spotlights would focus on the main gate, as distant cheers announced the Führer's approach. At the instant he entered, 150 powerful searchlights would shoot into the sky to produce a gigantic, shimmering 'cathedral of light,' as it was called. More vividly, the British ambassador famously described it as 'solemn and beautiful . . . like being inside a cathedral of ice.' In either case, 'cathedral' was the apt term since the essence of the ceremony was one of sacramental dedication to Führer and party."[11] Or as Albert Speer wrote in his memoirs, "I had long thought that all these formations, processions, dedications were part of a clever propagandistic revue. Now I finally understood that for Hitler they were almost like rites of the founding of a church."[12]

Such an aesthetic vision, of course, also relieves individuals of human agency and responsibility. All are acting in the name of a force much larger than themselves, all merely ciphers through which transhistorical events play themselves out. Hence, Leni Riefenstahl's claim until she died at age 101 that she was

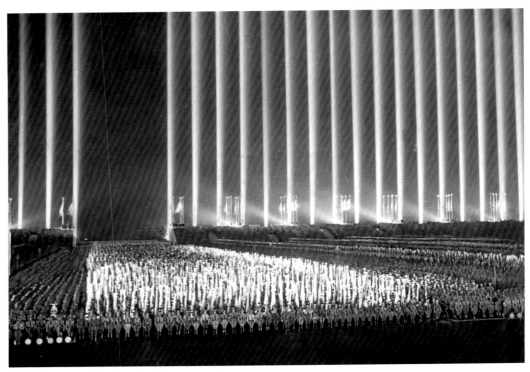

Albert Speer's "cathedral of light" at a Nuremburg rally. *Photo: Süddeutsche Zeitung Photo / Alamy.*

somehow passively documenting these Nazi rallies, was somehow even a victim of them, and not actively choreographing them. The result is an art and architecture without human beings to animate it. It is a strange concept, perhaps, but it is also at the heart of a Nazi aesthetics, which emphasized the idealized human forms of Arno Breker over the actual forms as found in life; which emphasized the spectacular, singular voice of the masses over the smaller, dissenting voices of individuals. Spectacular rallies that reduced people to spectators of something much larger than themselves, over which they had no control; art that represented life not as it was but as it should be according to Nazi precepts.

In Peter Cohen's 1989 documentary *The Architecture of Doom,* there is a fascinating filmed sequence of Hitler's visits to the great architectural wonders of Paris. On this, his first visit to Paris, Hitler arrives before dawn and then proceeds at breakneck speed through the empty streets, stopping for studied walks through the Opera, the National Library, the museums, and the Eiffel Tower. All of this is predawn, deliberately planned so that Paris is for the purposes of this visit, essentially a life-sized architectural model of itself, a place empty of life and

people, as formal and inanimate as the architectural blueprints he had studied so assiduously before his trip that he was able to lead his entourage through the Opera and point out a missing antechamber. Part of his fascination with ruins, one feels, is that they resemble more closely the plans and the models than they do the lived-in buildings themselves.

Indeed, our preoccupation with what we glibly call "the future of the past" finds a disturbing parallel in the Nazis' own aesthetic preoccupation with the future of their past. Recall Hitler's words again, "If the fate of Rome should strike Berlin . . . ," and then consider Harald Welzer's insightful parsing of Albert Speer's reflections on what he terms Speer's "memories of the future." As Welzer suggests, Speer concocted a theory of "ruin-value," whereby he would build into his architecture a calculation of what would be left behind after a thousand years. In Welzer's words:

> This theory originated in 1934, at the commission to restyle the Nuremberg party / conference grounds according to the scale and aspirations of the Third Reich . . . When Speer passed by the wrecked reinforced concrete construction, out of which iron components protruded and had already begun to rust, he shuddered at the thought that the buildings he had designed for the new Reich would at some point in history also be in such wretched condition. As a result, Speer developed his conception of the "ruin-value," which was nothing other than an aesthetic calculation of decay: What will the structures we build today look like in a thousand years—what does this say about the ideas we embodied in them?

Welzer continues by citing Speer's own words. "The employment of particular materials as well as attention to particular structural considerations," Speer wrote, "was meant to make buildings possible, which in a state of decay, after hundreds or (so we calculated) thousands of years would resemble the Roman models."[13] To illustrate what he aptly calls this "anticipated retrospection," Welzer cites one of Speer's romantic sketchings, which according to the Nazi architect, showed "what the grandstand of the Zeppelin field would look like after generations of neglect, covered with ivy, with collapsed pillars, the walls here and there fallen down, but in broad outline still clearly recognizable. Among Hitler's entourage this drawing was regarded as 'blasphemy.' The mere idea that I had calculated a period of decline for the freshly-established thousand year Reich seemed unheard of to many. But the idea struck Hitler as sensible and logical."[14] This is to view events constantly not as they are on the ground but always through a future-perfect prism, as Welzer has suggested. From a past-perfect mode of thought—"it has happened"—to a future perfect mode of thought, in which "it will have happened," a mode that looks back on what is imagined as having already come to pass.

Of course, such an aesthetic can also lead to the deluded inability to distinguish that which has happened from that which one imagines (or hopes) will have happened. Hence, Hitler's preoccupation in his last months with his plans for Linz and the 1950 victory parades that would never actually take place outside of his imagination. These and other thoughts occupied Speer in his days in the Spandau prison, where he was able retrospectively to grasp just the deludedness of this particular aesthetic of "anticipated retrospection." When one of his fellow prisoners was for health reasons given a chair that Speer had designed for the now-destroyed Reich chancellery, Speer came face to face with the reality of what was left of all his works. "The chancellery has already been demolished," he wrote morosely from his Spandau cell, "the Nuremberg parade ground is to be blown up, nothing else remains any more of all the grandiose plans which were to transform the architectural face of Germany. How often had Hitler said to me, that the greatness of our buildings would still bear witness to the greatness of our age after thousands of years—and now this chair."[15] And now this chair. That only this single chair would remain of all his great design works, and that it would now serve a completely humane function in the end, must have thrown into especially sharp relief the absolutely inhuman scale at the heart of the rest of his works, the ways in which individual lives were absolutely expendable in the pursuit of an idealized world.

Toward the end of his appreciative review of *Prelude to a Nightmare,* the *New Yorker* art critic Peter Schjeldahl found that this show "rebuts the comfortable sentiment that Hitler was a 'failed artist.'" For as Schjeldahl notes, "Once he found his métier, in Munich after the First World War, he was masterly, first as an orator and then as an all-around impresario of political theatre."[16] That is, Hitler was both a product of his time's aesthetic temper (even if his tastes were somewhat retrograde) and ultimately the greatest producer of political design and choreography who ever lived. The point is that we cannot separate Hitler's deeds, his policies, and his Nazi ideology from his aesthetic temper. Our reflex may be to protect the aesthetic realm from the ugliness and barbarism often committed in its name. But without examining the potential for evil in aesthetics, as well as the potential for good, we dismiss aesthetics altogether as a historical irrelevancy, as something disconnected from life as we actually live and experience it.

At the end of his review, Schjeldahl quotes the show's curator, Deborah Rothschild, from one of her wall texts: "The union of malevolence and beauty can occur; we must remain vigilant against its seductive power." But then Schjeldahl adds, "I disagree. We must remain vigilant against malevolence, and we should regard beauty as the fundamentally amoral phenomenon that it is."[17] But, in fact, it is not beauty's seductive power against which we must remain vigilant, but its

union with malevolence that we must guard against. In theory, beauty by itself may indeed exist outside morality. But when is beauty ever "by itself?" It is always a quality of something, part of something other than itself. Once yoked to a malevolent force, beauty is no longer amoral or benign, but now, as both Spotts's book and Rothschild's exhibition have made so disturbingly clear, it is also part of that malevolent force's logic. In this view, beauty and terror, aesthetics and power, may not only be paired after the historical fact—but must now be regarded as historical forces that also drove events as they actually unfolded at the time.

The Nazis by Piotr Uklański, 1998. *Photo: Courtesy Jewish Museum, New York.*

5

Looking into the Mirrors of Evil

Nazi Imagery in Contemporary Art at the Jewish Museum in New York

A notorious Nazi once said that when he heard the word "culture," he reached for his revolver. Now it seems, every time we hear the word "Nazi," we reach for our culture. Thus would we seem to protect ourselves from, even as we provide a window into, the terror of the Nazi Reich. It is almost as if the only guarantee against the return of this dreaded past lies in its constant aesthetic sublimation—in the art, literature, music, and even monuments by which the Nazi era is vicariously recalled by a generation of artists born after, but indelibly shaped by, the Holocaust.[1]

Until recently, however, this has also been an art that concentrated unrelievedly on the victims of Nazi crimes—as a way to commemorate them, name them, extol them, bring them back from the dead. By contrast, almost no art has dared depict the killers themselves. It is as if the ancient injunction against writing the name of Amalek, or against hearing the sound of Haman's name, had been automatically extended to blotting out their images, as well. Of course, such blotting out was never about merely forgetting the tormentors of the Jews. It was, in fact, a way to remember them. For by constantly condemning these tormentors to oblivion, we ritually repeat an unending Jewish curse that actually helps us remember them.

As we discovered in the New York Jewish Museum's 2002 exhibition *Mirroring Evil: Nazi Imagery/Recent Art,* however, a new generation of artists sees things a little differently. In my reflections here on this exhibition and its extraordinarily fraught reception in the weeks before and after its opening, I want to explore the questions such art raises for us now as well as this art's limitations for plumbing

the generational breach between what happened and how it now gets passed down to us.

In December 2001, almost three months before the exhibition itself was scheduled to open the following March 17, an intrepid *Wall Street Journal* reporter got wind of it at a New York dinner party. Even though there was no exhibition yet to review, a biting article soon appeared in the *Journal* that compared the Jewish Museum's *Mirroring Evil* to the Brooklyn Museum's 1999 *Sensation* exhibition, which included incendiary images of Catholic icons, and which was actually a self-promoting Saatchi collection on tour. Only this new exhibition at the Jewish Museum, the article implied, would now be a Holocaust or Nazi sensation. With a little push from the *Wall Street Journal,* it would also become a journalistic sensation, as reporters from across the city began showing a handful of the show's more provocative images to survivors and their children for reactions. The reactions were predictably mixed, with some survivors glad that if Nazi imagery in recent art is going to be shown anywhere, it would be in the context of a responsibly thought through exhibition at the Jewish Museum. Other survivors and their families, having been shown these images without any accompanying context, were provoked into condemning an exhibition that was still months away from opening. Still others, Jews and non-Jews, survivors and their families, simply had little interest in seeing how Nazi-imagery is used in any context, artistic or not. When asked what he was going to do about the exhibition, the new mayor Michael Bloomberg answered simply that it wasn't the mayor's job to say what should or shouldn't be shown in the city's great museums. Fair enough. But suddenly a meticulously conceived and prepared exhibition on Nazi imagery in recent art was officially deemed "controversial"—months before anyone even had a chance to see it.

The charge was led by someone I have long known and admired, Menachem Rosensaft, the founding chairman of the International Network of Children of Jewish Holocaust Survivors and a member of the United States Holocaust Memorial Council. He was soon joined by Brooklyn assemblyman Dov Hikind, representative of the largest population of Jewish Holocaust survivors in America. Having viewed some of the most disturbing images from the exhibition, Rosensaft pronounced the show an irredeemable desecration and trivialization of the Holocaust. This exhibition, he wrote, "is in excremental taste. There can be no excuse," he continued, "aesthetic or otherwise, for the crude desecration of the Holocaust inherent in the display." He went on to say that he was not shocked that there are "artists, novelists, filmmakers and other pseudo-intellectuals who ridicule the Holocaust and demean the suffering of its victims." But the main outrage for him was that "a respected, mainstream Jewish cultural institution

should be legitimizing the trivialization of the Holocaust."[2] At the end of this piece, which he wrote for *Forward,* he promised that loud demonstrations and pickets would be the least of the museum's problems, were they to go ahead with the exhibition, and that the museum's superb reputation would be irreparably compromised.

As one of the exhibition's academic consultants, I was invited by *Forward* to write a companion piece defending the exhibition and providing a rationale for it. Though neither of us had read the other's article, they were twinned nonetheless, printed side by side and titled, "Demystifying Nazism, or Trivializing Its Victims? A Debate." For my part, I asked everyone with half an interest in this show, pro or con, to step back and consider an old curatorial axiom: "Hot topic, cool treatment." The aim of this sober-minded show, I said, is not to inflame the already viscerally charged passions evoked in images of the Nazis and their mass murder of Jews. But rather it is to explore critically the ways a new generation of artists has begun to integrate images of the killers themselves into their work, much of it conceptual and installation art.[3] But I did not address a fundamental difference between audiences for this exhibition, which cut at least two ways. For many survivors, whose families were murdered and whose lives were permanently scarred by the Holocaust, it is impossible to see images of either the killers or the victims without their literal and visceral connection to their personal experience of events. But for the next generation, and for all who were not there, such experiences remain forever and only vicariously imagined and remembered. When these generations overlap, the breach between them is clear and perhaps unbridgeable. As the survivors' generation passes, however, these events will pass out of the realm of personal experience and into that of imagination only. If nothing else, this show exposes this generational fault line as never before, and for us in the next generation, part of what we recall must be just this divide, so that we never mistake our experiences for those of the survivors themselves.

"You can't shock us, Damien [Hirst]," are the words the artist Elke Krystufek has pasted over one of her collage works. "That's because you haven't based an entire exhibition on pictures of the Nazis." Is this to say that the point here is merely to shock? Or that in a culture inured to the images of vivisected animals, only the images of Nazis can still shock? Or is the artist after something else altogether? I think it's something else. Rather than repeating the degrading images of murdered and emaciated Jewish victims, thereby perpetuating the very images the Nazis themselves left behind, artists like Krystufek now turn their accusing gaze on the killers themselves. For these artists, the only thing more shocking than the images of suffering victims is the depravity of the human beings who caused such suffering.

To the traditional art that creates an empathetic nexus between viewers and concentration camp victims, these artists would add an art that brings us face to face with the killers themselves. Rather than allowing for the easy escape from responsibility implied by our traditional identification with the victims, these artists would challenge us now to confront the faces of evil—which, if the truth be told, look rather more like us than do the wretched human remains the Nazis left behind. In the process, we are led to ask: Which leads to deeper knowledge of these events, to deeper understanding of the human condition? Images of suffering, or of the evil doers who caused such suffering? Which is worse? The cultural commodification of victims or the commercial fascination with killers? These artists let such questions dangle dangerously over our heads, and in the end, I have to say over their own. At the same time, it may also be true that not all of this art or the artists can bear the weight of the questions they have posed.

On the one hand, victimized peoples have long appropriated their oppressors' insidious descriptions of themselves as a way to neutralize their terrible charge. But what does it mean to appropriate images of the Nazi killers into the contemporary artistic response to the terror they wrought? Is this a way to normalize such images, making us comfortable with them, bringing them back into the cultural conversation, denying to them the powerful charge that even the killers themselves hoped to spread? Or is it merely to redirect the viewers' attention away from the effects of such terror to its causes?

Alas, these are the easy questions articulated so disturbingly by this exhibition of Nazi imagery in recent art. Tougher, more unsettling, and yes, even more offensive questions are also raised and openly addressed by both the works in this exhibition and by the catalog essays written by the curator Norman L. Kleeblatt and others, including Lisa Saltzman, Ernst van Alphen, Sidra Ezrahi, Reesa Greenberg, and Ellen Handler Spitz. To what extent, for example, are we even allowed to consider the potential erotic component in the relationship between Nazi murderers and their Jewish victims? What does it mean to "play" Nazis by building your own model concentration camp out of LEGOs? Is this different from "playing" Nazis in the movies? Were Nazis beautiful? And if not, then to what aesthetic and commercial ends have they been depicted over the years in the hunkish movie-star images of Dirk Bogarde, Clint Eastwood, Frank Sinatra, Max van Sydow, and Ralph Fiennes in Piotr Uklanski's photo installation *The Nazis?* What does it mean for Calvin Klein to sell underwear and cologne in the Brekerian images of the Aryan ideal? And if this is possible, is it also possible for a son of survivors, the British artist Alan Schechner, to imagine himself standing amidst emaciated survivors at Buchenwald, drinking a Diet Coke? Is he merely

Self Portrait at Buchenwald—It's the Real Thing by Alan Schechner, 1993. *Photo: Courtesy Jewish Museum, New York.*

adhering to the Passover refrain that enjoins us to remember these events as if we were there, as Michael Berenbaum has suggested? Or is this an extension of the artist's other work, *Bar Code to Concentration Camp Morph,* which would critique the potential for commercial exploitation of the Holocaust by anyone, anywhere, including the artist himself?

Indeed, just where are the limits of taste and irony here? And what should they be? Must a depraved crime always lead to such depraved artistic responses? Can such art mirror evil and remain free of evil's stench? Or must the banality of evil, once depicted, lead to the banalization of such images, and become a banal

art? As the Jewish Museum has made very clear in the dissenting (and affirming) voices of survivors included as part of the show's installation, such questions constitute the very reason for this exhibition. These questions are asked explicitly in wall panels by survivors, artists, and rabbis in a talking-heads video, and they are implied in a fascinating compilation of popular cultural film and television clips, from *The Producers,* to *Hogan's Heroes,* to *The Twilight Zone.* What's worse, Mel Brooks's song from *The Producers,* "Springtime for Hitler," or art that self-consciously examines such a phenomenon? On Broadway in New York that spring of 2002, it was possible to pay $150 for the right to laugh at Hitler's shenanigans in *The Producers,* but it was not possible to laugh at art that questioned this cultural conversion of terror into entertainment.

Neither do the artists always help themselves. On the eve of the March 17 opening, a disastrous interview of the artist Tom Sachs by the art critic Deborah Solomon appeared in the *New York Times Sunday Magazine.* "Tell me about your 'Prada Deathcamp,' one of the more incendiary works in the show," Solomon asks. Tom Sachs answers agreeably, "It's a pop-up death camp. It's a sort of best-of-all-worlds composite, with the famous Gate of Death and Crematorium IV from Auschwitz. I made it entirely from a Prada hatbox."[4] He goes on to describe what Prada means to him, mainstream hipness and a place where you meet everyone you've ever known in your life. To which Solomon responds, "What does that have to do with Hitler?" And here the artist Sachs did his best to suggest that the Emperor of Contemporary Installation Art was as naked as its crankiest critics had long suggested. With queasy stomach, I quote: "I'm using the iconography of the Holocaust to bring attention to fashion. Fashion, like fascism, is about loss of identity. Fashion is good when it helps you to look sexy, but it's bad when it makes you feel stupid or fat because you don't have a Gucci dog bowl and your best friend has one." To which an incredulous Deborah Solomon can only say, "How can you, as a presumably sane person, use the Nazi death camps as a metaphor for the more coercive aspects of the fashion industry? It makes me think you have failed to grasp the gravity of the Holocaust." I couldn't have said it better myself.

But in fact, Sachs's work and approach to it, as puerile as it may be, also provides that negative benchmark of kitsch and shallowness against which the rest of the show's art might be measured and, I think, more seriously considered. Much more compelling, even haunting, are the fantasies of the Israeli artists Roee Rosen and Boaz Arad. In the former, Rosen's unfettered novelistic imagination asks us to put ourselves in the place of Eva Braun during her last moments in the bunker in Hitler's embrace—not a place many of us would want to go—but a

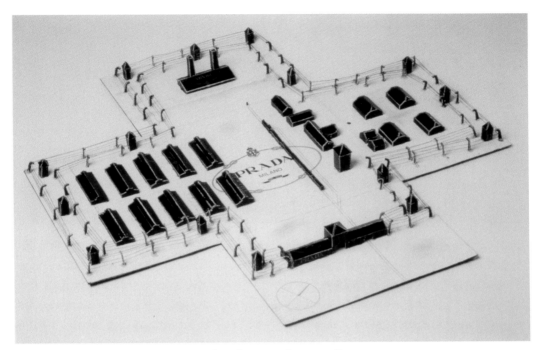

Tom Sachs, *Prada Deathcamp,* 1998. Carboard paper, ink, wire, adhesive.
Photo: Courtesy Jewish Museum, New York.

suspension of judgment that allows us to get an intimate look at evil incarnate. Boaz Arad's fantasy is of an entirely different order. It is not about Hitler the seducer of a woman or an entire nation, but about an Israeli Jew's simple need for an apology from Hitler for what he did. By cutting and remixing original film clips of Hitler's speeches, the artist literally forces Hitler's own guttural utterances into a Hebrew sentence, so that we see Hitler gesticulate and proclaim in his own voice, "Shalom Yerushalayim, ani mitnatzel" (Shalom, Jerusalem, I apologize). People laughed when the American artist Bruce Nauman proposed that Germany's Holocaust memorial simply be composed of a tablet with the words, "We're sorry for what we did, and we promise never to do it again." I don't think any of us should be ashamed for fantasizing about an apology from Hitler, especially not the artists whose job it is to show us what we were only imagining.

Another work, the Polish artist Zbigniew Libera's *LEGO Concentration Camp Set,* also attracted more than its share of negative attention. But in fact, having been widely shown in exhibitions around the United States and Europe (one

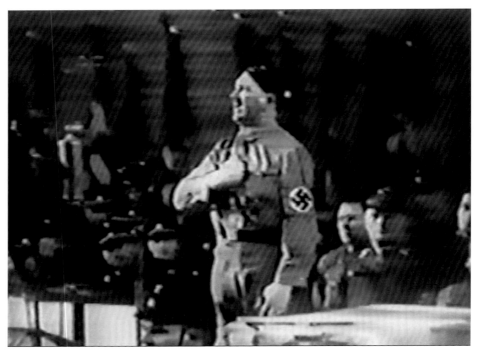

"Shalom Yerushalayim, ani mitnatzel." Still from Boaz Arad's *Hebrew Lesson* (2000).
Photo: Courtesy Jewish Museum, New York.

even cosponsored by the New Jersey State Holocaust Education Commission), this piece has already done much more than provoke outrage among viewers: it has also provoked dozens of thoughtful reflections on just how Auschwitz is ever going to be imagined by anyone born after the terrible fact. Like Art Spiegelman's *Maus,* it has also taken a seemingly "low form" of art and used it to address the artist's own tortured relationship to a place and events he never knew directly. And like David Levinthal, who when asked why he took photographs of Nazi toys instead of the reality itself replied that the toys, fortunately, were his only reality of Nazis, Libera similarly recognizes that his only connection to Auschwitz is an imagined one. Outraged critics like Menachem Rosensaft asked What's next, a LEGO recreation of the World Trade Center's destruction? What would the families of the murdered firefighters think of that?

At which point, I recalled how I'd stumbled upon my two young boys, ages five and seven, up early one morning at work on a LEGO memorial to the World Trade Center, this after we'd taken pains to protect them from nearly all the media's images of the destruction. I also recalled the night some two weeks after

the September 11 attacks, when I heard our seven-year-old Asher screaming at his younger brother from the other room, "But Ethan, you have to fall down when I crash into you—that's the tragedy of the World Trade Center, that the towers fell down when the planes crashed into them." Do our kids trivialize these events the moment they all too reflexively try to get their imaginations around them? Do we therefore proscribe "playing" with such events altogether, thereby relegating them to the unimaginable, despite the historical fact that someone, somewhere had to imagine such events in order to perpetrate them?

If these questions are problematically formalized in this exhibition's art works, they are also carefully elaborated in the exhibition's catalog essays. In this vein, the art historian Ellen Handler Spitz explores the perilous border between inviolate childhood and absolutely violated children, that inner-world terror of children devastated by a cruelty whose name they cannot pronounce. What can children do with such trauma? Ernst van Alphen persuasively argues that to some extent the child has come to stand "for the next generations, who need to learn a trauma they have not directly lived," who instead of talking about such terror, or looking at it, will necessarily "play-act" it as a way to know and work through it.[5]

In fact, all of the writers here are acutely aware that exhibiting and writing about works such as these may be regarded by some to be as transgressive and disturbing as the art itself. Thus, both the exhibition curator, Norman Kleeblatt, and the literary historian Sidra Ezrahi have probed deeply into what Ezrahi

Zbigniew Libera's *LEGO Concentration Camp Set,* 1996. *Photo: Courtesy Jewish Museum, New York.*

presciently calls the " 'barbaric space' that tests the boundaries of a 'safe' encounter with the past." Here, in fact, the cultural critic Reesa Greenberg reminds us that "playing it safe" is no longer a viable option for museums, curators, critics, or viewers when the questions at hand are necessarily so dangerous. For as the art historian Lisa Saltzman shows in her reconsideration of the avant-garde, since "all the verities are [now] thrown into question," such transgressions require an art that makes excruciating demands on both critics and viewers. It is almost as if the more strenuously we resist such art, the more deeply we find ourselves implicated in its transgressions.

For a generation of artists and critics born after the Holocaust, their experience of Nazi genocide is necessarily vicarious and hypermediated. They haven't experienced the Holocaust itself but only the event of its being passed down to them. As faithful to their experiences as their parents and grandparents were to theirs in the camps, this media-saturated generation thus makes as its subject the blessed distance between themselves and the camps, as well as the ubiquitous images of the Nazis and their crimes they find in the commercial mass media.

Of course, we have every right to ask whether such obsession with these media-generated images of the past is aesthetically appropriate. Or whether by including such images in their work, the artists somehow affirm and extend them, even as they intend mainly to critique them and our connection to them. But then, this ambiguity between affirmation and criticism, too, seems to be part of the artists' aim here. As offensive as such work may seem on the surface, the artists might ask, is it the Nazi imagery itself that offends or the artists' aesthetic manipulations of such imagery that is so offensive? Does such art become a victim of the imagery it depicts? Or does it actually tap into and thereby exploit the repugnant power of Nazi imagery as a way merely to shock and move its viewers? Or is it both, and if so, can these artists have it both ways? By extension, can a venerable institution like the Jewish Museum ever just hang such work on its walls without creating a space for it in the high-art canon? Can a museum ever show art in order to critique it without also implicitly affirming it as somehow great art that had to earn a place on the museum's walls?

In some ways, these questions assumed a greater prominence in the minds of both viewers and critics after September 11. The ever-collapsing line between gallery and museum exhibitions, encouraged by so much conceptual and installation art (and, let's face it, inspired by Duchamp many years ago), much of it brazenly anti-commercial, suddenly seemed like an indulgence we could no longer afford. Critics who had been complaining for years that the museum's role as arbiter of what was worthy and deserving of cultural preservation had all but

been eviscerated by showing art whose essence openly negated such curatorial aims dug in their heels. Their patience had been exhausted both by such shows (see the reviews of the 2002 *Whitney Biennial*) and by what they regarded as a self-absorbed generation of artists more preoccupied with their handiwork than with a world outside of themselves. Some critics, such as the *New York Times*'s Michael Kimmelman, grumpily admitted to having reached the end of their patience with the repetitive plumbing of shock value for its own sake, with contemporary installation art's repeatedly saying "look what I can do" over and over again. One week Kimmelman extolled the MoMA retrospective of Gerhard Richter, one of the main conceptual forebears of this show, and the next he excoriated the artists in *Mirroring Evil* for having taken their cue from him.[6]

Clearly, something in all these works resonated deeply with Norman Kleeblatt, who conceived and organized this exhibition. As the child of German Jewish refugees who barely escaped with their lives and the grandson and great-grandson of Jews murdered in the camps, Kleeblatt had the courage to face the images of an evil that has defined his truncated family legacy and continues, whether he likes it or not, to shape his identity as an American and as a Jew.

In mounting this exhibition, the Jewish Museum showed similar courage in the way it openly faced equally fraught institutional issues: Where is the line between historical exhibition and sensationalistic exhibitionism? Can any exhibition, even the most rigorously framed, or the artists, or curators, or even we as viewers objectively critique sensationalist imagery without participating in the sensation itself? In the end, viewers of the exhibition and readers of its catalog will have to decide for themselves—but only after they have actually seen the exhibition. Though even here, the answers may depend on just how self-aware each of us is when it comes to understanding our own motives for gazing on such art, our own need to look evil in the face even as we are repelled by what we see.

In reference to Germany's Holocaust memorial problem, I once wrote that after the Holocaust, there could be no more "final solutions" to the dilemmas its memory posed for contemporary artists; there can be only more questions.[7] For these artists, the issue was never whether or not to show such images but rather how to ask in them: To what extent do we always re-objectify a victim by reproducing images of the victim as victim? To what extent do we participate in their degradation by reproducing and then viewing such images? To what extent do these images ironize and thereby repudiate such representations? Or to what extent do these images feed on the same prurient energy they purportedly expose? To what extent does any depiction of evil somehow valorize or beautify it, even when the intent is to reveal its depravity?

For artists at home in their respective media, questions about the appropriateness of their forms seem irrelevant. These artists remain as true to their forms and chosen media as they do to their necessarily vicarious "memory" of events. But for those less at home in the languages of contemporary art, the possibility that form—especially the strange and new—might overwhelm, or even become the content of such work will lead some to suspect the artists' motives. Some may wonder whether such work seems more preoccupied with being stimulating and interesting in and of itself than it is with exploring events and the artist's relationship to them afterward. Some may be leery of the ways such art may draw on the very power of Nazi imagery it seeks to expose, the ways such art and its own forms are energized by the Nazi imagery it purports only to explore.

Even more disturbing may be the question the historian Saul Friedländer raised several years ago in his own profound meditations on "fascinating Fascism," whether an aesthetic obsession with Fascism is less a reflection on Fascism than it is an extension of it. Here Friedländer asks whether a brazen new generation of artists bent on examining their own obsession with Nazism adds to our understanding of the Third Reich or only recapitulates a fatal attraction to it. "Nazism has disappeared," Friedländer writes, "but the obsession it represents for the contemporary imagination—as well as the birth of a new discourse that ceaselessly elaborates and reinterprets it—necessarily confronts us with this ultimate question: Is such attention fixed on the past only a gratuitous reverie, the attraction of spectacle, exorcism, or the result of a need to understand; or is it, again and still, an expression of profound fears and, on the part of some, mute yearnings as well?"[8] As the artists in this exhibition suggest, the question remains open. Not because every aesthetic interrogation of Nazi imagery also contains some yearning for "fascinating fascism." But because they believe that neither artist nor historian can positively settle this question. In fact, by leaving these questions unanswered, these artists confront us with our own role in the depiction of evil doers and their deeds, the ways we cover our eyes and peek through our fingers at the same time.

No doubt, some will see such work as a supremely evasive, even self-indulgent art by a generation more absorbed in its own vicarious experiences of memory than by the survivors' experiences of real events. Others will say that if artists of the second or third generation want to make art out of the Holocaust, then let it be about the Holocaust itself and not about themselves. The problem for many of these artists, of course, is that they are unable to remember the Holocaust outside of the ways it has been passed down to them, outside of the ways it is meaningful to them fifty or sixty years after the fact. As the survivors have testified to their experiences of the Holocaust, their children and their children's children will

now testify to their experiences of the Holocaust. And what are their experiences? Photographs, film, histories, novels, poems, plays, survivors' testimonies. They are necessarily mediated experiences, the afterlife of memory, represented in history's afterimages.

Why represent all that? Because for those in this generation of artists, to leave out the truth of how they came to know the Holocaust would be to ignore half of what happened: we would know what happened to the survivors and victims but miss what happened to their children and grandchildren. Yet, isn't the important story what happened to the victims themselves? Yes, but without exploring why it's important, we leave out part of the story itself. Is it self-indulgent or self-aggrandizing to make the listener's story part of the teller's story? This generation doubts that it can be done otherwise. These artists can no more neglect the circumstances surrounding a story's telling than they can ignore the circumstances surrounding the actual events' unfolding. Neither the events nor the memory of them take place in a void. In the end, these artists ask us to consider which is the more truthful account: that narrative or art which ignores its own coming into being, or that which paints this fact, too, into its canvas of history?

6

The Contemporary Arts of Memory in the Works of Esther Shalev-Gerz, Mirosław Bałka, Tobi Kahn, and Komar and Melamid

I.
SPACES FOR DEEP MEMORY:
Esther Shalev-Gerz and the First Countermonuments

As I discussed in my Introduction, the dedication of Maya Lin's Vietnam Veterans Memorial in 1982 seemed a revelation for an entire generation of young memorial artists. In it they found a contrarian memorial vernacular for the expression of their own ambivalence toward conventional memorial forms and the fixed national memories those forms seemed to enshrine. Eventually, counter-memorial artists and architects such as Esther Shalev-Gerz, Jochen Gerz, Horst Hoheisel, Micha Ullman, and Daniel Libeskind (among others) would acknowledge that Lin broke the mold and made much of their own counter-memorial work possible.[1]

How startling, then, that in 1983, without yet having seen or heard about the Vietnam Veterans Memorial, Esther Shalev would uncannily counterpoint her nation's own memorial tradition in *Oil on Stone*—what might be called the "other" first counter-memorial of its generation. Immigrating to Israel as an eight-year old from Vilna in 1957, Esther Shalev (like others in her generation) lived through a succession of wars, including the 1967 Six-Day War, the Yom

Esther Shalev-Gerz, *Oil on Stone,* 1983, installed at Tel Hai.
Photo: Courtesy Esther Shalev-Gerz.

Kippur War of 1973, the Litani invasion of 1978, and the Lebanon War of 1982. But it was this last, the Israeli invasion of Lebanon in June 1982, a desperate attempt to run the PLO and its rockets out of Lebanon and away from Israel's northern border, that broke an entire generation's heart and national spirit. The aerial bombardment of Beirut, the Christian Phalangists' mass murder of Palestinians in the Sabra and Shatilla refugee camp under Israel's guard, and the death of an Israeli university student and peace demonstrator in a grenade attack by an Israeli counter-demonstrator led to mass demonstrations and the eventual resignation of then–defense minister Ariel Sharon.

An entire generation of Israeli writers, artists, and academics—already war weary and skeptical of the government's rationale for Israel's first "war of choice"—would now challenge not just the war but also their own young nation's founding myths and narratives, especially as they seemed to buttress the government's war claims and continued occupation of the West Bank. Israeli soldier-poets and playwrights suddenly began to evoke Holocaust imagery in their depictions of young Palestinian and Lebanese victims of Israel's invasion. Authors such as Amos Oz and A. B. Yehoshua publicly upbraided Prime Minister Menachem Begin for comparing Yasser Arafat in Beirut to Adolph Hitler in his Berlin bunker.[2] A rising school of Israeli academics, "the New Historians," openly began to question the state's founding fathers' version of the 1948 War of Independence and the subsequent Palestinian refugee crisis.[3]

In 1982, Esther Shalev took part in a large exhibition of contemporary art, *Here and Now,* at the Israel Museum in Jerusalem. For her piece, *Oil on Metal,* Shalev took a large sheet of steel, folded to be free-standing, and cut out a laser-etched human figure (inspired by Picasso, she would later say). The figure is absent, an empty space in the oil-painted metal sheet. Invited the next year to participate in a large outdoor landscape exhibition at Tel Hai, in the northern section of Upper Galilee, Shalev fabricated this same "missing figure" in a mortared wall of white stone blocks, which had been cut from a single large slab of Jerusalem stone. She installed *Oil on Stone* on a wild, rocky hillside, just north of and entirely visible from the national shrine to Yoseph Trumpeldor, an early Zionist pioneer and military hero killed while defending a small Jewish settlement at Tel Hai in 1920. According to Yael Zerubavel, "When the State of Israel was founded, Tel Hai was established as an Israeli national 'myth of beginning,' representing the pioneering era in Israeli history. . . . [T]o the Jewish community in Palestine, the battle at Tel Hai symbolized a major transformation of Jewish national character and the emergence of a new spirit of heroism and self-sacrifice."[4] As the national site of Israel's transformational myth of origins, Tel Hai would now become the site of yet another transformation in national consciousness.

Cutout, negative-form of *Oil on Stone.*
Photo: Courtesy Esther Shalev-Gerz.

Permanently installed in 1983, Shalev's *Oil on Stone* planted its missing human figure as a counterpoint to both the surrounding natural landscape and the white Jerusalem stone blocks composing *The Roaring Lion,* the sculptor Abraham Melnikov's memorial to the legendary Trumpeldor, designed in the blocky Assyrian style of its time, and dedicated at Tel Hai in 1934. By installing *Oil on Stone* within the sightlines of *Roaring Lion,* Shalev physically and visually countered this national memorial with another kind of memorial, challenging the fixed, heroic idealization of Trumpeldor with a work of sculpture that changes as visitors move around it. In its two carved-out panels of stone blocks, placed at forty-five degrees to each other, the absent human silhouette seems to move as one passes by, changing form, before seeming to crumble into fallen ruins. In its spatial dialogue with the national memorial to Yoseph Trumpeldor, *Oil on Stone* turns itself from a free-standing negative-form sculpture into a national counter-memorial par excellence—the other great "countermonument" of its generation—challenging (but not negating) the fixed memory of Israel's national origins.

The Vanishing Monument in Hamburg-Harburg

Other notable artists also participated in the 1983 Tel Hai open-air exhibition, including the Israeli artist Micha Ullman, whose installation *Sky* consisted of a trench dug into the hillside, an early negative-form monument and meditation on absence. Years later, Ullman would become renowned for his eloquent *Book Burning Memorial, Bibliotek,* a room of empty book shelves built beneath Berlin's Bebelplatz. His description of the empty library later echoed the pit he had dug out at Tel Hai: "It begins with the void that exists in every pit and will not disappear. You could say that emptiness is a state, a situation formed by the sides of the pit: The deeper it is, the more sky there will be and the greater the void. In the library containing the missing books, that void is more palpable."[5]

At the Tel Hai exhibition, Esther Shalev met another artist, Jochen Gerz, a Berlin-born conceptual artist of erasure and self-effacement. This was 1983, and a match was made between the Israeli artist whose patience with her national narrative and its shrines had run out and the German artist whose skepticism of monumental and other fixed art forms seems to have been bred into him. By 1972, Jochen Gerz had already mounted an exhibition—*Exit/Dachau*—which offered an explicit critique of Germany's attempt to memorialize its victims, suggesting that in its pedagogical rigidity, the national memorial at Dachau was actually an extension of the authoritarian principles whose victims it would now claim to memorialize. Thus matched in the "holy land," and married soon after, Esther Shalev-Gerz and Jochen Gerz would collaborate on what is commonly regarded as their generation's first and greatest countermonument to the victims of Nazi Germany: the vanishing *Monument against Fascism, War, and Violence—and for Peace and Human Rights* in the Harburg district of Hamburg (1986–1993).

In fact, in Germany the issues surrounding Holocaust memorialization come into the sharpest, most painful relief. In the land of what Saul Friedländer has called "redemptory anti-Semitism," the possibility that art might redeem mass murder with beauty (or with ugliness), or that memorials might somehow redeem this past with the instrumentalization of its memory, continues to haunt a postwar generation of memory artists.[6] Moreover, artists in Germany are both plagued and inspired by a series of impossible memorial questions: How does a state incorporate shame into its national memorial landscape? How does a state recite, much less commemorate, the litany of its misdeeds, making them part of its reason for being? Under what memorial aegis does a nation remember its own barbarity? Where is the tradition for memorial mea culpa? By 1989, Germany's "Jewish question" had morphed into a two-pronged memorial question: How does a nation mourn the victims of a mass murder perpetrated

in its name? How does a nation reunite itself on the bedrock memory of its horrendous crimes?

Further complicating Germany's memorial equation was the postwar generation's deep distrust of monumental forms in light of their systematic exploitation by the Nazis. In their eyes, the didactic logic of monuments—their demagogical rigidity and certainty of history—continued to recall too closely traits associated with fascism itself. A monument against fascism, therefore, would have to be monument against itself: against the traditionally didactic function of monuments, against their tendency to displace the past they would have us contemplate—and finally, against the authoritarian propensity in monumental spaces that reduces viewers to passive spectators. Rather than attempting to resolve such memorial questions, Esther Shalev-Gerz and Jochen Gerz would now strive for their formal articulation.

Within months of meeting Shalev at Tel Hai in 1983, Jochen Gerz had been invited as one of six artists to propose a design in Hamburg for a *Monument against Fascism, War, and Violence—and for Peace and Human Rights,* a tortuously convoluted title in German for a kind of "Holocaust monument." According to Shalev-Gerz, when Gerz first broached this invitation with her, she replied by gesturing out her window to Israel's own monument-strewn landscape. "What do we need with another monument? We have too many already. What we need is one that disappears."[7] Here she agreed to work with Gerz toward finding a form that challenged the monument's traditional illusions of permanence, its authoritarian rigidity. The resulting collaboration between Shalev-Gerz and Gerz would thus combine a traditional Jewish skepticism of material icons and a postwar German suspicion of monumental forms. "What we did not want," they declared, "was an enormous pedestal with something on it presuming to tell people what they ought to think."[8] Theirs would be a self-abnegating monument, literally self-effacing, and it won the competition for the Hamburg-Harburg monument.

Unveiled in Harburg in 1986, this twelve-meter-high, one-meter-square pillar was made of hollow aluminum plated with a thin layer of soft, dark lead. An inscription near its base read in seven languages:

We invite the citizens of Harburg, and visitors to the town, to add their names here to ours. In doing so, we commit ourselves to remain vigilant. As more and more names cover this 12-meter-tall lead column, it will gradually be lowered into the ground. One day it will have disappeared completely, and the site of the Harburg monument against fascism will be empty. In the end, it is only we ourselves who can rise up against injustice.

Esther Shalev-Gerz and Jochen Gerz, *Monument against Fascism, War, and Violence—and for Peace and Human Rights*, 1986–1993.

Wary that such memorials had too often served as substitutes for intervention rather than as calls for action, the artists reminded visitors that it was we, not our monuments, who would have to act against injustice.

With audacious simplicity, Esther and Jochen's countermonument would thus flout nearly every cherished memorial convention: its aim was not to console but to provoke; not to remain fixed but to change; not to be everlasting but to disappear; not to be ignored by its passersby but to demand interaction; not to remain pristine but to invite its own violation; not to accept graciously the burden of memory but to throw it back at the town's feet. How better to remember a now-absent people than by a vanishing monument? After several lowerings over the next seven years, the *Monument against Fascism* itself vanished on November 10, 1993, with its last sinking. Nothing is left aboveground but the top surface of the monument, even as a section of the sunken monument itself is partly visible through a glass window into its underground chamber, suggesting its having been internalized by the earth. On its complete sinking, the artists hoped that it would return the burden of memory to those who came looking for it. Now all that stands here are the memory tourists, forced to rise and to remember for themselves.

The now vanished *Monument against Fascism, War, and Violence.*
Photo: Courtesy Esther Shalev-Gerz.

Between Listening and Telling

Whether opening up spaces for dialogue between sculptures in the landscape, or opening up the space in a cityscape previously occupied by a now-vanished monument, Esther Shalev-Gerz lives and creates by a singular credo: "You have to open up spaces." Moreover, in her words, "Spatial constructions are not static. They are persistently transformed and re-defined by the people that 'practice' the space they are in."[9] In her extraordinary 2005 installation at the Hotel de Ville in Paris, *Between Listening and Telling: Last Witnesses, Auschwitz 1945–2005,* Shalev-Gerz visually plumbed the depths of what may be the most profoundly elusive of all memory spaces: that space between a survivor's deep memory of traumatic experience and its verbal articulation.

The Holocaust historian Saul Friedländer has drawn a clear distinction between what he terms "common memory" and "deep memory" of the Holocaust: common memory as that which "tends to restore or establish coherence, closure and possibly a redemptive stance," and deep memory as that which remains essentially inarticulable and unrepresentable, that which continues to exist as unresolved trauma just beyond the reach of meaning. Not only are these two orders of memory irreducible to each other, Friedländer says, but "any attempt at building a coherent self founders on the intractable return of the repressed and recurring deep memory."[10] That is, to some extent, every common memory of the Holocaust is haunted by that which it necessarily leaves unstated, its coherence a necessary but ultimately misleading evasion.

As his sole example of deep memory, Friedländer refers to the last frame of Art Spiegelman's Holocaust commix book, *Maus: A Survivor's Tale,* in which the dying father addresses his son, Artie, with the name of Richieu, Artie's brother who died in the Holocaust before Artie was even born.[11] The still apparently unassimilated trauma of his first son's death remains inarticulable—and thereby deep—and so is represented here only indirectly as a kind of manifest behavior. But this example is significant for Friedländer in other ways, as well, coming as it does at the end of the survivor's life. For Friedländer wonders, profoundly I think, what will become of this deep memory after the survivors are gone. "The question remains," he says, "whether at the collective level . . . an event such as the Shoah may, after all the survivors have disappeared, leave traces of a deep memory beyond individual recall, which will defy any attempts to give it meaning."[12] The implication is that, beyond the next generation's artistic and literary representations of it, such deep memory may be lost to history altogether.

In fact, there is another moment in Spiegelman's *Maus* that may also exemplify a survivor's deep memory and its untranslatability into narrative. It occurs during

From Art Spiegelman's *Maus: A Survivor's Tale*. Photo: Courtesy Art Spiegelman.

a session between Artie and his psychotherapist, Pavel, who like Artie's father is a Holocaust survivor. Here Spiegelman seems also to be asking how we write the stories of the dead without filling in their absence. In a way, the co-mixture of image and narrative allows the artist to do just this, to make visible crucial parts of memory work usually lost to narrative alone, such as the silences and spaces between words. In a series of four frames, Art listens as Pavel compares all that is written about the Holocaust to the absolute silence of the dead, the absence of the dead victims' stories. How to show a necessary silence? Pavel suggests that because "life always takes the side of life . . . the victims who died can never tell THEIR side of the story, so maybe it's better not to have any more stories." To which Art responds in the next panel, "Uh-huh. Samuel Beckett once said: 'Every word is like an unnecessary stain on silence and nothingness.'" This is followed by a panel without words, only Art and his therapist sitting silently, smoking and thinking, a moment in the therapeutic context as fraught with significance as narrative itself. This is not silence as an absence of words but silence as something that actively passes between two people—the only frame in the two volumes without words or some other sign denoting words. In the next panel,

Art gesticulates, "On the other hand, he SAID it." Pavel replies in the same panel, "He was right. Maybe you can use it in your book."[13]

Conceived to mark the sixtieth anniversary of the Red Army's liberation of Auschwitz, Shalev-Gerz's memory installation *Between Listening and Telling* turned the elegant space of the Hotel de Ville's Grande Salle outside-in, taking an interior space and inviting visitors to further interiorize the spaces between survivors' videotaped words. What was commemorated here would not be the physical liberation of survivors from the camp, but the nonliberation of survivors from their own internal memories. Being freed from Auschwitz is not tantamount to being freed from one's memory of what happened there. But how to show this?

In 2005, Shalev-Gerz assembled a team of videographers to record the testimonies of some sixty Auschwitz survivors living in Paris, in which they described their lives before, during, and after their internment. Leaving these taped interviews unedited, Shalev-Gerz then showed them on fifteen small monitors and DVD players, with headphones, allowing viewers to watch and listen to any of the audiovisual testimonies they chose, as they sat in four parallel rows of tables and chairs running the length of the Grande Salle. At the end of the room, on three large screens mounted side by side, a single silent video of survivors' testimonies was projected, but with a seven-second time-lapse clip showing only the slow-motion faces of survivors in the silent spaces between their words.

It is the space between words, the artist suggests, when memory remains wholly internal and still alive in the mind. Words may be necessary when one wants to share memory, but they also inevitably fix memory into a sound, an idea that it was not when it remained wholly internal and unverbalized. Without words, or between words, our eyes are drawn to the survivors' faces and eyes, where we can see them remembering, without knowing what is being remembered. Here we become witnesses to the survivors' inward-search for memory, witnesses to their search for language commensurate to their memory, witnesses to their inability to find such language, witnesses to the pain such memory now reinflicts on them. We watch as memory remains within, as it finds expression in facial contortions, but not in speech. Whereas writers and speakers must necessarily break silence in order to represent it, silence remains audiovisually palpable here. Silence that cannot exist in print except in blank pages is now accompanied by the image of one who is silent, who cannot find the words, who may have no words for such memory. In this installation, we are witness to the speaking and to the not-speaking. This is how Shalev-Gerz shows us not only the profound space between listening and telling, but also the untraversible space between a survivor's memory and her verbal testimony. It is almost as if, once verbalized, such memory is no longer the survivor's memory at all, but now only our own.

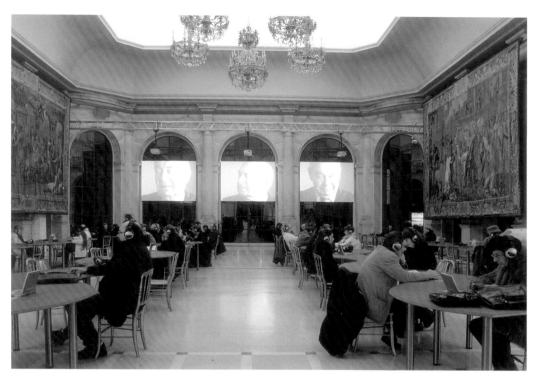

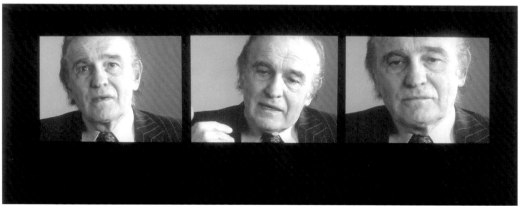

Esther Shalev-Gerz, *Between Listening and Telling,* Hotel de Ville, 2005. *Photos: Courtesy Esther Shalev-Gerz.*

II.
MIROSŁAW BAŁKA'S *GRAVES IN THE SKY*

An unapologetic child of history, Mirosław Bałka (b. 1958) came of age amidst the ruins and landscape of Polish national suffering. As the Polish landscape bore the literal, physical scars of World War II–era destruction and Holocaust, so too did Bałka seem inwardly scarred by the memory of events he never knew directly. He carries within him the burden of a history that was not his making, the memory of a past that is being made constantly for him.

The grandson of a gravestone carver and the son of an engraver of tombstone inscriptions, Bałka comes from a long line of monument makers. But his medium is no longer stone; instead, it is the light and shadows and ambient sound of video installation. Memory, in its ephemerality, demands an ephemeral medium. "Every day I walk in the paths of the past," Bałka has said. "Contemporary time does not exist. We cannot catch the continuous."[14] How to reflect on this past without fixing it? How to grasp it without concretizing it? We cannot catch the continuous, the artist implies, without making it discontinuous. As a medium, Bałka's "video memorials" are the closest the artist can come to gripping the ongoing, fluid presence of the past without fixing it. Like others in his postwar generation, Bałka grew up to be a "counter-memorialist" who bitterly rejects the memorial conventions that too often fix and thereby nullify living memory.

If the ruins of death camps such as Majdanek and Auschwitz-Birkenau are fixed in the landscape, the memory they generate in the artist is anything but fixed. In Bałka's video *Carroussell* (2004), the barracks at Majdanek spin around us in a dizzying, sickening swirl. The artist has trapped us in a memorial vortex, pulling us into the center of the Appelplatz, the roll call plaza, by the centripetal force of his spinning camera. Round and round and round the barracks whirl, a deadly "Ring around the rosies, pocket full of posies, ashes, ashes, all fall down!" It is as if the Black Plague–era nursery rhyme and game were being set to a more recent mass death. Majdanek swirls around us as it spins unendingly inside the artist's mind.[15]

Unlike *Carroussell*, which is installed vertically on the walls, several of his earlier video memorials based on the sites of former concentration camps have been cast horizontally onto the ground, gravelike. With their cinemagraphic illusion of depth, these video gravestones seem carved into the ground, video versions of negative-form monuments. For example, in his powerful video memorial *T. Turn* (2004), Bałka has filmed the sky and trees while lying on his back near the ramp at Treblinka, waving his palm-sized video camera overhead in a quasi-circular trajectory, a double rotation that turns the treetops and fields into a spinning blur. The whirling landscape of sky and trees is projected onto the floor with the

ambient sounds of a Hebrew-speaking tour guide broadcast from above. Our eyes are drawn downward to the large horizontal square at our feet, covered in granular salt to give the projected moving image a granular, stonelike texture. But this is not fixed stone. Rather, gazing into this video grave, we see the sky, and we think of Bałka's favorite poet, Paul Celan, and his lines from "Deathfugue":

> . . . we shovel a grave in the sky
> there it won't feel too cramped
> . . .
> he shouts scrape your strings darker you'll rise then in smoke to the sky
> you'll have a grave then in the clouds there it won't feel too cramped[16]

Bałka's video memorial is just this, "a grave in the sky," the visual articulation of Celan's brilliant poetic trope.

In two other, earlier concentration camp–based videos, Bałka similarly turns conventional memorial assumptions on their head. In *Bottom* (2003), also installed on the ground, we stare down at the shaky, hand-held video image of showerheads inside the bathhouse at Majdanek. The loud, echoing footsteps of the videographer are piped in from above, the sounds of our own hurried tour, our own escape from this concentration camp relic. Endlessly looped, however, we are condemned to repeat our stampede for the exit, for a way out, even as we can never leave.

In yet another, earlier camp-based video, *B* (2006), Bałka has turned his microlens onto the upside-down letter B in the infamous cast-iron slogan "Arbeit macht frei" posted over the gate into Auschwitz I. Through blowing snow, this inverted B is accompanied by the ambient thunder of wind in the microphone and the raucous laughter and joyful screams of young German boys in a snowball fight, apparently taking place at the Gates of Hell. The German voices and some-what indecorous horseplay at the entrance to Auschwitz make the site German again, reminding us that it was made by Germans for largely Polish and Jewish prisoners. But by concentrating on the inverted B, Bałka does more than focus our thought on the resistance of the camp inmate and ironworker who (the artist believes) sought to sabotage the iron lettering. He also estranges the slogan itself and thus breaks it down. Did "work set one free" at Auschwitz? No. And as it turns out, neither does the artist's "memory work" set him free now.

In fact, quite the opposite. Bałka is imprisoned by his memory work. It does not set him free, but rather it keeps his mind locked into the camp, which he now carries within him, wherever he goes. Toward the end of his wrenching short-story collection based on his experiences as a political prisoner in Aus-chwitz, the great Polish writer Tadeusz Borowski observed: "A certain young

poet, a symbolic-realist, says with a flippant sarcasm that I have a concentration-camp mentality."[17] That is, though liberated from Auschwitz, the writer was still trapped in the concentration camp of his mind. The world would now become his concentration camp.

It is this Holocaust-on-the-brain that turns otherwise small and banal objects of everyday life into ominous and threatening "glints of evil" for Bałka, and now for us, his audience. Thus viewed in *DB Real* (2008), an otherwise pedestrian and inert Euro-pallet used for transporting dry cargo morphs into a haunting apparition of the inside of a cattle car used by the Nazis to transport what they called Jewish "Stuecke" (pieces) to the death camps. The work's title, an acronym for Deutsche Bahn (German railway), points in the direction of the artist's preoccupation. The grid of the pallet and blinking light behind it are suggestive of the small vents of the cattle cars, the only source of light and air. It's all in the imagination, of course, evoked by very simple materials, their associations seared into the artist's mind, and now ours.

Similarly, in *AAA+Rauschsignale* (2007), we share the artist's revulsion in the throaty roar of an internal combustion engine, producing nothing more than smoke and exhaust, as it is revved continuously for five minutes and twenty-six seconds. With each rev a spout of black smoke bursts upward into a steel gray sky. A sustained rev will produce a little more exhaust. In this context, it is a killing smoke, of course, a smoke signal of mass death, a reminder of the exhaust used to kill victims of the "death vans" at Chelmno, and of the smoke of the crematorium chimneys. Lines from Celan's poem come again to mind:

. . . you'll rise then as smoke to the sky
you'll have a grave then in the clouds . . .

Are these smoke signals from history a terrible kind of code, or just the idling of an engine, spewing its exhaust to no other effect than to darken the heavens? Or did the heavens not darken, after all?

In an earlier video installation *BlueGasEyes* (2004), a single long take of a round stove-top gas burner is named so that this simple, everyday object, too, is stigmatized. Together, *BlueGasEyes* become Aryan-blue eyes, and we're reminded yet again of lines from Celan's "Deathfugue":

Death is ein Meister aus Deutschland his eye is blue

In fact, Bałka seems to find his fragments of memory everywhere, even in others' films. In *Primitive* (2008), the artist lifts a three-second excerpt from Claude Lanzmann's epic nine-and-a-half-hour Holocaust documentary, *Shoah* (1985), thereby committing a benign larceny of a clip that was itself surreptitiously

filmed by Lanzmann. In this three-second excerpt, a former SS camp guard describes the primitive but deadly efficiency of killing at Treblinka. The guard, Franz Suchomel, has just said: "Keep this in mind! Treblinka was a primitive but effective production line of death. Understand?" To which Lanzmann answers, "Yes. But primitive?" Suchomel: "Primitive, yes!" These two words ("Primitive, yes!") are looped endlessly, lodging them in mind until they make no more sense.

In *I Knew It Had a 4 in It* (2008), Bałka lifts another, equally disturbing moment from *Shoah* and turns it into a graphic tone poem. Interviewing a German woman, the wife of a Nazi schoolteacher who had been relocated to the town of Chelmno (also the site of a Nazi death camp) during the war, Lanzmann asks, "Do you know how many Jews were exterminated there?" Frau Michelsohn answers, "Four something. Four hundred thousand . . . , forty thousand . . ." Lanzmann: "Four hundred thousand." Frau Michelsohn: "Four hundred thousand, yes. I knew it had a four in it." Rather than showing us the clip, Bałka merely takes the visual numeral 4 and turns it on its nose-side, so that it appears as a combination of a cross and a triangle, or even the edge of a Star of David. To the steady, melancholy backbeat of Sun Ra's "The All of Everything," the camera pulls into close focus on the 4 (on its side), blurs into the center of its triangle, held aloft by the left arm of the cross, and then pulls back again. For Bałka, even the numeral 4 is now tainted with the memory of this moment from Lanzmann's film.

I Knew It Had a 4 in It, video and foam board. *Photo: Courtesy Mirosław Bałka.*

Of all the installations in this 2009 exhibition of Bałka's memory-themed video installations, perhaps the *Flagellare* series is most fraught with violent portent. Projected onto the gallery floor, the flinching, handheld video images of a shiny reflective concrete floor show three versions of a belt (or leather strap) repeatedly, rhythmically, and loudly striking the concrete. With every sharp lash, the video image jerks a little, an inadvertent flinch of the videographer as he simultaneously films and snaps the belt, a twist on the notion of self-flagellation. The point of view is now the gallery visitor's own: What does it mean to whip with one hand and to record the whipping in film at the same moment with the other hand? In the cavernous space, the flagellation of the floor—one lash per second—sounds like a rifle shot, each lash leaving its trace on the poured concrete floor, its sharp snap echoing in our ears.

At first glance, Bałka's *Pond* (2003) seems to be a beautifully composed study in landscape: a small, still pond seen through the winter trees, with only sounds of the wind, the videographer's even breath, the camera's whir, and a church bell ringing, or perhaps ringing children's voices. A rooster crows, the videographer breathes, and the white birch trees are bereft of leaves. Birkenau is both a birch forest and a death camp. The wind in the microphone is thunderous, and the videographer's breathing is soft, as if the artist were trying to still the slight tremor in his hand. Like other postwar artists and writers, Bałka is seemingly preoccupied by silence (nocturnal and divine) in the face of mass murder—and the impossibility of expressing such silence in any living, breathing memorial medium.

In the artist's similarly quiet and short film *Bambi* (2003), three deer are joined by one more, as they graze in the snowy grass among the ruins of barracks at Auschwitz-Birkenau, all framed by barbed wire, fence posts, and brick chimneys. Rooting in the snow for edible greens, the deer are startled (perhaps by the videographer's own camera sounds), pause and look up, then trot quickly away. The only sound is the wind in the microphone, as the deer run off through the camp, still enclosed by the barbed wire fence. The camera's telephoto lens collapses distance and the several layers of fences and barracks chimneys. The video is shot in color, though in its winter tones, it is largely monochromatic, except for the tan coats of the deer. All else is a study in black, white, and gray, snow and barbed wire. Like the artist, they are trapped in the concentration camp, however whimsically and incongruously.

At first encounter, both *Mapping the Studio, Too* (2008) and *Sundays Kill More* (2008) seem thematically out of place. *Mapping* is Bałka's abbreviated homage to Bruce Nauman's original *Mapping the Studio* (2001), itself an ironic homage to John Cage's "silent" three-movement composition *4'33"* (1952). In Nauman's piece, a mouse breaks the visual stillness of a night view of his studio. In all three

Still from *Bambi* by Mirosław Bałka. *Photo: Courtesy Mirosław Bałka.*

of these works, the artists and composer share a preoccupation, the formal articulation of ambient silence in space, as also studied in Bałka's *Pond.*

Sundays Kill More seems a further conceptual stretch. It is set in a rainy landscape of distant trees, illuminated by flashes of lightening, accompanied by Charles Bukowski's recitation of his powerful poem of the same name. The question is: What is this poem doing here, in this room, with *Pond, Bambi,* and *DB Real?* Is it possible that the artist would turn even Bukowski, the nihilistic, German-born American "poet laureate of lowlife" into a Holocaust poet? Probably not. Still, the mind reaches for associations: the Polish origins of the poet's name, the poet's attempted suicide by gas in 1961 (when this poem was first published), the poet's bitterness and bile: "We're men, bitter, brave, and numb." Is this what the artists hears in his brain while filming these landscapes? What happens when we view these installations in the same space? Indeed, what happens to us in the spaces between such installations?

"My work doesn't occupy the whole exhibition space," Bałka has said. "It occupies just a little bit of space, and the space that surrounds the work has the same importance as the space occupied by the object."[18] That is, as do the works of other artists in his generation, Bałka's installations leave space open not to be filled by viewers but to inspire an opening up of space within viewers. The aim is not to crowd out the viewers' experiences with the artist's expressions but to open space up for viewers' experiences of these expressions.

Like the other great counter-memorialists of his generation (Gerz, Shalev-Gerz, Hoheisel, Ullman, Stih & Schnock), Bałka skeptically critiques the redemptory premise of conventional memorials and monuments, the ways they can crowd out our own internal memory work. Neither work nor memory work actually sets us free. Every fixed memorial and museum carries within it the authoritarian logic it would have us commemorate, mandating how to think about the past, how to remember it. For lived memory, Bałka suggests, look inwardly and outwardly in the same moment. By reanimating everyday objects of life in a landscape of ruins, the artist reanimates memory of the past with ongoing life itself.

III.
TOBI KAHN'S *EMBODIED LIGHT:*
The Memory Spaces Within

In this 2011 multimedia installation at the Ernest Rubinstein Gallery of the Educational Alliance in New York City, Tobi Kahn has created a space for the intricate movements of mind during the work of memory.[19] As we move from memorial piece to memorial piece, our minds move from thought to thought, associated memory to associated memory, in our contemplation of the 9/11 attacks and lives lost on that day. This is a singular space in which several kinds and forms of memory have been collected: from the variegated cityscape at our feet to the memorial lights and miniature shrines on the walls to our right; from the 220 memorial building blocks on a table to Nessa Rapoport's exquisitely composed meditations on light, loss and dawn printed on the wall to our left. Each part formalizes a different kind of memory, each with its own meanings and associations. My own mind wanders to the serendipitously enumerated chapter "Eleven" of the *Tao Te Ching*, as compiled by the sixth-century BCE Chinese poet-philosopher, Lao Tsu:

> We join spokes together in a wheel,
> but it is the center hole that makes the wagon move.
> We shape clay into a pot,
> but it is the emptiness inside that holds whatever we want.
> We hammer wood for a house,
> but it is the inner space that makes it livable.
> We work with being,
> but non-being is what we use. (Trans. S. Mitchell, 1995)

It is the spaces between memorial pieces that constitute the whole, where our movements between pieces correspond to movements of the mind's eye; the spaces are filled with our memory; the spaces are where memory takes hold.

Self-described as an "object maker," Tobi Kahn is acutely aware of "what is not there" after his objects are made. His collection of found pieces of wood, the remnants left on his studio floor from his "object making" since 9/11, are what is left of the carved spaces within his sculptural works. They are literally the formal articulations of what is missing. He has taken these chunks and cubes, what Rachel Whiteread has called in her own work "the material index of absence," and has fittingly recomposed them into an ashen-hued cityscape, haunted by "what is not there." It is the room's centerpiece, installed at our feet, yet we may not enter it. Instead, we view it from on high, as if from a heavenly perch above, the way we used to gaze down on Lower Manhattan's densely clustered grid and canyons from World Trade Center 2's Top of the World observation deck.

If we raise our gaze from the memorialized view that is no more, our eyes alight on a table covered with multicolored and -textured building blocks, 220 total, one for each of the 110 floors of the fallen Twin Towers. Each of these wooden

Tobi Kahn, *Embodied Light: 9–11 in 2011,* installation view. *Photo: Courtesy Tobi Kahn.*

Embodied Light, floor piece cityscape.
Photo: Courtesy Tobi Kahn.

Embodied Light, memory blocks. *Photo: Courtesy Tobi Kahn.*

"memory blocks" has been painstakingly hand-painted by the artist in the same ash-white hue as the cityscape at our feet. Without referencing the slight word-play between the buildings' 220 stories and the victims' and our own life stories, the artist invited 220 friends, family, and acquaintances to take a block home and turn it into a "memory block" that would evoke their own memory of the day. "Do whatever you want with your block," the artist has asked. As long as it reflects outwardly the ways you were changed inwardly by that day, he seems to imply. Like the multiple media comprising the exhibition itself, these blocks reflect the multivalent responses of friends and family who collectively consti-tute the artist's community. His writer friends write on these blocks, artists draw, sculptors sculpt; some remember loved ones lost on 9/11, and others remember what broke inside them on that day. Whether trained or not, all would be turned into "memory artists" attempting to express formally and outwardly an otherwise ineffable grief.

Visitors to the exhibition are asked, in turn, to engage in their own play of memory, manually arranging these building blocks into new towers, or perhaps into memorial cairns, pyramids, and shrines. Like memory, like the towers them-selves, the forms these stacked blocks take are ephemeral, all-too-fragile, and easily toppled. Like the ongoing, evolving memory of 9/11, these blocks will be in constant flux, alive to the touch of new builders, reminding those who play and work with them that both memory and the arts of memory are processes, perhaps never to be completed. Here the artist might invoke the wisdom of Rabbi Tarfon, from *Pirkei Avot* (2:16):

> It is not your obligation to complete the work,
> but neither are you free to desist from it altogether . . .

Neither memory nor its forms are ever fixed, even when we hope they are everlasting.

In Jewish tradition, the spirit of the eternal is said to burn in the *ner tamid,* an everlasting flame or light placed in religious sanctuaries. Lighting memorial can-dles and lights is also a common practice in other religious traditions, a consoling way to recall lost loved ones and the ephemeral quality of life itself—whether found in the flickering flame of a *Jahrzeit* candle or in the candlelight vigils of mourners around the city on the night of 9/11. In his seven memorial lanterns, meant to hold and burn oil, Tobi Kahn recognizes the traditional memorial medium, even as he brings it into the contemporary moment. Dating from 2001, the first of these lamps is also a broken vessel, a gesture to the rent garment of mourning. The rest of these lamps, dating from 2008 to 2011, show the slow return to wholeness and repair, their oil basins held aloft by four pillars, then

by a four-cornered pyramidal base, then by an elegantly balanced two fingers, suggesting a sublime equilibrium in the memorial light. "You're allowed to be devastated," the artist told me. Loss is part of life, as is the constant striving to integrate it through our memorial traditions.

In a parallel vein, the artist has conceptually reinterpreted the memorial shrine to integrate (however abstractly) the forms of the fallen towers and, to my eye, the traditional Shinto *torii* of Japan, the wooden gateway arches traditionally marking passage from profane to sacred space. Like the traditional *torii* gates, these seven shrines are made of wood, an ephemeral memorial medium when compared to stone or metal. But unlike the classic *torii* arches, these shrines are composed of only two vertical pillars, without the overhead arch. Only when one tower leans brokenly into the other is a sheltering archway formed; otherwise, the towers remain apart, an open gate but a broken shrine. These pieces are both stand-alone sculptures and models for actual shrines to be built in the landscape; as shrines go, they are miniatures, until they are actually built. In these memorial shrines, the artist suggests both the destruction and the attempt to repair it through memory, which is itself a passage from profane to sacred space.

Part of the artist's work in all of his memorial pieces has been to animate traditional forms through their contemporary reinterpretation. In the case of the two "charity boxes," he has drawn on Judaism's traditional memorial prayer for the dead, Yizkor, emphasizing one of its central components over the other. "I don't believe in sacred martyrdom," the artist told me, "dying in the name of God"—which since the eleventh-century Crusader massacre of Jews in Europe had become one of the twin motifs of the Yizkor blessing. But he believes very much in the other pledge one makes when reciting Yizkor: donating charity as a way to honor and remember the dead. That is, we remember the dead not for the sake of memory alone but toward bettering the world, toward repairing the sense of loss our loved ones' passing leaves in us. Toward this end, the "charity boxes" in this exhibition are fitting emblems of "memory work" that does not culminate ritually in itself (thereby remaining hermetically self-enclosed); neither are they empty spaces to be filled only with memory of lost loved ones. Instead, the empty volumes of these boxes ask to be filled with action taken on behalf of memory. As beautiful as they may be to look at, it is the empty space within that makes them useful.

IV.
THE SOVIET MONUMENT IN RUINS:
Komar and Melamid's Monumental Propaganda

After the fall of the iron curtain in 1989, a new specter haunted Eastern Europe and the former Soviet Union—that of thousands of Communist-era monuments, crumbling, broken, and buried. Hundreds of granite pedestals sat empty and bereft, swept clean of everything but the invisible memory of heroic busts they once held aloft. Instead of burying the West, the people of the former Soviet Union now buried their monuments to a Socialist past. City parks were transformed into graveyards for monuments, where busts and statues of Lenin, Stalin, and Dzerzhinsky lay in great tangled heaps of tarnished bronze. Ashes to ashes and dust to dust, the monuments to the heroes of the Bolshevik revolution lived about as long as the human beings who made them.

In *Monumental Propaganda,* the whimsically conceived 1993 exhibition by Soviet-émigré artists Vitaly Komar and Alexander Melamid, some 160 artists from around the world were invited to examine the life and fate of Soviet Socialist realist monuments in the instant of their demise—and to propose ways as to how the Soviet-era monuments might be recycled as public art.[20] But by preserving the images of a people's uprising against their monuments, the artists punctured the conventional illusions perpetrated by all monuments everywhere. In this, the ultimate demystification (and humiliation) of the monument, Komar and Melamid revealed both the desire in every state to concretize and eternalize the righteousness of its birth and the ultimate futility of this desire in the face of a people's resistance. As it turns out, even as monuments serve as the nodes around which a nation's official history is told and remembered, they do so only with the explicit cooperation of the people.

Monuments have long sought to provide a naturalizing locus for memory, in which a state's victories and defeats are commemorated as preternaturally ordained. By suggesting themselves as kin to the landscape's geological outcroppings, monuments would cast a nation's ideals and founding myths as as naturally true as the landscape in which they stand. These are the monument's sustaining illusions, the principles of its seeming longevity and power. But as Komar and Melamid made scathingly clear, neither the monument nor the meaning it assigns to memory is really everlasting. Both are constructed in particular times and places, as conditioned by and subject to the same forces of history as we are. Indeed, the first hope of any regime is part and parcel of the monumental delusion: that it will be as permanent as it supposes its monuments to be. Such

monumental delusions may not be unique to the former Soviet Union, but they are brought into especially sharp relief here.

When the party eliminated the Holy Icon, it left a great vacuum in the people's lives, a gaping hole in the public landscape, which generations of party leaders proceeded to fill with busts of themselves—everywhere—until the place of an absent God had been filled. Like the Egyptian kings before them, who spent as much time defacing and removing the monuments of their predecessors as they did in building new shrines to themselves, successive Soviet regimes attempted to displace the stone idols of their forebears with new monuments to themselves. Lenin destroyed the monuments of the tsars; Stalin destroyed the busts of Lenin; Khrushchev destroyed those of Stalin; Brezhnev removed those of Khrushchev. Only Gorbachev, who brought an end to the monuments industry, is credited with not destroying the busts of his predecessor, Brezhnev.

With this in mind, we realize that the very premise of *Monumental Propaganda* rested squarely on the cracked and peeling shoulders of Lenin himself, who first recognized the essentially anti-populist character of the everlasting monument. In an early gesture intended to win the support of the masses, Lenin proposed what he hoped would be a people-friendly environment of ever-perishable monuments. His Plan for Monumental Propaganda was founded in the revolutionary notion of a monument's essential impermanence. Instead of bronze, marble, and granite, Lenin proposed a landscape of party posters, slogans, and temporary plaster busts.

Unfortunately for Lenin's campaign, however, the Party's posters, slogans, and temporary plaster busts proved a poor substitute for bread and butter. The mutability of the state's monuments was to have reflected the people's own changing lives and needs, but it was not long before the people discovered that only the forms were changing: the underlying message was always the same and so grew increasingly ossified over time. The masses were not to be fooled by the new packaging of the same old slogans. Art for the masses now began to recede into an ever-drearier landscape, tattered ideals increasingly served by tattered monuments.

Not only did the Soviet state's exhortative monuments grow bigger and less perishable over time, but it wasn't long before the living and breathing Lenin himself was turned into the Soviet Union's preeminent state monument par excellence. Embalmed in a secret fluid, guarded by young scouts, and saluted by generation after generation of leaders, Lenin's corpse and mausoleum functioned, in the words of Komar and Melamid, as a "unique and unreproducible Communist temple, the spiritual center of world communism, and it contain[ed] the god himself."[21] According to the official state fairy tale, the genius of Socialist science would one day find a way to bring Lenin back to life.

In their ironic recapitulation of Lenin's Plan for Monumental Propaganda, Komar and Melamid have taken Lenin's accomplishment and turned it on its head: the forms remain but now embody entirely new meanings. Though they could not unlock the secret of Lenin's magical embalming fluid, Komar and Melamid did find an antidote to its monumental pretensions. As it turns out, the surest corrective to the traditional high seriousness of monuments is below-the-belt parody. Nothing, after all, looks so absurd and foolish as the heroic bust brought low, a monument out of its element, its time and place. Stripped of its authority, its pretensions bared for all to see, the monument becomes a laughingstock, a self-deriding clown at the mercy of those whose respect it had once commanded under the threat of death.

In fact, Komar and Melamid have shown that the only life left in these monuments may derive from the artists' and public's own ironic, irreverent approach to them. In this manner, they suggested that part of the liability in any monument may be its own self-seriousness, its sense of self-appointed sacredness. By turning the monuments upon themselves in self-humiliating poses, they suggest that only the parodic mirror is strong enough to neutralize the monument's solemn charge. Thus would they preserve the ruins of Soviet Socialist monuments and thereby transform them into sites of memorial instruction.

In felling these monuments, Russia's post-Soviet leadership opened up a startlingly new way of looking at the former regime's icons, now estranged. *Monumental Propaganda* merely picked up where the new regime left off. The artists invited by Komar and Melamid reanimated these monuments with possibilities their makers would have shuddered to imagine: a statue of Stalin is hanged by a cable noose from a crane; or strung upside down by his feet, Mussolini-style; or encased in a gigantic wooden box, which in the end can be nothing but a monumental coffin on its way to the cemetery. On its back, another great statue of Stalin lolls in the dust, seemingly bound and helpless, unable to move. He no longer breathes down necks, but rather his eyes now stare glassily at the heavens.

In another image, Thomas Lawson has proposed turning a similarly felled statue of Lenin into a water fountain. Bending to meet Lenin's lips now would be rewarded with a small gusher. Other projects commissioned by the artists leave the statues of Lenin standing, but now altered. In *Cleaning House,* for example, Florence Weicz drapes an oriental carpet over Lenin's outstretched arm while placing a vacuum cleaner at his feet, its tube coiling around his legs as he vacuums with his other hand. Constantin Boym has adorned the base of a similar statue of Lenin with a Nike running shoe logo. Lenin is now mocked by the goddess of victory, transformed into a fleet-footed capitalist. In his contribution to the project, Art Spiegelman manipulated a photograph of what was formerly the greatest

Florence Weisz, *Cleaning House*, 1992, color photocopy. *Photo: Courtesy Komar & Melamid Archive.*

Art Spiegelman, *One Step Forward, Two Steps Back (After)*, 1992. *Photo: Courtesy Komar & Melamid Archive.*

of all hammer-and-sickle monuments—The Proletariat and Agriculture—to portray the heroic couple stepping blindly off their pedestal into empty space, the abyss. Even Lenin's mausoleum, former holy shrine of the Soviet Union, is transformed in the imaginations of Komar and Melamid. Lenin's name has been displaced by a Jenny Holzer–style LED display. Moving red lights on Lenin's tomb remembering everything from Mom to Grape-Nuts, turn the tomb into a generic monument, space for rent to the highest bidder. In one version of the LED lights, the word "Leninism" shares the crypt of its founder.

In one of the most popular images of the new revolution, a bare-chested hero stands on the shoulders of "Iron Felix" Dzerzhinsky, the former head of the secret police, and places a steel noose around his neck, just before hoisting him to his destruction. Komar and Melamid have proposed a new statue depicting Dzerzhinsky's hangman: it will be a monument commemorating the former monument's own destruction. Komar and Melamid brazenly juxtapose both current

Thomas Lawson, *Lenin Drinking Fountain,* 1992, mixed media. *Photo: Courtesy Komar &
Melamid Archive.*

Komar and Melamid, *Leninism,* 1993, hand-colored computer graphic. *Photo: Courtesy Komar
& Melamid Archive.*

and past sets of monumental desecrations not to link today's revolutionaries with Nazi counterrevolutionaries, but to reinvigorate these monuments with the memory of their own life cycles. Thus would the artists highlight the life of the monument over time, its total performance expanded to include its coming into being, its weathering over time, and even its eventual destruction. In the eyes of Komar and Melamid, how else would an authoritarian regime commemorate itself except through authoritarian art like the monument? Conversely, how better to celebrate the fall of an authoritarian regime than by celebrating the fall of its monuments?

Lest this project appear as a triumphalist monument in its own right, however, I would point out that *Monumental Propaganda* is not just an interrogation of Soviet-era monuments alone. But rather, in their exposure of the monument in its most retrograde, archaic form, Komar and Melamid would bare the soul of all monuments everywhere, even those in the West. In this way, they have simultaneously revealed the source of the monument's magic and called its bluff.

The point here is not to suggest that only Soviet-made Socialist realist monuments were lying shams, or that only Hitler's Fascist monuments were irredeemably evil. For in fact, any nation's monuments can be similarly decontextualized, stripped of their self-importance, their self-naturalizing certainty, their eternal pretensions. As sacred as we hold them, no nation's monuments are intrinsically sacrosanct, no matter how holy and charged they seem to be. The source of any monument's sanctity derives not from the goodness of its memory or the perfection of its form. Rather, as became all too clear in the case of Soviet monuments, the sacredness of the monument's space derives from a public's willing complicity in the monument's essential illusion. That is, monuments depend on the public for their very lives: as long as the public shares a regime's desire for permanence or its formal self-idealizations, it suspends disbelief in the monument's own impermanence and thus makes the regime's monument its own sacred space. But the moment the public withdraws its faith and belief in the ideals embodied in a regime's icons, monuments are left exposed and vulnerable. In effect, monuments live solely by the consent of their public. In this most Jeffersonian of conceits, Komar and Melamid remind us that we may not need our monuments so much as they need us.

The material of a conventional monument is normally chosen to withstand the physical ravages of time, the assumption being that its memory will remain as everlasting as its form. But the actual consequence of a memorial's unyielding fixedness in space is also its death over time: a fixed image created in one time and carried over into a new time suddenly appears archaic, strange, or irrelevant altogether. For in its linear progression, time drags old meaning into new

contexts, estranging a monument's memory from both past and present, holding past truths up to ridicule in present moments. Time mocks the rigidity of monuments, the presumptuous claim that in its materiality, a monument can be regarded as eternally true, a fixed star in the constellation of collective memory.

In the end, neither concrete nor iron nor mortar can prop up a monument emptied of its meaning for the disaffected masses. Once the people renege on their collaboration with the monument, its power is gone. It no longer draws people into the space of their shared beliefs, but rather unites them in opposition to both a regime and its monuments. Sometimes this happens all at once; at other times, it takes several generations for a monument to be eaten away gradually by the contempt of its public—until one day, the monument topples over in the slightest breeze, or at the softest touch.

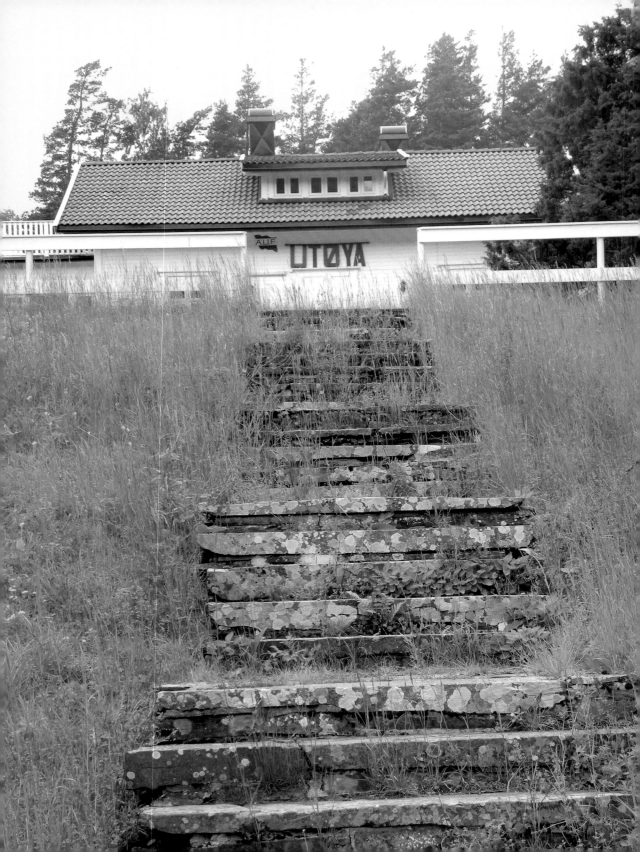

7

Utøya and Norway's July 22 Memorial Process

The Memory of Political Terror

In many ways, I find it repellent to write about Anders Behring Breivik.
—Karl Ove Knausgaard, "The Inexplicable"

On July 22, 2011, a thirty-two-year-old Norwegian anti-immigrant fanatic drove into the city center of Oslo, where he detonated a car bomb in the Government Quarter.[1] The bomb went off at 3:25 p.m., killing eight people, wounding over two hundred (many severely), and destroying the government center. The office of Prime Minister Jens Stoltenberg from the Labor Party was badly damaged, and parts of the government quarter are to this day still inaccessible. Immediately afterward, the terrorist, Anders Behring Breivik, drove to the tiny island of Utøya, thirty-eight kilometers outside Oslo, home to the annual summer camp of the Norwegian Labor Party Youth League, held every July since 1950.

That same morning on Utøya at 11 a.m., former Labor Party prime minister Gro Harlem Brundtland (Norway's first female head of government) delivered an impassioned speech on the Labor Party's inclusiveness and its promising future, as embodied in the young faces of the 564 Labor Youth campers gathered before her in the camp's beloved Café Building assembly hall. She left the island at 3 p.m. It was later revealed that Breivik had originally planned to arrive at the island just before Brundtland's departure, so that he could capture and then decapitate the former prime minister, regarded as the "Mother of the Nation," in full view of "her children," the future leaders of the Labor Party.

Stone path leading from the landing dock to the carriage house on Utøya.

At 5 p.m., now dressed and posing as a state police officer coming to secure the Labor Youth Camp after that afternoon's Oslo bombing, Breivik boarded the ferry to Utøya, which was steered by Jon Olsen, ferry captain and Utøya caretaker. Olsen was accompanied by his wife, Monica Bosei, who together with her husband, had served as the island's caretaker and Labor Youth Camp coordinator for many years. During the fifteen-minute ferry ride to the island, Bosei grew suspicious of Breivik's story and quietly called ahead to alert the island's two security guards, Trond Berntsen, an off-duty police officer and Rune Havdal, a privately contracted guard, neither armed. Both men had worked as the island's security detail for several summer camps, but this had been the first year that the guards had brought their young sons (nine and eleven years old) with them.

At 5:21 p.m., Bosei escorted Breivik from the ferry onto the island, where they were greeted by Officer Berntsen, who began asking Breivik questions about which police unit he belonged to and who else he may have known on the police force. According to Breivik's court testimony, he feared he was about to be exposed. So as Berntsen and Bosei turned to lead him up a path to a little white clapboard carriage house overlooking the ferry dock, Breivik pulled out a Glock 34 semiautomatic pistol and shot Berntsen and then Bosei in the back of the head, killing them instantly. At that moment, Bosei's husband had just driven Breivik's heavy case of arms (several hundred pounds) from the ferry up a short gravel path to the little white administration building, parked the car (the only one on the island), and then rounded the building's corner just in time to see Bernsten and his wife shot. He watched in horror as they crumpled to the ground and Breivik stood over them, firing twice more into each of their bodies to finish them off.

Having also watched as his partner and Bosei were shot, Rune Havdal bolted up the path toward the Café Building to warn the young campers who had begun to gather there in advance of the security briefing they thought they were going to hear from the state police officer. But as Havdal ran toward the Café Building, Breivik shot him in the back and then on his way up to the Café Building, Brevik shot him again several more times at point-blank range. Rune Havdal was Breivik's third victim. Victim number four, killed shortly after Havdal, was also a first responder. Hanne Anette Balch Fjalestad (age forty-three) worked as a volunteer for the Norwegian People's Aid. As Breivik continued up the path toward the Café Building, Hanne confronted him, and according to witnesses shouted at him, "You cannot murder children!" The historian and director of the July 22 Memorial Research Project, Tor Einar Fagerland, believes that Hanne's intervention bought precious time and probably saved the lives of several teenagers. Both Havdal's and Berntsen's young sons survived that day but were severely traumatized by the things they saw.

For the next hour, the small island was transformed into a nightmarish death-trap where teenage campers in hiding, or on the run, were systematically tracked down and executed. Between 5:21 and 6:35 p.m. sixty-nine people, almost all teenagers, were murdered. Most of them were shot in the head or in the face at close range. One drowned trying to swim off the island, and dozens of others were rescued by local boaters and vacationing visitors camping at a boaters' campsite on the mainland across from the island. The two youngest victims were four-teen years old. Thirty-three others were severely wounded, many permanently disabled, and hundreds more were traumatized. At 6:27 the first police officers finally reached the island, where at 6:35 they converged on Breivik on its rocky south shore. Even before he could see the officers as they approached, Breivik simply dropped his weapons and raised his hands and waited for them. Live aerial news footage of the island showed that he was surrounded by scattered bodies in colorful raincoats, children he had killed only minutes before he surrendered.

How will a nation like Norway, historically (and blessedly) free of both domes-tic mass murder and the memorial traditions that might guide the meaning and commemoration of national catastrophe, remember the atrocities committed against their children on Utøya and on their government in Oslo on July 22, 2011? There is no memorial template, no prescribed process by which to mourn and remember such unprecedented loss and destruction. Indeed, no nation in Europe since World War II has experienced the attempted political assassination of an entire generation of aspiring youth leaders, accompanied by the planned decapitation of their "nation's mother" and former prime minister and the actual destruction of the Government Quarter.

Without its own memorial precedents, Norway gave itself the time and space to study the all-too-bountiful examples of mass murder and its memory in other lands—all toward finding a way to mourn and remember on its own terms. Nor-wegian memorial experts like Tor Einar Fagerland and others in both the Labor Youth League hierarchy and in the cultural ministries grasped almost immedi-ately that the National July 22 Memorial had to be understood in its ongoing, unfolding stages—in the spontaneous candlelight vigils and demonstrations, in local vernacular shrines, in the unscripted outpourings of grief by family mem-bers, artists, and political leaders.

The National July 22 Memorial would thus be imagined and conceived over time, composed in its long durée, and over the landscapes of countless Norwegian communities that were home to the victims and survivors—and would include the actual sites of destruction. This mass murder of innocents was committed on political grounds and carried out in the most grotesquely personal manner pos-sible. Beloved civic and private landscapes had been profaned by the diabolically

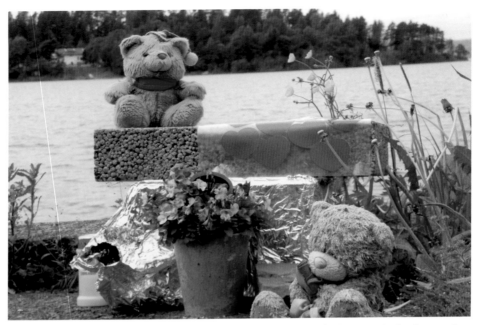

A spontaneous memorial on a vantage point near Sørbråten, with Utøya in the background.

systematic mass murder of Norway's children and would now require both personal and political reconsecration before being reintegrated into daily public life.

In tandem with its citizens' spontaneous acts of memory, large and small, Norway's Ministry of Culture quietly but transparently initiated an "Art Plan" for the country's July 22 Memorial Sites.[2] Less than a year after the attacks, two memorial sites had been established: one in Oslo's Government Quarter and one on the land facing the island of Utøya in Hole Council. A highly professional Art Selection Committee was appointed in November 2012, an international "request for proposals" was issued, and eight finalists were chosen to present their designs to the committee in Oslo. In February 2014, a brilliant design by the Swedish artist Jonas Dahlberg was chosen for the narrow fingerlike peninsula on Sørbråten pointing across the water to Utøya.[3]

In *Memory Wound,* Dahlberg proposed slicing into the peninsula and opening a narrow channel whose flat edges would be polished smooth and engraved with the names of the victims on that day. With its distinct nod to Maya Lin's Vietnam Veterans Memorial, in which she imagined "cutting into the earth and polishing its open sides, like a geode," *Memory Wound* would thereby create another very small island, whose tip points to Utøya.[4] It would be inaccessible by land, but visitors would be able to walk out to an observation point on the edge of the

mainland to view Utøya, foregrounded by the new little island and the names carved on its polished black granite edge. In the artist's proposal, the earth and flora carved from this wound would be transported back to Oslo to form the foundation of a "July 22 Memorial Garden" at the Government Quarter, thereby linking and creating a memorial matrix between the two sites.

As conceptually audacious as it is formally exquisite, this plan has, perhaps unsurprisingly, antagonized some of its local neighbors in Hole, who resent that through no fault of their own, their beloved landscape will forever be scarred by this "memory wound," reminding them of an event, which like the memorial itself, had been imposed on them from the outside. In a wise and patient response, the memorial's planners announced a one-year delay in the memorial's construction, a good faith gesture by which the memorial's organizers hoped to find a way to rapprochement between the local community and a national memorial they did not choose. Again, the memorial's organizers seemed to understand that dissent and debate were also part of the process and that any memorial worth realizing had to be capacious enough to contain and manage the needs of both its advocates and its detractors, both its local and its national constituency.

Meanwhile, the Labor Party Youth League (AUF), which owns the island of Utøya and runs the summer camp there for its youth leaders, continued to wrestle painfully with how to restore and renew their beloved island. How to mesh the memory of their murdered children with the memory of sixty previous years of life and joy there, how to mark and respect the emotional wounds of the victims' and survivors' families, and how to build into the island's landscape spaces for new life, without erasing the historical traces of a deadly attack on their very existence?

Again, there would be no prescribed paths to take, no instant solution to reconciling the personal memorial needs of families and the civic and political needs of the AUF to regenerate and rebuild itself, even on the memory of those killed in its name. As the Ministry of Culture had also done, AUF's leadership turned for guidance to Tor Einar Fagerland and his university-sponsored July 22 Memorial Research Group. In fact, perhaps the greatest single innovation in Norway's process is this research project, called July 22 and the Negotiation of Memory, proposed and directed by Fagerland, which simultaneously documents and analyzes the memorial process as it plays out, so that its ongoing expert critique actually contributes to the direction of the process.

Some years before July 22, 2011, Fagerland, a history professor at the Norwegian University of Science and Technology in Trondheim, had begun intensive research into how nations and communities remember catastrophic events, how societies collectively mourn and heal. He had already become instrumental in

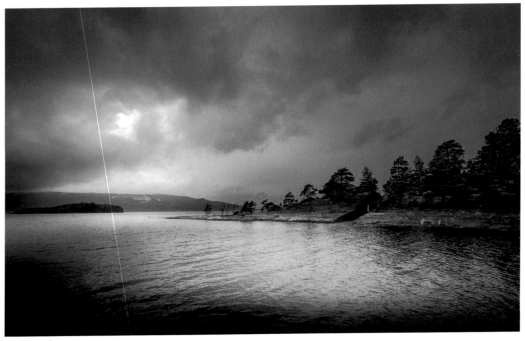

View of Jonas Dahlberg's *Memory Wound. Photo: Courtesy Public Art Norway.*

Rendering of *Memory Wound* with names of the victims engraved on the granite edge. *Photo: Courtesy Public Art Norway.*

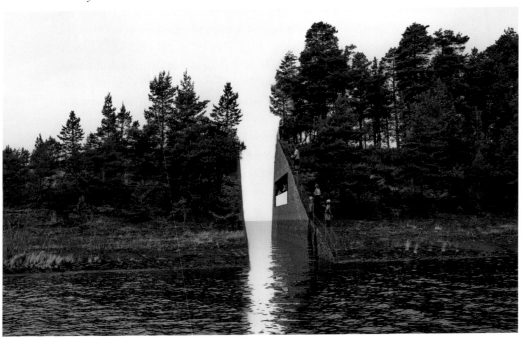

when he began shooting, the island's and Labor Youth's histories could never be reduced to a single day of terror. The greatest tragedy of all, she said, would be if the memory of what happened on July 22 blotted out the sixty years of previous history on that island, a place where the Labor Party spawned itself and several generations of leaders. In short, without knowing the Labor Party's history on Utøya, I could not understand what I was about to see and hear about July 22.

Even thus prepared, however, I had a difficult time absorbing all at once the island's sights and Mari's memories of that day, evoked place by place on the trail of terror, but each place also reminding Mari of the happy times she had known here all the years before 2011. Walking the trail with Mari meant that my own memory of this day would now include both what I saw and what I heard. Told simply—and, I thought, with characteristic Norwegian stoicism—Mari's and Jørgen's stories of the Café Building continued to echo in its empty Main Assembly Hall, even as we stepped through the small entry room, which was pockmarked by bullet holes and still discolored by the blood of some thirteen teenagers who had been tracked down and shot here. As I took photographs, Mari and Jørgen wondered aloud what would become of the Café Building, still redolent of both mass murder and Labor Youth's happiest memories.

When we came down to the rocky beach from which Mari had begun her swim to the mainland (she was one of only a few to make it all the way, the others having been picked up by local campers in their fishing boats, and one swimmer drowning), she pointed matter-of-factly to the spot on the other side where she landed, and I took a photograph of her pointing. My own emotions were spinning out of control as I tried to "make sense" of the island's beauty,

Mari Aaby West points to where she landed on the mainland shore.

Mari's affection for its trails (one called the Love Path), glens, and nicknamed beaches, her story of survival, her stories of others' sickening deaths (the kids who hid behind the water tower and were murdered as they cowered together for comfort), and our sudden and constant discoveries of small family-built shrines of candles, photographs, and teddy bears left by mothers and fathers on the sites of their children's execution. In my emotional upheaval, I could only internalize one thing at a time: I could hear Mari's words, but my eyes would glaze over the views of water through the trees; if I crouched to read the messages family members left in their little shrines, I could no longer hear Mari's words, or any voices other than the ones exploding in my head. I began to choke on my own words.

It took only ten minutes to walk back from the far side of the little island, on a narrow cliffside trail high above the rocks and water below. Not long after the attacks, a volunteer crew had fashioned a safety fence of weaved branches on the edge of the trail overlooking the cliff and fjord. They wanted to make sure that this place of former danger was now safe for remembering. The entire path back was dotted with small homemade shrines of votive candles, photographs of smiling kids, and occasional name plates fastened to trees. The entire island could be traversed from side to side and around its perimeter in about half an hour. As the sun began to set, we arrived at a pebble- and sharp rock–strewn beach on the south side of the island where Breivik had surrendered. Tor pointed out to me where he had been confronted by the police and where he had dropped his weapons and ammunition packs. A few feet from that spot, the water sparkled in a golden sunset hue, and my eyes caught the glint of five or six votive candles clustered together, perched at topsy-turvy angles on the rocks. A pink laminated paper heart with a square photograph of a teenage girl in its center fluttered on a string tied to a slender sapling that had taken root on that rocky beach, amidst the votive candles.

The next day, I met with the AUF Executive Committee to hear their plans for Utøya and to share thoughts on what I had seen the day before. In earlier correspondence that summer, Tor had prepared me for the Youth League's first, visceral response to the rebuilding of Utøya. It was the same as many of the victims family members': demolish the Café Building and Main Assembly Hall, now seemingly hopelessly profaned and corrupted by the blood of Labor's children. Such a response was perfectly understandable. How could anyone expect to pass through those doors again for a meal, a party, a dance, or a speech and be reminded by the blood stains on the linoleum and bullet-holes in the walls of what had happened to their friends or siblings on July 22? But as I sat down to listen to the Executive Committee's plans that day, I couldn't help but think back

intent to turn a "site of history" into a "site of memory."[8] This intention and its deliberative process really should not be short-circuited, as difficult and painful as it may be. Rather, find a way to reintegrate this building into the island's reconstruction as a site of both memory and ongoing Labor Youth life and learning. Even if Labor Youth leadership and the families of the victims eventually arrive at a decision to replace this building with a new one, I said, they would need to find a way to mark this decision-making process, too, and to involve the kids who come back to the island somehow in the island's renewal. If the building is to be demolished, then the reasons why must be made part of its demolition, acknowledging that demolition in this case is part of the grieving and memorializing process, even part of the island's renewal and reconsecration as a memorial site.

One of the alternatives to demolishing the Café completely would be to leave it standing with part of it rededicated as a memorial space, even an empty space that could accommodate an annual memorial offering of flowers, candles, and contemplation. Or if the Café Building is taken down, its footprint or a remaining wall or room might remain behind as a gesture to what was, as both Alice Greenwald and Ed Linenthal suggested in correspondence, to what happened on that site, and to why the building was eventually demolished. Again, my own visceral response to the building's demolition comes from the sense that without working through mindfully why it needs to be torn down, its demolition becomes an extension of the terrorist's destruction and crime, and not a commemoration of the victims of this crime. Does this make sense? I asked.

Between that day in October 2013 and the end of May 2014, Labor Youth, its memorial committee, and the National Memorial process had made profound progress. A brilliant design had been chosen for the off-island site at Sørbråten, along with a design for the Government Quarter. And Labor Youth, too, had come a long way with its own designs for the New Utøya and plans for reopening its beloved Labor Youth Camp on the island. A memorial site had been chosen on the island for a central place for families to gather on the July 22 anniversary, and artists' and landscape architects' proposals were being considered for this commemorative site. One last piece of Utøya's memorial process remained: What would they do with the Café Building? Tor Fagerland invited Ed Linenthal, Alice Greenwald, and me to visit the island again at the end of May 2014, to hear all sides of the discussion within Labor Youth and the families of victims and survivors of the attacks, and to help advise a way forward.

Alice had to stay in New York City to follow up on the grand and successful opening of the National September 11 Memorial Museum on May 15, an event I also attended as a member of the museum's academic advisory committee. Twelve days later, on May 27th, Ed and I arrived in Oslo. A few days before our arrival,

Tor and Labor Youth leadership had visited Utøya yet again, but with a specific and concentrated agenda: Is the Café Building to be completely demolished and rebuilt, partly demolished and sections of it preserved as a memorial center, or completely preserved and repurposed as an educational museum? On this trip, according to Tor, they first visited the chosen spot on the island for the families' memorial to their children, called *The Clearing*, after which they discussed at length how to integrate learning about July 22 into the new life of the island. They also brought with them a group of young Labor Youth members to the island to hear what it was like for them to be on the island for the first time.

But their main focus was on the Café Building. In Tor's words, "Here both Jo Stein, talking about the history of the island and the power of place, and Erlend, visualizing how different choices regarding the Café Building would affect the landscape and the new buildings, performed brilliantly." The most important part of this trip, however, came when the leadership gathered together in one of the rooms where the murders took place and expressed their feelings about July 22, the future of the island and of the Café Building in particular. As Tor later reported to me, the leadership was split in two, with Eskil Pederson (the head of Labor Youth) and Mari West strongly in favor of keeping the most crucial parts of the building and deputy leader Åsmund Aukrust (partly) and general secretary Marianne Wilhelmsen (strongly) in favor of demolishing the building.

On the day before our planned trip to Utøya on Wednesday, May 28, we met one more time with the Executive Committee of Labor Youth at the AUF offices. In addition to Tor and two of his graduate student researchers, Mari, Jørgen, Hilde Firman Fjellså (Central Board member and Utøya survivor), Marianne Wilhelmsen (who was not on Utøya that day), and Erlend were there, as well as the parents of a child who had survived that day and parents of a child who had not. The meeting was chaired by Eskil Pederson, the outgoing head of Labor Youth, who had been on the island that day and survived. Eskil opened the meeting by asking the parents to reflect on their feelings about the island and the Café Building, and then asked Jørgen to summarize his sense of what the families he had interviewed wanted Labor Youth to do with the island.

As Tor had suggested earlier, while most all now agreed that Labor Youth would return to the island and renew it with new buildings and the family memorial site, consensus was still missing on what to do with the Café Building. At this point, Eskil chose to relate his own last meeting with nearly a dozen family members of victims. "They told me," he said, "that if we chose to demolish the Café Building, they would chain themselves to it and we'd have to demolish them, too." A stunned silence followed. I couldn't stop myself from saying, "Then it's settled. The parents of these murdered children have already consecrated this

Jon Olsen steering the ferry to Utøya in May 2014.

building and turned it into a shrine, taking the matter out of your hands. Your job is to protect this shrine and turn it into a place of memory and education."

Then, moments later, I was struck by the generosity of Hilde Fjellså, a twenty-three-year-old Utøya survivor and camp counselor, who proposed that Labor Youth now share Utøya with all groups, Labor and non-Labor, who want to come learn about that day and to learn how to fight racism, intolerance, and bigotry. More discussion followed, and Jørgen asked for a show of hands from those who planned to come with us to Utøya that afternoon. To my surprise, both Hilde and Marianne raised theirs. After the morning's discussion, they wanted to see the island now through our eyes, and, of course, we wanted to see the island through theirs.

It was a relatively large group, driven in two cars by Mari and Erlend. The island caretaker and ferry driver Jon Olsen was waiting for us at the ferry landing, and he would take us there. We all knew the story of the day, how Jon had witnessed his wife's murder and then jumped back into the ferry to take it back to the mainland for help. Now as Jon steered the ferry to Utøya, Mari and Jørgen visited with him. As we debarked, I thanked him for taking us to the island. I asked Mari and Jørgen what Jon would do while we were there, whether he would want to show us any of the island or talk about that day, and they answered in unison that Jon wanted no part of being a "memorial guide" to the July 22 attacks, that he wanted only to continue his work as caretaker and ferry operator.

We walked in small clusters up to the Café Building. Unlike our visit in October when the rooms were bare, marked only by bullet holes and blood-stained

The Café Building.

linoleum, we now found small bunches of flowers, some fresh, some dried, with votive candles and photographs of some of the victims who had been killed behind the piano or in another corner. Parents had come to the island on their own (and some had been ferried there by Jon) to remember their children on their birthdays. The sites of these children's murder were now enshrined, whether authorized or not by Labor Youth.

With great tenderness, Hilde approached a small clutch of flowers on the floor in the small hall with a photograph of a blond teenage girl on the wall above. I asked if she knew this camper. "Yes, I held her while she died." I didn't know what to say, so I asked Hilde where she was during the shooting. She took my hand and led me to one of the toilet stalls just opposite her friend's little shrine, maybe ten feet away. "This is my toilet," she announced, affectionately gesturing to the porcelain water basin with her free hand. "I hid in this toilet stall with three others and listened as Breivik's boots moved through the hall next to us, and we heard him shooting and heard our friends screaming." Hilde was composed, but I was not. "Did he shoot anyone through the toilet stall doors?" I asked lamely. "No," Hilde replied. "There were kids in all three toilet stalls with the doors locked. He didn't shoot through the doors because he needed to look everybody in the face as he shot them. We stayed there for an hour until the police came. When we came out of the stalls, the policeman asked who was in charge. I said I was a counselor, and he asked me to take care of the girl on the floor who was still breathing until

The place where children were killed trying to hide behind a piano.

Family shrines in the Café Building.

A toilet stall where surviving campers hid from the gunman.

medics could arrive. I held her there," Hilde said, pointing to the dried roses and votive candle on the floor. "She had a pink streak in her hair."

I don't remember how much time passed as Hilde and I stood in the little hall of the Café Building in front of the lavatories, but suddenly I realized everyone else had stepped out of the building and moved into a meeting hall down the hill. Hilde and I walked down to join them, and there I told Tor what I had just heard from Hilde. Suddenly, we both knew that the lavatories, too, would have to be preserved along with the places of death in the Café Building. For Hilde, this was where she was saved, a place of chance survival, as well as a place of death. The Café Building was a de facto shrine to both life and death, a shrine to good and ill fate. We approached Erlend and asked him if any of the plans included saving the lavatories, and he replied no, only the little hall with the family shrines. As we walked back up to the Café Building, we told him Hilde's story and asked him how to protect that entire section of the Café Building, how we could make it a memorial setting to remember both survival and mass murder. Once family members had spontaneously consecrated these sites, enshrining them with flowers, candles, and photos, they became both charged and sacred and so would need to be sheltered. In the case of the lavatories, these spaces were chosen by the historical events of that day, by the children who were saved by hiding in them.

The next day, Tor, his two graduate student assistants, Ed, Erlend, and I met in the AUF offices to brainstorm. What would the Café Building's shrine look

The shrine to Hilde's friend. The photograph shows a teenage girl in a traditional Norwegian costume, holding a long-stemmed rose representing the Labor Youth group.

like? In a fever of freehand drawing and free association, we sketched on large sheets of butcher paper the outline of the Café Building, and Erlend sketched out a new plan, leaving the little hall, lavatories, and a section of the large assembly hall intact, taking away the rest, but sheltering the preserved sections with a kind of canopy, and leaving the columns of the foundation in place as a hillside landscape of pillars, connecting this building to the new ones but also setting it apart. Erlend signed and dated these drawings for us, and we called in first Eskil, then Jørgen, to let them know what we were proposing and why. They both agreed immediately that this would be our plan going forward.

As designed by Erlend, areas of the Café Building already enshrined by the parents of children killed there and marked by the events will be preserved intact, along with the lavatories where children survived in hiding, and approximately one quarter of the large adjoining assembly hall. The enshrined areas will continue to be accessible to families for annual placing of flowers and candles, as they wish. But for other visitors, these preserved areas will only be viewable from a slightly lowered walkway and floor built around them. A new sheltering structure consisting of light and semi-transparent walls made of 564 vertical poles representing the number of people on Utøya that day will be built around these remaining parts of the Café Building. According to the architect, 69 of these vertical poles will extend skyward to support the canopylike roof of this new building, each pole representing one of the victims. Skylights will let daylight pour into the enshrined spaces below.

The concrete pillars that once formed the foundational footing of the Café Building will be preserved when the rest of the building is taken down. The resulting sloping field of white concrete pillars (each human-scaled) will gently refer to the building they had once held aloft and to the building's absence. Enough space will be preserved in the main assembly hall to mount a minimal exhibition of the events of July 22, 2011, along with the names and faces of those murdered. In Erlend's design, the new structure will be rotated slightly around the preserved section of the Café Building so that outwardly it relates to the other new buildings on the island.

Seen from the outside, the new structure will share architectural features with the other new buildings, thereby functioning as a gateway between the new life outdoors and the memories of July 22 inside. Keeping both the thin walls of the lavatories that saved so many lives and the assembly areas where thirteen were murdered will enable new generations to learn the stories of both life and death, and of the challenges and impossible choices that their fellow Labor Youth members had to face on the island that day. It will also, of course, be a teaching exhibition, a lesson in Labor Youth civics, since this memorial center is located on an

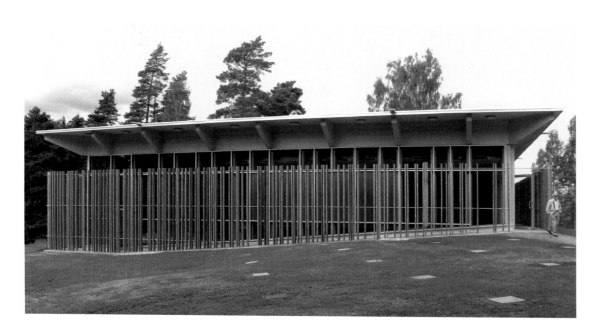

The sheltering canopy for the Café Building on Utøya, held aloft by 69 memorial columns commemorating those killed that day and screened by narrower columns commemorating the others of the 564 people on the island during the attack.

The visitors walkway surrounding the enshrined remainder of the Café Building. *Photo: Courtesy Erlend Blakstad Haffner.*

island owned by the Labor Party Youth League and the visitors to the center will be members and campers of the Labor Youth League. And if Hilde has her way, non-affiliated visitors will also be welcome, all of whom will learn that working for justice, against racism, fascism, and intolerance sometimes comes with a high price. They will also learn how members of the Labor Youth League protected and cared for one another in ways that were both personal and political. The victims will be remembered as targeted and murdered because they were Labor Youth leaders, and they will be remembered and mourned by their families as children cut down in the flower of youth. The murders were politically motivated but very personally perpetrated by an ideological fanatic. The sites of memory on Utøya Island are necessarily sites of both personal and civic memory, each an extension of the other.

Within weeks of the attacks and the murder of his wife there, Jon Olsen returned to Utøya as its caretaker and ferry driver. Breivik took his wife from him, devastated the Labor Youth League, and stopped three successive Labor Youth summer camps as the league worked through its mourning and rebuilding processes. But when asked whether he wished to return to his job, Jon didn't hesitate. Of course, he said, this is what I do. Breivik may have taken Monica from Jon and their two children, but Jon insisted that Breivik could not take the island and his work away from him.

Unable ever to forget what he saw, Jon will not need a memorial to visit for the memory of his wife. Her memory and the memory of the children murdered there are built into his daily ferry trips and his caretaking of the island, his bringing the island back to life, his anticipated transport of new Labor Youth campers to the island in May 2015 and beyond. By tending the island and its visitors, Jon remembers life with life and knows that if he can return to the island, where mass murder and survival will now be remembered as they cleave together in the new life on Utøya, surely the rest of Norway will find a way to follow.

The Clearing is a sculpture and landscape installation that opens a 36-foot-wide circular clearing in the island's forest overlooking the water, where family members of victims and AUF campers can assemble in one memorial space. A suspended steel ring 12 feet in diameter, etched with the names of all who died on Utøya that day, hangs at eye level, enclosing those who stand within it. Dedicated and opened on July 22, 2015, the fourth anniversary of the massacre, The Clearing was the winning design of a competition for a "family memorial space" on the island, by the Bergen-based architectural firm 3RW. An essential part of the design for 3RW was that the memorial could be constructed by volunteers, parents of victims, and AUF members, following the Norwegian tradition of dugnad, or collaborative process.
Photo (top): Tor Einar Fagerland.

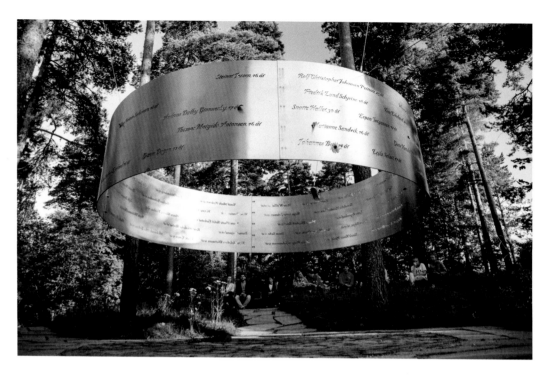

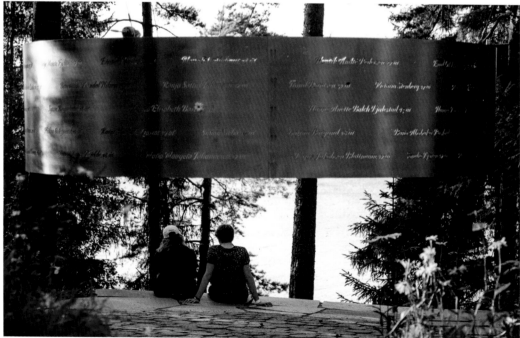

NOTES

INTRODUCTION. THE MEMORIAL'S VERNACULAR ARC

1. Wyatt, "Officials Invite 9/11 Memorial Designers to Break the Rules."
2. See Shelley Hornstein's comprehensive history of this memorial in her "Invisible Topographies: Looking for the *Memorial de la deportation* in Paris," in Hornstein and Jacobowitz, *Image and Remembrance,* 305–23.
3. Lin, *Boundaries,* 4:09, 4:11. Here Maya Lin recalls her Yale professor Vincent Scully's description of Lutyens's "memorial to the missing," in particular. In her words, "Professor Scully described one's experience of that piece as a passage of journey through a yawning archway. As he described it, it resembled a gaping scream, which after you passed through, you were left looking out on a simple graveyard with the crosses and tombstones of the French and the English. It was a journey to an awareness of immeasurable loss, with the names of the missing carved on every surface of this immense archway" (4:11).
4. Ibid., 4:10.
5. Ibid.
6. Ibid., 4:05.
7. For a full discussion on the origins and execution of Germany's "counter-monuments," see Young, *Texture of Memory* and *At Memory's Edge.*
8. Adorno, "Engagement," 125–27.
9. Friedländer, *Memory, History, and the Extermination of the Jews of Europe,* 61.
10. See Friedländer, *Nazi Germany and the Jews,* 3.
11. For an extended discussion of the New England Holocaust Memorial's origins and internal debates, see Young, *Texture of Memory,* 323–35.
12. For a full history of Germany's "Memorial for the Murdered Jews of Europe," see "Germany's Holocaust Memorial Question—and Mine," in Young, *At Memory's Edge,* 184–223.
13. Giedion, *Architecture You and Me,* 28.
14. Mumford, "Monumentalism, Symbolism, and Style," 179.
15. J. L. Sert, F. Leger, and S. Giedion, "Nine Points on Monumentality," in Giedion, *Architecture You and Me,* 48.
16. Giedion, *Architecture You and Me,* 25.
17. Augé, *Oblivion,* 89.
18. Ibid., 88.

CHAPTER 1. THE STAGES OF MEMORY AT GROUND ZERO

1. Riley, "[REIMAGINE]; What to Build," 92–96.

2. For an early and authoritative account of this project, see Ebony, "Towers of Light for New York City," 35.
3. What follows are some of the thoughts, many of them raw and unformed, that I shared with groups at several of these symposia and conferences, including "Remember Life with Life: The New World Trade Center," for the panel "Building/Memorials/Meanings" with Paul Goldberger at "Between Expedience and Deliberation: Decision-Making for Post-9/11 New York" symposium organized by CUNY Urban Consortium and Rutgers University Center for Urban Policy Research, Baruch College, February 8, 2002; panel with Ray Gastil on WNYC radio series *Six Months: Rebuilding Our City, Rebuilding Ourselves,* March 4, 2002; "Remembering Life with a Living Memorial: The New World Trade Center," at the Samuel Dorsky Symposium on Public Monuments, Public Monuments Conservancy, Time & Life Building, New York, March 22, 2002; "Building a Living Memorial," at "Rebuilding Downtown New York," conference, NY-NJ-CT Regional Plan Association Twelfth Regional Assembly, New York, April 26, 2002; "Memorials as Experience and Form," at "Evolve New York—Open Studio: Rebuilding Proposals" conference, Urban Planning Program, Columbia University, May 9, 2002; "Memory and Community," for "Building Memories: The Future of September 11" conference, Pace University and The Legacy Project, September 5, 2002; "Polemic as Process in the Spaces of Public Memory," The English Institute, Harvard University, September 21, 2002; "Remember Life with Life," at "Trauma at Home: Remembering 9/11" symposium, The Humanities Institute at SUNY Stony Brook, October 15, 2002; "Paths to Memory," Lower Manhattan Development Corporation, New York City, November 6, 2002; "Memory and the Monument after 9/11," Visiting Artists Program Lecture, The School of the Art Institute of Chicago, November 18, 2002. My early writings on these thoughts include "Celebrate Life with Life"; "Remember Life with Life"; and "Memories in High Relief."
4. See Exod. 20:10–11: "For six years you shall sow your land and gather its yield; but in the seventh year you shall let it rest and lie fallow."
5. Young, "Celebrate Life with Life."
6. This essay is adapted from Young, "The Memorial Process" and "The Stages of Memory at Ground Zero."
7. Muschamp, "An Appraisal."
8. For details on the two teams of finalists, see Goldberger, *Up from Zero,* 154–203; for a well informed and insightful discussion of the memorial process, see 204–34.
9. "Lower Manhattan Development Corporation Appoints Anita Contini Vice President and Director for the Memorial, Cultural, and Civic Programs," press release, July 2, 2002, available at www.RenewNYC.org,
10. Members of the LMDC Memorial Mission Statement drafting committee included Kathy Ashton, Lt. Frank Dwyer, Tom Eccles, Capt. Steve Geraghty, Meredith Kane, Michael Kuo, Julie Menin, Antonio Perez, Nikki Stern, and Liz Thompson.
11. Cited in Lower Manhattan Development Corporation, "World Trade Center Site Memorial Competition Guidelines," 2003, 18 (available online at http://www.wtcsitememorial.org/about_guidelines.html).
12. The LMDC Memorial Program drafting committee included Diana Balmori, Frederic Bell, Paula Grant Berry, Max Bond, Albert Capsuoto, Christy Ferer, Monica Iken, Father Alex Karloutsos, Richard Kennedy, Tom Roger, Jane Rosenthal, and Christopher Trucillo.
13. LMDC, "World Trade Center Site Memorial Competition Guidelines," 18–20.
14. Ibid., 10.
15. Wyatt, "Officials Invite 9/11 Memorial Designers to Break the Rules."
16. LMDC, "Joint Meeting of Memorial Competition Jury and Families Advisory Council, LMDC Offices, May 27, 2003, 6:15 p.m.," transcript, 43.
17. Ibid., 51.
18. Collins, "8 Designs Confront Many Agendas at Ground Zero."

19. In this vein, also see Dowd, "The Unbearable Lightness of Memory," in which she lamented the paucity of "darkness" in these designs.
20. Muschamp, "Amid Embellishment and Message, a Voice of Simplicity Cries to Be Heard."
21. *New York Times,* "Toward a Final Design."
22. Kimmelman, "Ground Zero's Only Hope: Elitism."
23. Ando, "Hope for a Shattered Life," 86.
24. Rabinowitz, "Holocaust Heroes."
25. Dunlap and Bagli, "New Look at Memorial Lowers Cost."
26. Filler, "At the Edge of the Abyss."

Chapter 2. Daniel Libeskind's Houses of Jewish Memory

1. For an elaboration of these questions in the larger context of what constitutes Jewish culture, see Young, "Introduction to the Posen Library of Jewish Culture and Civilization."
2. Lane, "The Shutterbug," 80.
3. Quoted in Kozloff, *New York,* 70.
4. Zevi, *Ebraismo e Architettura,* 68, 111 n. 77.
5. Rosenfeld, "Ground Zero as a Lab for New Art." For an excellent and comprehensive elaboration of these insights, see Rosenfeld, *Building after Auschwitz.*
6. See Popper, "Transforming Tragedies into Memorable Memorials."
7. See Bendt, "Das Jüdische Museum."
8. Simon, *Das Berlin Jüdische Museum in der Oranienburger Strasse,* 34. Quoted in Weinland and Winkler, *Das Jüdische Museum im Stadtmuseum Berlin,* 10.
9. The issue of what constitutes Jewish art remains as fraught as ever in contemporary discussions of national and ethnic art. Among other discussions of the subject, see Gutmann, "Is There a Jewish Art?"
10. Weinland and Winkler, *Das Jüdische Museum,* 10.
11. See Bothe and Bendt, "Ein eigenstandiges Jüdisches Museum als Abteilung des Berlin Museums," 12.
12. "Nichts in Berlins Geschichte hat die Stadt jemals mehr verändert als die Verfolgung, Vertreibung und Ermordung ihrer jüdischen Bürger—dies war eine Veränderung nach Innen, die ins Herz der Stadt traf," ibid. 12.
13. Ibid., 169.
14. Libeskind, *Between the Lines,* 3.
15. Libeskind, "Between the Lines," 63.
16. For further insightful reflection on role these voids play in Berlin generally and in Libeskind's design in particular, see Huyssen, "The Voids of Berlin."
17. See Young, *At Memory's Edge,* on which part of the present essay is based and in which I give the entire account of Germany's national Memorial for the Murdered Jews of Europe in Berlin, including Libeskind's proposed design. In submitting a design for this memorial, the architect made clear that he did not want his museum design for a Jewish museum to be turned into a Holocaust memorial.
18. Libeskind, "Project Description."
19. Bloom, "Broken," 190.
20. Adorno, "Valery Proust Museum," 175.
21. Among other accounts, see Leo Goldberger, ed., *Rescue of the Danish Jews,* 3–12.
22. Libeskind, "Mitzvah 2003," 93.
23. Jewish Museum of San Francisco, "Preservation Philosophy," Draft Architectural Building Program, June 1996, 46.
24. Turner, "Report on the Architectural Significance of Existing Structures in the Yerba Buena Center Area, San Francisco."

25. Carbonara, "The Integration of the Image," 238.

26. Ibid., 239–40.

27. Ouroussoff, "Conflict and Harmony Together in One Design."

28. Ibid., 65.

29. See Appelbaum, "Plans for the Future."

30. Newhouse, "Designs That Reach Out and Grab."

31. Sanders, "They're Building It, but Will They Come?"

32. Appelbaum, "Plans for the Future."

33. Wolfson, *Language, Eros, and Being,* 453 n. 197.

34. Sanhedrin 2b.

35. Krinsky, *Synagogues of Europe,* 5.

36. Ezek. 11:16.

CHAPTER 3. REGARDING THE PAIN OF WOMEN

1. Among other groundbreaking works, see Ofer and Weitzman, *Women in the Holocaust;* Rittner and Roth, *Different Voices;* Goldenberg and Baer, *Experience and Expression;* Katz and Ringelheim, *Proceedings of the Conference on Women Surviving;* Peskowitz and Levitt, *Judaism since Gender;* Fuchs, *Women and the Holocaust;* Heinemann, *Gender and Destiny;* Hertzog, *Life, Death, and Sacrifice;* Baumel, *Double Jeopardy;* and Horowitz, *Gender, Genocide, and Jewish Memory.* On Mariya Bruskina, see Tec and Weiss, "A Historical Injustice."

2. Sontag, *Regarding the Pain of Others,* 8.

3. In Smith and Peterson, *Heinrich Himmler,* 201, as quoted in Ringelheim, "Genocide and Gender." The earlier citations by Otto Six, the Wannsee Protocol, and Himmler are also drawn from this paper, which cites *Trials of War Criminals* (Nuremberg Green Series), 4:525, as their source.

4. See Ringelheim, "The Split between Gender and the Holocaust." For an earlier iteration of this idea, see Ringelheim, "The Unethical and the Unspeakable."

5. Ibid., 342.

6. Ibid., 343, 344.

7. First published in Holland as *Het Achterhuis* (The annex), it appeared in translation as *Anne Frank: The Diary of a Young Girl,* with an introduction by Eleanor Roosevelt.

8. In effect, the unexpurgated diary has even served to counterpoint some of the universal and national myths that brought the Anne Frank House and Museum into being and which continue to sustain it. See *The Diary of Anne Frank: The Critical Edition.* Also see Young, "The Anne Frank House."

9. See Kluger, *Still Alive.*

10. Spiegelman, *Maus,* 1:158.

11. See Miller's deeply insightful essay, "Cartoons of the Self," 49.

12. Spiegelman, *Maus,* 1:12, 84.

13. Ibid. 1:158.

14. Miller, "Cartoons of the Self," 49.

15. Though often reproduced, they can be seen most clearly in the museum catalog, Gutterman and Shalev, *To Bear Witness,* 126, 114, respectively.

16. For an elaboration of the ways women's corpses, in particular, have been represented as emblematic in our culture, see Bronfen, *Over Her Dead Body.*

17. Bataille, *Eroticism.*

18. A few months later, in April 1995, at the "Memory and the Second World War in International Perspective" conference in Amsterdam, Joan Ringelheim gave me a copy of her paper "Genocide and Gender: A Split Memory," a version of which was later published in Ofer and Weitzman, *Women in the Holocaust.*

19. Sontag, *On Photography,* 11–12.

20. See Kleeblatt, "The Nazi Occupation of the White Cube," 10–11.

BIBLIOGRAPHY

Adorno, Theodor W. "Engagement." *Noten zur Literatur* III. Frankfurt am Main: Suhrkamp Verlag, 1965.

———. "Valery Proust Museum." In *Prisms.* Translated by Samuel Weber and Shierry Weber Nicholsen. Cambridge, MA: MIT Press, 1981.

Ando, Tadao. "Hope for a Shattered Life." *Royal Institute of British Architects Journal* 104.1 (1997).

Apel, Dora. *Memory Effects: The Holocaust and the Art of Secondary Witnessing.* New Brunswick: Rutgers University Press, 2002.

Appelbaum, Alec. "Plans for the Future." *Nextbook.org,* January 29, 2008.

Ashton, Dore, ed. *Monumental Propaganda.* Instigated by Komar & Melamid. New York: Independent Curators International, 1995.

Augé, Marc. *Oblivion.* Minneapolis: University of Minnesota Press, 2004.

Azoulay, Ellie Armon. "The Accidental Sculptor." *Ha'aretz,* September 27, 2009.

Bałka, Mirosław. "Frogs, Knocks, and Other Blinks: A Conversation between Mirosław Bałka and Gregory Salzman on February 4, 2009, in Amherst, Massachusetts." In *Gravity* and available online at http://www.umass.edu/fac/media/Frogs.pdf.

———. *Mirosław Bałka: Gravity.* Catalog with audio CD published in conjunction with the exhibition at the University Museum of Contemporary Art, University of Massachusetts Amherst, 2009.

Bataille, Georges. *Eroticism.* London: J. Calder, 1962.

Bauer, Yehuda. "Fruits of Fear." *Jerusalem Post,* June 3, 1982.

Baumel, Judith Tydor. *Double Jeopardy: Gender and the Holocaust.* London: Mitchell Vallentine, 1998.

Bendt, Vera. "Das Jüdische Museum." In *Wegweiser durch das jüdische Berlin: Geschichte und Gegenwart,* 200–209. Berlin: Nicolai Verlag, 1987.

Berger, Joseph. "As a School Shooting's First Anniversary Nears, Newtown Asks for Privacy." *New York Times,* December 7, 2013.

Bernard-Donals, Michael. *Forgetful Memory: Representation and Remembrance in the Wake of the Holocaust.* Albany: State University of New York Press, 2009.

Blais, Allison; and Rasic, Lynn. *A Place of Remembrance: Official Book of the National September 11 Memorial.* Washington, D.C.: National Geographic Society, 2011.

Bloom, Barbara. "Broken." In *The Collections of Barbara Bloom,* edited by Dave Hickey, 183–203. New York: Steidl/ICP, 2007.

Borowski, Tadeusz. *This Way for the Gas, Ladies and Gentlemen.* Translated by Barbara Vedder. New York: Penguin Books, 1976.

Bothe, Rolf, and Vera Bendt. "Ein eigenstandiges Jüdisches Museum als Abteilung des Berlin Museums." In *Realisierungswettbewerb: Erweiterung Berlin Museum mit Abteilung Jüdisches Museum.* Berlin: Senatsverwaltung fur Bau- und Wohnungswesen, 1990.

Bronfen, Elisabeth. *Over Her Dead Body: Death, Femininity, and the Aesthetic.* New York: Routledge Press, 1992.

Carbonara, Giovani. "The Integration of the Image: Problems in the Restoration of Monuments." Excerpted in *Historical and Philosophical Issues in the Conservation of Cultural Heritage,* edited by Nicholas Stanley Price, M. Kirby Talley Jr., and Alessandra Melucco Vaccaro. Los Angeles: Getty Trust Publications and Getty Conservation Institute, 1996.

Collins, Glenn. "8 Designs Confront Many Agendas at Ground Zero." *New York Times,* November 20, 2003.

Corning, Amy, and Howard Schuman. *Generations and Collective Memory.* Chicago: University of Chicago Press, 2015.

Cowan, Alison Leigh. "Newtown Helps Map Out a New Path to Healing." *New York Times,* March 30, 2014.

Demo, Anne Teresa, and Bradford Vivian, eds. *Rhetoric, Remembrance, and Visual Form: Sighting Memory.* New York: Routledge, 2012.

Dowd, Maureen. "The Unbearable Lightness of Memory." *New York Times,* November 30, 2003.

Dunlap, David, and Charles V. Bagli. "New Look at Memorial Lowers Cost." *New York Times,* June 21, 2006.

Ebony, David. "Towers of Light for New York City." *Art in America,* November 2001, 35.

Faust, Drew Gilpin, ed. *In the War Zone: How Does Gender Matter?* Chapel Hill: University of North Carolina Press, forthcoming.

Feinstein, Stephen C., ed. *Absence/Presence: Critical Essays on the Artistic Memory of the Holocaust.* Syracuse: Syracuse University Press, 2005.

Feldshuh, Michael, ed. *The September 11 Photo Project.* New York: Regan Books, 2002.

Felstiner, John. *Paul Celan: Poet, Survivor, Jew.* New Haven, CT: Yale University Press, 1995.

Filler, Martin. "At the Edge of the Abyss." *New York Review of Books,* September 21, 2011.

Frank, Anne. *Anne Frank: The Diary of a Young Girl.* Translated by B. M. Mooyaart-Doubleday with an introduction by Eleanor Roosevelt. Garden City, NY: Doubleday, 1952.

———. *The Diary of Anne Frank: The Critical Edition.* New York: Doubleday, 1989.

Friedländer, Saul. *Memory, History, and the Extermination of the Jews of Europe.* Bloomington: Indiana University Press, 1993.

———. *Nazi Germany and the Jews, Volume I: The Years of Persecution, 1933–1939.* New York: Harper Perennial, 1998.

———. *Reflections of Nazism: An Essay on Kitsch and Death.* New York: Harper & Row, 1984.

———. "Trauma, Transference, and 'Working Through' in Writing the History of the *Shoah*." *History and Memory* 4 (Spring–Summer, 1992): 39–59.

Fuchs, Esther, ed. *Women and the Holocaust: Narrative and Representation.* Lanham, MD: University Press of America, 1999.

Giedion, Sigmund. *Architecture You and Me: The Diary of a Development.* Cambridge, MA: Harvard University Press, 1958.

Gintz, Claude. "'L'Anti-Monument' de Jochen & Esther Gerz." *Galeries Magazine* 19, (June–July 1987): 80–82, 130.

Godfrey, Mark. *Abstraction and the Holocaust.* New Haven, CT: Yale University Press, 2007.

Goldenberg, Myrna, and E. Baer, eds. *Experience and Expression: Women and the Holocaust.* Detroit: Wayne State University Press, 2003.

Goldberger, Leo. *The Rescue of the Danish Jews: Moral Courage under Stress.* New York: New York University Press, 1987.

Goldberger, Paul. *Up from Zero: Politics, Architecture, and the Rebuilding of New York.* New York: Random House, 2004.

Greenberg, Judith, ed. *Trauma at Home: After 9/11.* Lincoln: University of Nebraska Press, 2003.

Gutmann, Joseph. "Is There a Jewish Art?" In *The Visual Dimension: Aspects of Jewish Art,* edited by Claire Moore, 1–20. Boulder, CO: Westview Press, 1993.

Gutterman, Ella, and Avner Shalev, eds. *To Bear Witness: Holocaust Remembrance at Yad Vashem.* Jerusalem: Yad Vashem Publications, 2005.

Halbwachs, Maurice. *The Collective Memory.* Translated by Francis. J. Ditter and Vida Y. Ditter. New York: Colophon, 1980.

Hamann, Brigitte. *Hitler's Vienna: A Dictator's Apprenticeship.* Translated by Thomas Thornton. New York: Oxford University Press, 1998.

Hansen-Glucklich, Jennifer. *Holocaust Memory Reframed: Museums and the Challenges of Representation.* New Brunswick, NJ: Rutgers University Press, 2014.

Heinemann, Marlene E. *Gender and Destiny: Women Writers and the Holocaust.* New York: Greenwood Press, 1986.

Hertzog, Esther, ed. *Life, Death, and Sacrifice: Women and Family in the Holocaust.* Jerusalem: Gefen Publishing, 2008.

Hinz, Berthold. *Art in the Third Reich.* New York: Pantheon Books, 1979.

Hirsch, Marianne. *Family Frames: Photography, Narrative and Postmemory.* Cambridge, MA: Harvard University Press, 1997.

Hitler, Adolph. *Mein Kampf.* Translated by Ralph Manheim. Boston: Houghton Mifflin, 1943, 1971.

Hornstein, Shelley. *Losing Site: Architecture, Memory, and Place.* Burlington, VT: Ashgate Publishing Company, 2011.

———, and Florence Jacobowitz, eds. *Image and Remembrance: Representation and the Holocaust.* Bloomington: Indiana University Press, 2002.

———, Laura Levitt, and Larry Silbertstein, eds. *Impossible Images: Contemporary Art after the Holocaust.* New York: New York University Press, 2003.

Horowitz, Sara R. *Gender, Genocide, and Jewish Memory* (forthcoming).

———. "Women in Holocaust Literature: Engendering Trauma Memory." In Ofer and Weitzman, *Women and the Holocaust,* 364–77.

Huyssen, Andreas. "The Voids of Berlin." *Critical Inquiry* 24.1 (Fall 1997): 57–81.

————. "Monument and Memory in a Postmodern Age." In Young, *Art of Memory*, 9–17.

Jacobs, Steven L. *Shirot Bialik: A New and Annotated Translation of Chaim Nachman Bialik's Epic Poems*. Columbus, OH: Alpha Publishing Company, 1987.

Kahn, Tobi. *Embodied Light: 9/11 in 2011, an Installation by Tobi Kahn*. New York: Educational Alliance, 2011.

Kaplan, Brett Ashley. *Unwanted Beauty: Aesthetic Pleasure in Holocaust Representation*. Urbana: University of Illinois Press, 2007.

Katz, David. "The Artist as Provocateur." *Jewish Quarterly* 52.3 (2005): 21–26.

Katz, Esther, and Joan Ringelheim, eds. *Proceedings of the Conference on Women Surviving: The Holocaust*. New York: Institute for Research in History, 1983.

Kimmelman, Michael. "Ground Zero's Only Hope: Elitism." *New York Times,* December 7, 2003.

————. "Gerhard Richter: An Artist beyond Isms." *New York Times,* January 27, 2002.

————. "Art Review; Evil, the Nazis, and Shock Value." *New York Times,* March 15, 2002.

Kleeblatt, Norman L., ed. *Mirroring Evil: Nazi Imagery/Recent Art*. New York and New Brunswick, NJ: Jewish Museum and Rutgers University Press, 2001. Published in conjunction with the exhibition at the Jewish Museum, New York.

————. "The Nazi Occupation of the White Cube: Transgressive Images / Moral Ambiguity / Contemporary Art." In Kleeblatt, *Mirroring Evil*, 3–16.

Kluger, Ruth. *Still Alive: A Holocaust Girlhood Remembered*. New York: Feminist Press of the City University of New York, 2001.

Knausgaard, Karl Ove. "The Inexplicable: Inside the Mind of a Mass Killer." *New Yorker,* May 25, 2015.

Komar, Vitaly, and Alexander Melamid. "In Search of Religion." *Artforum,* May 1980, 36–46.

Kozloff, Max. *New York: Capital of Photography*. New Haven, CT: Yale University Press, 2002.

Krinsky, Carol Herselle. *Synagogues of Europe: Architecture, History, Meaning*. Cambridge, MA: MIT Press, 1985.

Lane, Anthony. "The Shutterbug." *New Yorker,* May 21, 2001.

Lang, Berel. *Holocaust Representation: Art within the Limits of History and Ethics*. Baltimore: Johns Hopkins University Press, 2000.

Libeskind, Daniel. *Between the Lines: Extension to the Berlin Museum with the Jewish Museum*. Amsterdam: Joods Historisch Museum, 1991.

————. *Counterpoint: Daniel Libeskind in Conversation with Paul Goldberger*. New York: Monacelli Press, 2008.

————. "Between the Lines." In *Daniel Libeskind: Erweiterung des Berlin Museums mit Abteilung Jüdisches Museum,* edited by Kristin Feireiss. Berlin: Ernst & Sohn, 1992.

————. "Mitzvah 2003: Danish Jewish Museum." In *Daniel Libeskind and the Contemporary Jewish Museum: New Jewish Architecture from Berlin to San Francisco,* edited by Connie Wolf, 92–99. New York: Rizzoli, 2008.

————. "Project Description." Studio Daniel Libeskind, 1995.

Lin, Maya. *Boundaries*. New York: Simon & Schuster, 2000.

————. *Topologies*. New York: Rizzoli, 2015.

JAMES E. YOUNG is Distinguished University Professor of English and Judaic Studies and director of the Institute for Holocaust, Genocide, and Memory Studies at the University of Massachusetts Amherst. In 1997, Young was invited to serve on the commission to oversee the design competition for the Berlin *Denkmal*. He has consulted with Argentina's government on its memorial to the *desaparacidos*, as well as with numerous city agencies on their memorials and museums. In 2003, he was appointed to serve on the jury for the National September 11 Memorial design competition. Most recently, he was invited to serve as an adviser to Norway's July 22 Memorial Research Group during their process of memorializing the mass murders on the island of Utøya in 2011.

Young is the author of several books, including *At Memory's Edge: After-Images of the Holocaust in Contemporary Art and Architecture; The Texture of Memory: Holocaust Memorials and Meaning,* which won the National Jewish Book Award; and *Writing and Rewriting the Holocaust: Narrative and the Consequences of Interpretation.* He has written widely on public art, memorials, and national memory with articles, reviews, and Op-Ed essays appearing in *The New York Times Magazine, The Forward, Critical Inquiry, Representations, Tikkun,* and *Slate,* among dozens of other journals and collected volumes. His books and articles have been published in German, French, Hebrew, Japanese, and Swedish editions.